With love on our 34th
anniversary — especially for
"hanging in there" with the old model.

Pauline

December 7, 1975

Western Painting Today

Western Painting Today

by Royal B. Hassrick

WATSON-GUPTILL PUBLICATIONS/NEW YORK

Library of Congress Cataloging in Publication Data
Hassrick, Royal B
 Western painting today.
 Includes index.
 1. Painting, American. 2. Painting, Modern—20th
century—United States. 3. The West in art. I. Title.
ND212.H34 759.13 75-12862
ISBN 0-8230-5710-0

First Printing, 1975

To the men and women
who paint pictures of the West

Contents

The Artists

Page numbers in italic indicate color plates

Introduction

Today, there is an increasing number of artists who are selecting the American West for their subject matter. This can be explained in part by the need of our mobile society, with its changing values, to establish a sense of heritage and find security in heroes. And the drama of the historic West amply offers both heritage and heroes, surely accounting for the growing popularity of the contemporary Western painters.

The work of these artists covers a range of styles, from traditional realism to impressionism to photorealism. Quite understandably, there is an absence of pure color theory and abstract expressionism in their work, for they take the narrative approach—their paintings tell a story or impart a mood. Many paint in the tradition of Frederic Remington and Charles Russell and stand firmly in their belief that recording the Western heritage, both past and present, is a necessary responsibility. While over 70 artists are included here, there are many more who are not represented. Some artists who should be included could not be reached; others failed to respond to the invitation. The examples in this book were selected much as the paintings in a museum are: artists whose works were known were invited to submit samples for inclusion; those whose works were unknown were asked to send selections to be judged.

In order to give context to the illustrations in this book, a historical sketch of the American West has been included. This should provide a focus, a sense of perspective, on both the subject matter of Western art and the painters that carry on the tradition of capturing the spirit of the West—as it was, and as it is today.

It seems timely in the light of the growing interest in the Western scene that there should be a book about the devoted artists who paint the West. The sincerity and skill with which their goals are accomplished indeed deserve recognition. It is hoped that by bringing before the public the work of so many capable and devoted men and women this volume will show the scope of the contemporary effort.

Royal B. Hassrick
Franktown, Colorado

1. The Romance of the West

The story of the American West is without question one of the most exciting and dramatic chapters in this nation's history. Here, the lives of men and women with diverse and often opposing ambitions were encompassed: the fur trapper considered it a source rich in spoils; for the pioneer, it was a land of opportunity; and for the miner it was a mountainous terrain where fortunes might be made. In this land of destiny cattle barons carved out empires of grass, railroad tycoons grew rich, and mining speculators squandered fortunes. This was the West of nineteenth-century America, the nation's era of romance.

Indian Tribes and Traditions

The story's beginnings, however, reach far back in time. The American continent, from the Great Plains to the arid desert of the Southwest, from the Rocky Mountains to the shores of the Pacific, was the established homeland of many Indian tribes. Among the most highly sophisticated were the Pueblos of Arizona and New Mexico—the Hopi and the Zuñi to the west, and the Rio Grande tribes to the east. These peace-loving farmers were descendants of the cliff dwellers and other similar multiple apartment house dwellers. The men tilled the fields of corn, beans, squash, and cotton, and wove handsome shawls and kilts in diamond and twill patterns. Women prepared the food, grinding the corn in stone *metates*, and fashioned decorative clay pottery. The territory of the Pueblos extended from Taos, the most northerly of their apartment complexes, to the Hopi and Zuñi villages perched high on shimmering mesas to the west. The Pueblos were ruled by priestly clan chiefs who received their authority from a hierarchy of ancestral spirits, or *kachinas*. Ceremonial rituals were held in great circular subterranean structures, or *kivas*. From these, masked men representing the *kachinas* would emerge and dance before the people in supplication to the spirits. Life among the Pueblos was rigidly ordered, static, and serenely successful.

Surrounding the Pueblos in the desert were the Navahos and the Apaches. Originally marauding hunters from the north, the Navahos later engaged in modest farming and the herding of sheep. The women who tended the great flocks wove blankets at first and later rugs of uncommon beauty and charm. With the introduction of silver, the men made jewelry that was often handsomely set with sky-blue turquoise. The warlike Apaches living to the south fought valiantly under the leadership of heroes such as Cochise and Geronimo to preserve their way of life against white encroachment.

Unlike the peaceful Pueblos, the Indians of the Great Plains were belligerent. These nomadic tepee-dwelling buffalo hunters moved their villages to follow the herds. With the introduction of the horse, mobility increased and their culture flourished. They made war not only to expand and defend their territories, but to capture horses, thereby gaining wealth and prestige. Among the Indians of the Great Plains were the Blackfeet and Crows in the north, the Sioux, Cheyennes, and Arapahos in the central regions, and

the Kiowas and Comanches in the south. They were so colorful in their streaming eagle-feather warbonnets, so daring as horsemen, so skillful with the bow and arrow that they were regarded as the epitome of all that is romantically Indian. The Sioux, in defense of their homeland, often clashed in battle with the United States cavalry. Sitting Bull, Gall, and Crazy Horse led the Sioux in strategy and in battle, resulting in the destruction of General George Custer's Seventh Cavalry at the Battle of the Little Big Horn in July of 1876.

West of the High Plains and the towering Rockies is the Great Basin, a barren wasteland where the Paiute and Western Shoshone eked out an existence living on wild rabbits, grasshoppers, and roots. Because of this they were derogatively referred to as "Diggers." Early miners shot them down for sport just as if they were stray dogs. To the east in the more mountainous areas lived the Utes and Mountain Shoshone, who after the advent of the horse rode from their mountain lairs to hunt buffalo and pillage the plains. In the plateau country north of the Great Basin lived such people as the Flatheads, the Nez Perce, and the Walla Walla. California was composed of a medley of colorful smaller tribes. They existed by hunting and seed gathering, and the women were noted for the handsome baskets they wove. For the miners, however, these tribes were a nuisance and they, too, were killed with gleeful abandon.

The early explorers looked upon the West as a vast, foreboding, and awesome land occupied by strange and fearsome natives. Coronado, a Spanish conquistador in search of fortune, was the first European explorer to make significant discoveries in the Southwest. Lured by tales of the fabled Seven Cities of Cibola, he reached the pueblo dwellings of the Zuñi in 1540. After a pitched battle, Coronado's troops overcame the Indians and within an hour had plundered their village. However his victory became a hollow one when he found that the Zuñi had no gold or precious jewels. While Coronado's band was encamped near what is now Santa Fe, a beguiling Plains Indian named The Turk brought rumors of the incredible golden cities of Quivira. In 1541, led by The Turk, Coronado set out, heading east over the Texas plains and north to the Oklahoma panhandle, possibly as far as Kansas. But here, instead of cities of gold, he found only the grass lodges of the Pawnee Picts. Discouraged, he turned his forces around and headed for Mexico, his hope for instant wealth thoroughly shattered.

Forty years later, however, the Spaniards returned to the land of the Pueblos 400 strong. Under the leadership of Don Juan de Oñaté, the colonists brought horses, cattle, swine, and sheep. Setting his capitol at Santa Fe, Oñaté promptly subjugated the Indians, throwing the men into slavery for twenty years or cruelly cutting off a foot of those who resisted. Hatred for the Spaniards smoldered in the Indians, but not until 1680, roused by an Indian named Popé from the pueblo of San Juan, did they revolt. United, they attacked the Spanish haciendas, ravaged the churches, and even raided the capitol itself. So embittered were the Indians that they slaughtered nearly 500 settlers and drove some 2,500 others from their country, including the overbearing governor.

Early Explorers

Due primarily to the foresight of Thomas Jefferson and his purchase of Louisiana from France, the nation's most historic exploration was undertaken. Leaving from Cahokia (near St. Louis) in the spring of 1804, Captains Meriwether Lewis and William Clark proceeded up the Missouri River as far as the earth lodge villages of the Mandans. Here they wintered, preparing their thirty men for an expedition not only to record the terrain and its flora and fauna, but to advise the Indian nations that their allegiance should now be to the United States.

In April, guided by the Shoshone woman Sacajewea, the explorers left the Mandan villages and continued west to the falls of the Missouri. After a portage, Lewis and Clark reached the "three forks" of the Missouri where the Madison, Gallitin, and Jefferson rivers converge. Here a decision had to be made as to which river would offer the best route to the Pacific. They chose the Jefferson, and as they proceeded, Sacajewea recognized the territory and reassured them that they were heading in the right direction. Following the Beaverhead River, the party crossed the Continental Divide and eventually entered the mountainous land of the Shoshones. From them, the explorers hoped to secure horses without which their trek across the Plateau—which extends from the eastern Rockies to the Cascade Mountains—would be nigh impossible. Their first encounter with the Shoshones was a wary one. However the situation was soon resolved when it was fortuitously discovered that the chief was Sacajewea's brother.

So now, with horses, the men continued west. This portion of the journey proved most arduous, for instead of the Rockies being composed of one range of mountains as was thought, there turned out to be range after range separated by barren and inhospitable plateaus. When at last the expedition reached the headwaters of the Clearwater River, they left their horses with the Nez Perce and built canoes. Paddling down the Clearwater, the Snake, and the torrents of the Columbia, they eventually reached the Pacific Ocean. Their journey from the Mandan villages had taken them seven months. Building themselves a little fort which they named Clatsop, the men spend five soggy months in the rain-soaked forest. Here they prepared their notes and laid claim to the territory in the name of the United States.

On the return journey, they followed their original route over the danger-filled Cascade Mountains. Upon reaching the camps of the Nez Perce, they picked up their horses. From here, Lewis and Clark continued on to the Bitterroot River where they split forces. Lewis chose to go east over what would soon be called the Lewis and Clark Pass to the falls of the Missouri River via the Marias River. His hope was to discover a waterway to the Pacific. However the search was fruitless; there was no passage. Giving up, Lewis turned back to rendezvous with Clark, who had gone south to explore the Yellowstone River to its juncture with the Missouri. On the way, Lewis was confronted by Blackfoot Indians. He made camp with them, and while he slept they tried to steal his guns and horses. Two of the thieves were killed in the ensuing pursuit before the horses could be

recaptured. Now Lewis was very quick to leave and join up with Clark. Together they drifted down the Missouri to a glorious welcome in St. Louis in September 1806.

Though failing to find a Northwest Passage, Lewis and Clark dispelled a myth. Moreover, they laid claim to the Northwest for the new nation, advised the Indians and the fur traders that their allegiance was henceforth to be to the United States, and compiled copious and valuable notes about the nation's new purchase, Louisiana.

While historically the explorers have received the credit for discovering the West, in reality it was the unheralded trappers and fur traders who first penetrated many of the unknown regions. Valuable furs collected by the Indians were exchanged for pots, pans, glass beads, and firearms. The beaver pelt was particularly desirable as the basis of felt for men's hats. Since the Indians were less inclined to trap, it was largely the French and later the English and Americans who engaged in this work. Among the trading posts established throughout the West, the most prosperous was the American Fur Company founded by John Jacob Astor. Here, Indians and trappers brought their furs for barter or for cash.

The trapper's life was a lonely and dangerous one. Always subject to attack by Indians, these hardy men sought out the most remote corners of the country in search of beaver and in hope of wealth. The fur industry, however, ended in the 1830s due to the whim of fashion in Europe; silk hats for men became the fad and beaver hats went out of style.

Go West, Young Man

As the nation expanded and the population grew, the pioneer spirit continued to dominate the attitude of the populace. Eastern farmers, feeling cramped or angered at the low prices they received for their crops, picked up their families and belongings and set out to begin farming in this western wilderness. When the wonders of Oregon were touted in the 1840s, a mass migration took place. Emigrants by the thousands embarked from Independence and Westport, Missouri, in caravans of prairie schooners to find a new life in the promised land. The trip over the Oregon Trail was fraught with hardship and danger. Indian attack was an ever-present threat while the waterless plateaus, the hazardous mountain passes, and the surging rivers cost many a pioneer's life. This, as was the Mormon's trek, was a saga of endurance and heroism.

The discovery of gold in 1848 at Sutter's Mill in California drew a new surge of emigrants. Lured by the hope of quick riches, thousands journeyed over the Oregon Trail to the California Trail heading for the gold fields of the Pacific coast. Ten years later, William Green Russell found gold near the headwaters of Cherry Creek in Colorado. With his find a new exodus from the East took place with its go-for-broke motto "Pike's Peak or Bust."

To protect the frontier settlers against the ravages of marauding Indians and to guard the supply lines, the United States posted troops of infantry and cavalry at strate-

gic but lonely forts throughout the West. The trooper's lot was far from glamorous. While on duty at the fort, life was a monotony of details, but during campaigns great endurance and courage was required. Actually, most skirmishes were short and casualties few, but several major battles stand out in history, such as Custer's massacre of the Cheyenne at the Washita River and the Sioux's destruction of his Seventh Cavalry at the Little Big Horn. Custer's defeat was anomalous, for not only was it the Indian's last victory, but it spelled the end of native resistance, and in fact, of their very way of life.

Of all the American culture heroes, the cowboy stands foremost. The story begins in Texas after the Civil War when returning veterans found themselves destitute and their herds scattered. The cattle-poor Texans, noting the increasing need for meat in the burgeoning cities of the Northeast, seized the opportunity. By rounding up their stray longhorns and driving them to the railheads, the Texans believed they might enjoy high profits—and they did.

There were several trails leading north: the Shawnee to Kansas City, the Chisholm to Abilene, and later the Western Trail to Dodge City. A typical cattle drive might consist of a thousand head with nine men, a trail boss, a cook, and between 60 and 66 horses. The drive was usually managed by a drover who bought the cattle at about $8 per head and hoped to sell them at the railhead for perhaps $20. Subtracting the expenses of wages and supplies, he might make as much as $30,000 for one drive. If, however, a drover were plagued by stampedes, droughts, blizzards, or a shrunken market at the end of the trail, he might lose his shirt.

There were many rivers to cross from southern Texas to the Kansas railheads. When the rivers swelled, they became hazardous, causing cattle to panic at floating logs. Often the cowboys plunged in among the milling beasts to urge them in the right direction. Many a man was swept from his horse and lost in the surging current. Stampedes, however, were most feared. In the hope of preventing them, cowboys sang to the cattle at night, but the animals were so skittish that a burst of thunder or even the mere striking of a match could incite the herd to bolt. If this happened, the cowboys rode hard to head off the leaders, trying to turn the pounding herd in upon itself so that it would mill and eventually stop. One herd of cattle was known to have run 45 miles in one night before it was halted and another stampeded 18 times in the same night.

For the cowboys riding among the herd, danger was imminent, and not infrequently a horse and rider were overrun and trampled by pounding hooves. It was the cook's sad job to dig the grave while the cowboys stood around in tribute with hats in hand.

Not all cowboys were devoted to driving herds north to Kansas. In New Mexico, Colorado, and Wyoming, cattlemen established great spreads on the free grass, often running as many as 10,000 cows. Rather than a drover, the cowboy became a herdsman, riding the borders, or "line," trying to keep the owner's cattle from drifting into a neighboring rancher's range. When barbed wire was introduced in 1874, miles upon miles of fence were stretched. This not only separated the ranches, but made the line rider's job an easier one.

The cattle barons of the 1870s were plagued by droughts, blizzards, and cattle thieves. Their ranches were so huge, often covering several hundred square miles, that the cowboys were hard pressed to patrol the entire territory. In some areas rustling became a way of life and even though all cattle were branded, the branding marks could be altered. While individual rustlers were often either shot or summarily hung when caught, organized rustling fanned range wars where cowboys of opposing factions were often bushwhacked, drygulched, or lynched at a "necktie party."

Fall was the time for the annual roundup. Here the cattle were sorted, the cowboys separating their owner's cows from those of his neighbors'. That season's calves were branded while the steers were driven to the shipping points where they were loaded in cattle cars and transported east to the packing houses.

In the mid-nineteenth century, tying the West to the rest of the nation became increasingly urgent as trade, commerce, and communications expanded. Wagontrains plied the Santa Fe and Overland Trails. Stagecoaches rocked from San Francisco to St. Louis, and the Pony Express carried mail from the West Coast to St. Joseph, Missouri, in the record time of ten and one half days. As time progressed, towns and cities grew, railroads crossed the continent, and the West prospered. This was the land of opportunity; the proof lay in its success.

Western Heritage

Today, the reminders of the Old West are the Indians, the miners, and the cowboys. In modern-day ranching the traditions of a century ago are carried on, although like the traditions of the Indians and the prospectors, much has changed. English breeds such as Hereford and Angus as well as French Charolais and Swiss Maine Anjou have replaced the longhorn. Much attention is paid to breeding lines so that they will produce quick-gaining calves with more pounds of edible red meat. In the springtime the cowboys brand the calves and steer the young bulls. The cattle are rounded up in the fall and the calf crop is either marketed, being sold to the feeder for fattening, or wintered through on grass and disposed of the following spring. Cowboying involves more than mere riding fence or rounding up cattle—it often means mundane and hard work like building fences, making hay, oiling windmills, and doctoring sick animals. A cattleman may be a college graduate in Levis or a businessman wearing spurs.

From the time of the early explorers to the cowboys of today, the American West has continued to cast an aura of color and drama. There is, in fact, more enthusiastic interest in the story of this heritage today than ever before.

2. The Artists of the West

A land of such wondrous grandeur, unfathomed scope, untapped resources, and heroic people was bound to attract the curiosity of the artist. These artists had varied goals, directions, and styles, but almost without exception their common denominator was a desire to record the West and to capture the spirit of its drama. Most of the early Western artists were highly trained in schools in New York and Europe, and some were successful professional illustrators for the popular magazines of the day. Many were prolific, and the record they left is as handsome as it is monumental.

Early Interpreters

One of the first was Peter Rindisbacher, a Swiss artist who painted Indian life of the northern plains in a more or less naive style in the 1820s.

Better known was George Catlin, who as early as the 1830s set himself to the task of painting an "Indian Gallery." His decorative, romantic portraits, reminiscent of Thomas Sully in style, won him acclaim at home and abroad.

Less of a showman was Karl Bodmer, an artist who recorded the German Prince Maximilian zu Wied's scientific expedition to the northern Plains. Bodmer's tight and carefully detailed realism made his Indian portraits a superbly accurate record.

Alfred Jacob Miller didn't care what he painted as long as he could paint. But as the artist for the adventurous sportsman from Scotland, Captain William Drummond Stewart, his lively, impressionistic renderings of Indians and the pageantry of the fur trade rendezvous of the Indians, trappers, and traders are compelling works.

Charles Bird King was a portrait painter who let the West come to him. His paintings of western Indians who visited Washington, D.C., in the mid-nineteenth century are handsome, colorful, and accurate interpretations.

Rudolph Kurz, a young Swiss artist inspired by the nobility of the American Indian, went West where he made beautiful and graceful drawings and watercolors typical of the Victorian romanticism of the day.

In conveying the grandeur of the Western landscape, no one surpassed Albert Bierstadt and Thomas Moran. Bierstadt's portrayals of the Rocky Mountains in the grandiose style of the "Hudson-River-School-Moved-West" brought him prominence and wealth. Moran's colorful scenes of natural wonders such as the Grand Canyon and Yellowstone Falls are masterpieces of breathtaking beauty.

No two artists have struck the fancy of the American public more than Frederic Remington and Charles Russell. Remington, a graduate of the Yale School of Fine Arts, was determined to recapture the spirit of the West. His powerful paintings are filled with action and drama. Charles Russell, a self-taught artist and horse wrangler, caught the flavor of the West he knew so well in free, colorful, and vigorous illustrations.

But Remington and Russell were by no means the only artists of the time who concentrated on Western subjects. There were many others—John Mix Stanley, Henry Farney, Charles Schreyvogle, William Ranny, and Charles Wimar—who brought the West

to the parlors and galleries of the East. And in New Mexico, Joseph Sharp and later **Bert Phillips** and Ernest Blumenschein found the magic of the mesas and the nobility of **the** Indians worthy of their canvases. In 1912, along with Irving Couse, Oscar Berninghaus, and Herbert Dunton, these intrepid Western artists organized the Taos Society of Artists, a "school" that grew in members and prominence for nearly 50 years.

These Taos artists were painting in the tradition of art for art's sake. They were imbued with the ideas of the noble savage and the wonders of the West and approached their work with the attitude that "all's right with the world." Unlike their predecessors, these men were painting very tame Indians in a very tame West. Although they wallowed in esthetic rhetoric, most of these artists had technical ability and were well trained. Some were romintic realists, and others were influenced by impressionism, fauvism, and cubism. Despite their saccharine approach, they achieved a vast number of impressive works of art. Included in their number were artists such as Henry Balnick, Andrew Dasburg, Nicolai Fechin, and Walter Ufer.

The fascination of the West would not be stilled. Throughout the twentieth century, artists like W.H.D. Koerner and Olaf Seltzer painted cowboys much in the spirit of Charles Russell. From vigorous buffalo hunts to passive Pueblo Indian scenes, these paintings have a shimmering brilliance combined with the draftsmanship of a master.

The Changing West

Today the charisma of the Old West is even more compelling. Well over a hundred contemporary artists are devoted to producing pictures of the Western scene. Curiously, this approximates the number of painters who portrayed the West when it was a dynamic part of the nation's destiny. Much of the reason that an increasing number of people are painting the West is undoubtedly due to a nostalgia about the glamor of the past. Many artists try to recapture such excitement as the Plains Indians' battles with the cavalry, to relate to the rigorous and boisterous life of the cowboys; in short, to cling to an era of heroes.

Many of the traditions are still alive in the West. The Plains Indians have outlived the U.S. cavalry, though their life is far from the dramatic one of their colorful forefathers. The Pueblos, Navahos, and Apaches of the Southwest have retained many tribal customs and much of their ceremonial life. The cattle industry continues in many respects to carry out the old practices intact. The modern rodeo offers cowboys a chance to compete for cash prizes in contests ranging from bull riding to calf roping. Crowds throng the grandstands to catch the flavor of the cowboys' rugged sport.

The wildlife that was once so common can still be found in the more remote areas: antelope and coyote still roam the plains and deer, elk, bear, mountain sheep, and goat frequent the mountainous country. However, buffalo, which once roamed by the millions, are now confined to preserves throughout the West. But with all the taming **the** West has undergone, much of its wild beauty still remains.

The work of contemporary painters of the West falls into a variety of categories both in style and in subject matter. Many paintings are in truth illustrations and many artists are or were professional illustrators. Other paintings stand as works of art created by men whose training and approach is predominantly esthetic. Most, however, are a combination of the two wherein the artist endeavors to pictorially tell a story or describe an event; in essence, to illustrate a subject in compelling manner.

There are those in certain intellectual circles who look down their noses upon the practitioners of Western painting. Art critics, curators of contemporary art museums, and college professors of fine art often disparagingly refer to these artists as "illustrators," "cowboy artists," or even "buckeye painters." This, of course, is their prerogative. Yet much in the same way as a classical musician decries the music of Lawrence Welk, no one dares ridicule the Boston Pops. And so it is with the Western painters. The overall quality of their work, both technically and esthetically, is so high that they should not be denied their proper recognition—nor are they. These men and women are popular painters and public demand for their work is increasing in amazing proportions. They have struck the right note.

Charles Russell, and to a lesser degree Frederic Remington, were both once labeled as illustrators. Russell most likely didn't know the difference and probably couldn't have cared less. Remington, on the contrary, was keenly aware and strove hard to be recognized as an artist. His greatest honor was election as an Associate to the National Academy of Design, an achievement he deeply cherished.

Modern Subject Matter and Styles

Subject matter for today's Western artist is wide in scope and may vary from an interpretation of past events, real or imaginary, to a recording of present-day happenings. Those who paint bygone days must pay careful attention to historical accuracy. Proper uniforms for cavalrymen and correct costuming and weapons for Indian warriors are essential considerations if the work is not to be ridiculed. The paintings included in this book show a high degree of respect for detail. Howewer, even some of the more famed artists made mistakes. Russell's historical interpretations of the Lewis and Clark Expedition show nineteenth-century Blackfoot styles on early Hidatsa Indians. Although his watercolor *At the Spring* shows an Indian girl carrying a jar, the Plains Indians made no pottery. Russell's buffalo-hunting scenes invariably show Indians aiming their arrows at the right side of the fleeing beasts. However, hunters always aimed at the left side, nearest the heart. Remington, a stickler who prided himself on his authenticity, flubbed it in his painting *The Smoke Signal* by showing women's saddles on warriors' horses.

Painting historical events after the fact is risky and at best is the artist's interpretation. When done after careful research and familiarity with locale, paintings became engaging imagery of what might have been. Like the historical novel, they conjure up a semblance of truth to fulfill a romantic vacuum.

The contemporary artists are not without their errors. One artist fell into Russell's mistake of showing Indian hunters shooting arrows at the running buffalo from the wrong side. Another artist concealed his accurately costumed Indians behind a cut in a hill which turned out to be a geological impossibility.

Those artists painting the present-day scene, of course, are on much firmer ground. Though limited to wildlife, ranching, and modern American Indians, there are innumerable situations, moods, and atmospheres that can be portrayed. In much the same way that the early Western painters captured characters and events which have now become historical records as well as works of art, so also does today's artist make a record for the future by painting a cowboy rounding up cattle or Pueblo Indians baking bread. And like the earlier artists, he has the advantage of being on the spot. He can catch the feel of the moment and at the same time have the assurance of correctness of detail. Only through careful observation and a sure brush can an artist catch just the way a running cow holds its head, or precisely how a roper throws his lariat.

Subject matter for these artists ranges from genre and wildlife to Indians and cowboys. Their scenes faithfully reflect the character of the West, and it is a tribute to their skill that its special flavor is so effectively captured. Those preferring to portray the native birds and animals vary in technique from detailed realism to the more conventional pastoral approach. The modern Indian—especially the colorful Navajo and Pueblo—is a popular subject for several of these artists.

The styles in which today's Western artist presents his or her subject matter are almost as diverse as the artists themselves. While some have taken their cue from their respected predecessors—in particular Remington and Russell—others lean toward expressionism. Still others have been influenced by the mural work of Diego Rivera, and in turn, by Thomas Hart Benton and Jackson Pollock. Most, however, are traditional realists in the figurative manner of Andrew Wyeth. Of these artists, some are self-trained, and some grew up on ranches or are themselves cattlemen today. For the latter, the term "cowboy artist" is no misnomer. As an example of photorealism, the works of Frank C. McCarthy are a case in point. Choosing for his subject matter such imaginary historical events as Indian battles, U.S. cavalry forays, and stagecoach attacks, he has achieved a degree of bold realism in his action-filled pictures that few artists have surpassed. These factors, combined with his masterful technique in the realistic rendering of old trees, weathered rocks, and majestic mountains, make a fascinating setting for his figures, whether they be mounted troopers or highwaymen in hot pursuit of a rushing stage.

Ray Swanson is a portrait painter with a particular finesse for revealing the craggy, wrinkled countenances of old Navaho characters as well as the soft roundness of the faces of their little children. In a photographic way he clothes his figures in such realistic attire that his compositions sparkle with vitality and brilliance. His precisely executed renderings of contemporary Indian life present a handsomm and colorful record.

Similar in style and feeling are the portraits of Indians by Robert Rishell and Alfredo Rodriguez. Both have an uncanny flair for catching a likeness with photographic presicion. At the same time they create strong and colorful portraits that seem to shim-

mer with life. Startling, too, are the photograph-like portraits by James Bama. His characters realistically grasp the flavor of the heroic and rugged men who still give the West its unique color.

John Clymer, a realist, prefers for his subject matter reconstructions of historical incidents. With careful attention to detail he portrays the Lewis and Clark Expedition in their arduous journey.

At the other end of the spectrum are impressionists such as Tony Eubanks and Ned Jacob. By balancing lights against darks, Eubanks creates sharp contrasts in his figures. Jacob's Indians are freely drawn, giving them special animation. Ethnographically accurate, his portraits show a thorough grasp of his medium and a genuine sensitivity toward his subject matter.

Harry Jackson, although beginning his career as an abstractionist, changed to figurative painting to better express his devotion to the West. His realistic portrayals of cowboys and other Western characters are infused with a fine balance of line, color, and form. Long a serious student of masters such as Goya and Rubens, his work possesses a strength of execution that gives his figures a powerful impact.

A student of N.C. Wyeth, Peter Hurd chose portraiture and the grandeur of New Mexico for his subject matter. His studies in tempera have an atmospheric quality that captures the nuances of light and color typical of the Southwest. The shimmering quality of his realism gives his paintings a mark of unique identity.

Philosophy and Inspiration

Possibly as important as the skill displayed by today's Western painters or the esthetic appeal of their work are the artists' own motivations. A random sampling of some of their comments help explain why they paint what they paint as well as something of the philosophy of their art. Fred Fellows, the 1974–1975 President of the Cowboy Artists of America, whose paintings of cowboys are inspired by his work on several large ranches, still ropes steers at rodeos. He says, "I just try to paint a good picture. Good drawing, good design, good values. If the content happens to be Western, that's because that's where my heart is."

Ernest Berke, a self-taught artist, has a straightforward philosophy when he says, "I prefer to let the work itself speak in whatever way it can. If it does, that is my statement." And it surely does.

Nicholas Firfires grew up as a cowboy and has this to say: "I'm not just trying to record what I have seen and know of ranch life. I'm trying to paint the spirit of that way of life as I know it, and I know it as good. I try to make each painting a work of art regardless of subject. I try to let the subject speak for itself and make its own demands. To submit to the subject rather than dominate it, to let its special character and unity be expressed through the medium of one's own skills rather than to use it for illustrating and confirming those skills. These have been my guiding principles."

Kenneth Ralston, born in Choteau, Montana, in 1896, rode a string of horses on the

open range for several of Montana's oldest cow outfits. He listened to the words of the early pioneers who crossed the plains to make Montana's history. Ralston writes: "I have been drawing pictures as far back as I can remember and have made it my life's work to try and make the Old West I knew and loved so well live again on canvas." In this, he has been most successful.

An 89,000 acre spread in Idaho was home for Cecil Smith. As a cowboy at the age of 13, Cecil sold his first painting. Later, his study of impressionism and the work of Robert Henri and George Bellows led him to expressionism, which was followed by an interest in cubism and the work of Max Weber. But it was realism that Smith found the most rewarding. Smith says: "The experience of trappers, Indians, and cowboys whom I knew plus my own experiences are what I have tried and am still trying to put down on canvas and in bronze. I feel that an artist should paint the subjects he knows and lives with. The feeling in a work of art is a demonstration of the love the artist has for the subject he paints."

Acrobat, stuntman, U.S. cavalryman, patrolman, horse wrangler, cowpuncher, and rodeo bronc-rider, Olaf Wieghorst, born in Denmark in 1899, knows whereof he speaks: "I have sat on the rim of some canyon for hours at a time watching rolling thunderclouds, blue summer skies, arid desert, and blue-green mountain country. I have watched herds of cattle drift across the wide prairie, heard the hoofbeats as a band of horses came down some box canyon for water. As I watched nature's wonders, it dawned on me now small and insignificant I was. Here are thousands and thousands of cubic miles of space, of sky, of earth, and millions of living creatures—and my goal was an impossible one, a goal that did not exist. But if I could succeed in putting a tiny fraction of nature's wonders on canvas and into people's homes, whether they be mud huts or mansions—if that painting would give some enjoyment and pleasure to the people, if it would add dignity to the home—I would feel my effort had not been in vain.

"Painting has given me much joy, and some despair. Joy when some old cowpoke has looked at a painting of a ranch scene and commences to tell me all about it: he knows the breeding of the horses, the brand of the cattle; he gets lost in his memories of some cowcamp or some horse he has broken. That's music to my ears. Despair when I have worked for weeks on some canvas only to destroy it because I cannot get the spirit, the atmosphere, or the mood I am after.

"When the time comes for me to put away my palette and unsaddle my pony, I hope that my canvases will in some small measure add to the historical recording of an era: the cowpony, the cowboy, and the Great American West."

The popularity of Western art can be determined in part by the number of painters whose works are selling as fast as they are produced. The great majority of paintings included here are of recent execution and are already in the hands of private collectors. How long this demand will continue is unpredictable, but it is not unreasonable to assume it will endure for quite some time. With the nation increasingly looking to its heritage, today's Western artists should have bright prospects for a good market. This is deserved, for the men and women faithfully recording this heritage are doing so with sincerity and love of the West as the illustrations in this book so handsomely confirm.

3. About the Artists

Gathered here are short biographies of the artists represented in this book. They come from a variety of backgrounds: some are Western born and bred, others grew up in the East and later headed West, and there are even a few who live in other parts of the country. But whatever their background and their approach to their art, the common bond that unites these artists is a devotion to depicting the West they know and respect. And their skill and dedication gives them a vital role in the Western scene today.

Robert Abbett. Born in Hammond, Indiana, in 1926, Abbett now lives in Bridgewater, Connecticut. He is a graduate of Purdue and the University of Missouri, and also studied at the American Academy of Art and the Chicago Academy of Fine Arts. Abbett is a freelance artist, illustrator, and teacher, and his work has been exhibited in numerous shows including the National Academy of Western Art. His work has even been exhibited as far away as Peking, People's Republic of China. Abbett's paintings catch the flavor of the West: the tilt of the cowboy's head and the reluctance of the little critter to hurry in his painting *Sandstorm on Flat Top* (p. 121) is "exactly like it is." Abbett says, "The vitality of our frontier days is very close to the surface in our western states . . . and is echoed in countless scenes and activities that we still experience. When I view a scene I want to paint, or have an idea, it is far from a satisfying experience. I have an irrepressible urge to set it down in picture form so that others may see it. Only when this is done am I content, briefly, till the cycle begins again."

Wayne Baize. Baize, a western Texas cowboy who took art lessons when he was twelve, now lives in Baird, Texas. The traditional realism in his painting *Got Away* (p. 65) shows the graceful rhythm of the roper and his horse at that instant of disappointment. The artist has shown his work in many exhibitions and has illustrated several western publications. His paintings are found in many private collections. "The cowboy and livestock he works with," says Baize "are my subjects. They are a great challenge for the artist."

James Bama. Born in New York City, Bama received his training at the Art Students League of New York and worked for twenty years as a professional illustrator. Intrigued by the dignity and courage of the cowboy, the Indian, the homesteader, the prospector, Bama moved to Wapiti, Wyoming, where he lives now. Here he can best absorb and delineate the characters of a bygone day. His photorealistic portraits capture the rugged heroism of his subjects. His work may be found in the National Cowboy Hall of Fame, the Football Hall of Fame, the Air Force Academy, and the Pentagon. Bama says, "I try to approach each painting with a fresh eye and a controlled mind and hand."

Joe Beeler. Founder and former President of the Cowboy Artists of America, Beeler lives in Sedona, Arizona. Growing up among both cowboys and Indians—Beeler himself is part Cherokee—he found his inspiration to record the West in the paintings of Charles Russell. In his painting *The Crossing* (p. 168), depicting an oldtime longhorn cattle drive fording a river, Beeler successfully portrays the beasts' natural reluctance to plunge in, and the drover's determination to see that they do. Beeler has had many one-man shows, including exhibitions at the National Cowboy Hall of Fame, the Thomas Gilcrease Insti-

tute of American History and Art, the Historical Society of Montana, and the C. M. Russell Gallery.

Bill Bender. Born in Oro Grande, California, in 1920, Bender now lives in El Segundo, California. His impressions of cowboy life have won many awards and prizes, including fellowships in the American Institute of Fine Art and the American Artists Professional League. Bender is both an author and an illustrator. His paintings are in many galleries and private and public collections, including the White House. Bender says, "I paint the West because that's all I savvy. More th n a way of making a living, it's my teacher and go-between with nature . . . which is basically what our life here is all about anyway."

Ernest Berke. Born in New York in 1921, Berke now lives in Santa Fe, New Mexico. He has had a long career as a successful commercial and freelance artist, and is versatile as a painter of murals and a sculptor. His work is in several collections, including the University of Texas Library and the Whitney Gallery of Western Art. Author and illustrator of *The North American Indians* (Doubleday), his attention to ethnographic accuracy is a credit to his sympathetic treatment. Berke's realistic paintings are powerfully dramatic statements of the West he knows so well.

Joseph Bohler. Born in Great Falls, Montana, in 1938 and raised on a cattle ranch at the foot of the Rocky Mountains, Bohler now lives in Prairie Village, Kansas. His watercolors exhibit an easy and refreshing grasp of the Western scene as it exists today. Winner of several awards including the silver medal at the National Academy of Western Art in 1974 and Best of Show at the C. M. Russell Auction, Bohler's paintings are exciting and true-to-life examples of cowboy life. Joe Bohler surely has a feel for the Western scene and conveys it most convincingly.

James Boren. Born in Texas in 1921, Boren lives in Waxahachie, Texas. He received his M.F.A. from the Kansas City Art Institute in 1951. Former President of the Cowboy Artists of America, Boren has won many prestigious awards. His work is in the private collections of the former Governor John Connally, Senator Harry Goldwater, and the late President Lyndon B. Johnson. Boren's *Afternoon in New Mexico* (p.104) gently portrays his conviction that the artist "can see and discover moods that the casual observer misses."

John Clymer. Born in Ellensburg, Washington, in 1907, Clymer now lives in Teton Village, Wyoming. He has been a freelance artist for 50 years and has won numerous gold medals. His work has been exhibited, among other places, at the Whitney Gallery of Western Art, the National Cowboy Hall of Fame, the Historical Society of Montana, and the Royal Canadian Academy. "The people, the mountains, and the animals of this country have always been my favorite subjects. I try to transfer the mood and excitement of this area into my work." His paintings *Up the Jefferson* (p.154) and *Skirmish on the River* (p.122) are tributes to his devotion to the historical scene.

Joseph Dawley. In addition to being a successful political and spot cartoonist, Dawley has held many one-man shows. He has exhibited at the Grand Central Art Galleries in

New York City and the Texas Art Gallery in Dallas, and is the author of several books, including *Character Studies on Oil, The Painter's Problem Book,* and *Painting Western Character Studies* (all Watson-Guptill). Dawley's work is in several museums as well as in the private collections of Governor Dolph Briscoe of Texas and U. S. Representative for New Jersey, Peter Rodino. Dawley lives in Cranford, New Jersey. He comments on his paintings: "Western people are great character studies and their native costumes are colorful and interesting. I hope to capture the significance of these people in their culture in a manner and style that I feel is in keeping with the great traditional painters."

Leslie B. DeMille. Born in 1927, DeMille lives in Laguna Beach, California. He is a teacher and painter and his work has won numerous gold medals and Best of Shows from New York to the West Coast. He has done portraits of California Governor Ronald Reagan and President Richard M. Nixon. DeMille's comments express his philosophy well: "My whole life has been dedicated to capturing the expression and inner character and beauty of the subject I paint—whether it be a child, a matriarch, or a bucket of flowers. American Indians have become a special part of my work. I derive great satisfaction in portraying their honor and dignity, hopefully, in a way that others will see what I see."

George Dick. With an impressionistic flair, Dick portrays the life of the cowboy. He has an M. F. A. from the University of New Mexico. Dick, who lives in Albuquerque, New Mexico, has exhibited in many galleries throughout the Southwest. Dick explains his style this way: "The impressionistic approach is very much the way I regard Nature. If I am capable of creating a feeling of fantasy and mystery and at the same time can project a sense of humility, this I would do." *Checking the Back Trail* (p. 132) accomplishes his ambition with finesse.

Darol Dickinson. Born in 1942, Dickinson raises registered quarter horses and runs longhorn cattle on his 2,700 acre ranch in Calhan, Colorado. While Dickinson specializes in portraits of horses, his traditionally realistic paintings of contemporary ranch life are refreshing stories of what takes place today. His painting *Horse Tank Armada* (p. 39) attests to the success of his approach.

Nick Eggenhofer. At an early age, Eggenhofer became entranced by the West and its history and has since devoted his skills to interpreting the Western scene. His work has been exhibited in many galleries, including the Kennedy Galleries in New York City, the Cowboy Hall of Fame, the Buffalo Bill Historical Center, and the C. M. Russell Gallery. He is the author of *Wagons, Mules, and Men.* Eggenhofer is a serious student of the subject matter he paints and his work is proof of it. Born in Gauting, Germany, in 1897, he now lives in Cody, Wyoming.

Chet Engle. Born in 1918, Engle resides in Sherman Oaks, California. He is a commercial artist for Lockheed Aircraft Company. His crisp and colorful paintings have been shown in places such as The Museum of Modern Art in New York City, the National

Gallery of Art in Washington, D. C., the Los Angeles County Museum of Art, and the National Gallery in London.

Tony Eubanks. Born in 1939 in Dallas, Texas, Eubanks lives in Grapevine, Texas. For many years he worked as an impressionistic illustrator and did numerous cover illustrations for Houghton Mifflin, Doubleday, and Dell. He has taught painting at the University of Dallas since 1944. "To me," says Eubanks, "the most challenging element of a painting is the design of lights and darks and how I can use this element to its best possible advantage."

Fred Fellows. Fellows was born in 1934 in Ponca City, Oklahoma. He paints the West both as it was and as he now knows it, and his work has been shown at the C. M. Russell Gallery, the Whitney Gallery of Western Art, and the National Cowboy Hall of Fame. An example of his attention to historical fact is his painting *The Overland Stage* (p. 132), which catches the feeling of the early West. Having worked on several large ranches throughout his life, he still ropes steers at rodeos. He is currently vice-president of the Cowboy Artists of America and lives in Bigfork, Montana.

Nicholas Firfires. Born in 1917 in Santa Barbara, California, Firfires lives there still. He has been a cowboy artist from the time he could sit a horse and hold a pencil. His painting *The Dogger* (p.110) catches that moment when the rodeo cowboy grabs the horns of the steer and wrenches him to the ground in record time or misses his catch and collects no score at all.

W. H. Ford. Born in 1920, "Hank" Ford lives in Chicago, Illinois, where he has been a freelance artist for many years. He has an affinity for horses and for a while ran the KB Ranch in El Monte, California. His painting *The Intruders* (p. 80) vividly grasps the horses' alarm at an unexpected confrontation.

Bill Freeman. As a horse wrangler and a cowboy, Bill Freeman has worked on ranches from Montana to Arizona and from Wyoming to California. As a painter, he has exhibited in many one-man shows and won several first prizes. Freeman is prolific: his work—painting and sculpture—is in the possession of nearly 2,000 private and public collections. He paints both cowboys and Indians, and his studies of wildlife are as naturalistic as they are handsome.

Walter Graham. Born in Illinois in 1903, Graham now lives in Manatchee, Washington. He studied at the Chicago Academy of Fine Arts and The Art Instutute of Chicago. Graham's work as a cowboy on a Wyoming ranch led to a career of Western outdoor-life painting. He believes that "even though the composition and design are based on the abstract, the final result should have realism that needs no explanation." In this, Graham has been eminently successful.

Joe Ruiz Grandee. Born in 1929 in Dallas, Grandee now lives in Arlington, Texas. He is a Fellow of the Company of Military Historians and his interest in this area is expressed in

his paintings. Grandee is prolific and his work has graced scores of magazine covers as well as the walls of private and public collections. A recipient of many gold medals, his attention to detail combined with his flair for achieving vibrance make his renditions of historic scenes come to life. "I paint the historical West because it was the reality of my country. A dynamic principle of self-reliance, confidence, and ingenuity was formed in the basic nature of our forebears as they encountered the challenges of the Western frontier. I try to capture this great experience in my paintings and sculpture."

W. C. Griffith. Griffith was born in 1905 and is a graduate of The Art Institute of Chicago. He operated the Bar 20 Ranch in Montana with his brother and was also a professional illustrator for many years. He now pursues the luxury of painting whenever he pleases. His painting *End of the Hunt* (p. 84) portrays just exactly the way a bawling mother cow carries her head when she is worried. Griffith now lives in Crystal River, Florida.

John W. Hampton. Born in New York City in 1918, Hampton now resides in Scottsdale, Arizona. He was a founding member and a former president of the Cowboy Artists of America and has worked as an illustrator showing his paintings in many exhibitions. Cowboys and Indians are his special subjects and his paintings attest to his attention to accuracy. Once asked if he did his paintings through inspiration he replied. "More like desperation."

G. Harvey. Born in San Antonio, Texas, in 1933, Harvey now lives in Leander, Texas. In addition to his many exhibitions and one-man shows, Harvey's paintings also add to the collections of presidents, governors, and ambassadors. Harvey paints "to record the people and the land as they were and as they are today—to preserve a proud heritage." His paintings *Night Patrol* (p.102) and *Crossing the Canyon* (p. 150) attest to the success of his purpose.

Bud Helbig. Born in Butte, Montana, in 1919, Helbig now lives in Kalispell, Montana. He was raised on a ranch in the Bitteroot Valley and his interest has always been in the cowboy life. For many years he has been a professional illustrator. He is a member of the Cowboy Artists of America. His hope is to preserve as much as possible of the vanishing history of the West and the story of cattle ranching for future generations; his painting *Robber's Roost* (p. 134) goes a long way in fulfilling his goal.

Tom Hill. Hill is a teacher, author, and master watercolorist. He was elected as an Associate Member to the National Academy of Design. He has had a varied career as a sketch artist for Universal Studios in Hollywood, a staff artist for the Chicago Tribune, and a freelance artist. Through his transparent watercolors, Hill endeavors to convey to the viewer a thought or feeling he has about the subject. If the viewer responds in a similar way, Hill considers his painting a success.

Harold Hopkinson. Born in 1918, Hopkinson lives in Byron, Wyoming. His work has been exhibited in many shows throughout the West and in the *Western Horseman*, the *Western*, and the *Appaloosa* magazines. He is also a professional educator. "I try to cap-

ture," says Hopkinson, "one dramatic moment of any individual who has lived in and loved the West: the way the clouds pile up before a storm and the way the light hits the hills and mountains after the clouds clear away."

Peter Hurd. Born in Roswell, New Mexico, in 1904, Hurd lives on the Sentinal Ranch in San Patricio. In the 1920s he studied with N.C. Wyeth and at the Pennsylvania Academy of Fine Arts. Since then Hurd has received numerous commissions for his murals and portraits and has exhibited in many museums. Also an illustrator of books, he has received several awards and prizes. His ability to portray the majestic, shimmering landscape of the Southwest he knows so well is unsurpassed.

Wilson Hurley. Born in Tulsa, Oklahoma, in 1924, Hurley now lives in Albuquerque, New Mexico. Hurley is a graduate of the United States Military Academy, West Point, and was an Air Force pilot. He is now a practicing attorney in addition to being an artist. He won the silver medal at the National Academy of Western Art in 1973. "Early in my life," says Hurley, "I fell in love with the beauty of the world and ever since I have been trying to develop the skill to permit me to communicate my feelings."

Harry Jackson. Born in Chicago in 1921, Jackson started to draw horses when he was five. Eleven years later he ran away to Wyoming in favor of a cowboy's life. He was a combat Marine and at the age of 20 he became the youngest Official Combat Artist. Since then he has devoted his painting and sculpturing skills to the Western scene. His epic companion murals *Stampede* (p. 92) and *Range Burial* (p.98) at the Whitney Gallery of Western Art are poignant masterpieces of cowboy tragedy.

Ned Jacob. Born in Tennessee in 1938, Jacob now lives in Denver, Colorado. At eighteen he hitchhiked to Montana where he became acquainted with the Blackfoot Indians. Later in Taos, New Mexico, he began painting seriously, carefully studying American Indian life. Winner of gold and silver awards at the National Cowboy Hall of Fame, Ned Jacob's faithfully accurate yet often impressionistic renderings of the Americans are at once handsome and sensitive.

Geoffrey Jenkinson. Born in Leeds, England, in 1925, Jenkinson lives in Tubac, Arizona. He is a member of the Royal Cambrian Academy and winner of the British Saxon Barton Prize, and he has held many exhibitions throughout England and the United States. His work is in numerous collections, including that of Haldiman Insurance in Phoenix. "Living in the Southwest," says Jenkinson, "I am surrounded by the desert and find it a challenge to paint this vast landscape in all its moods."

Harvey W. Johnson. Johnson has long been a painstaking student of the historic West. Not only does he make annual sojourns to the region, but he has a large library of books on the West and a collection of Plains Indian artifacts, guns, and cowboy items. For many years he has been a successful illustrator of books and magazines devoted to the Western theme. Johnson says, "I try to include a bit of a story or an incident in my paintings. I try to paint paintings that I would like to keep myself."

James Ralph Johnson. Born in Alabama in 1922, Johnson now lives in Santa Fe, New Mexico. A United States Marine officer for 22 years, a professor of Naval Science for three years, the author of over two dozen books on wildlife, outdoor living, and American history, James Johnson finds time to paint. "I paint representational Western and wildlife subject matter because it is a satisfying, competitive field. The only critic of interest to me is the man on the street or on the ranch." Certainly no cowboy would find fault with his work.

Bob Kuhn. Born in Buffalo, New York, in 1920, Kuhn now lives in Roxbury, Connecticut. He is a self-employed illustrator and his animal paintings have been reproduced in several books—among them *The Animal Art of Bob Kuhn* (Watson-Guptill)—and have been in many one-man and group shows in this country and abroad. "I paint animals because I am moved to paint them. Perhaps I see things in animals that others, even animal lovers, don't. And that is what I attempt to put down."

Ted Long. Long was born on a ranch near North Platte, Nebraska, in 1932. He is a freelance artist who has held many one-man shows throughout the West. His work hangs in collections at the Air Force Academy Museum, the Woolaroc Museum, and the University of Nebraska. Long's interest in the Western scene spans both the present and the past. "Coming from both Indian and pioneer backgrounds," says Long, "I grew up with the subjects I paint."

Tom Lovell. A freelance artist for many years, Lovell's illustrations have appeared in dozens of national magazines, and he is the winner of several gold medal awards. His work is included in the collections of the Franklin Mint, the United States Marine Corps, the National Cowboy Hall of Fame, the United States Capitol, and the Explorer's Club. "My deep interest is in the portrayal of man," says Lovell, "as he has appeared in the pages of history . . . with particular interest in and sympathy for the American Indian." Born in New York City in 1909, he now lives in East Norwalk, Connecticut.

Fred Lucas. Born in 1944 in Tacoma, Washington, Lucas now lives in Las Lunas, New Mexico. He is a senior structural designer and a technical illustrator with the Atomic Energy Commission. His paintings capture a realism that is both authentic and dramatic: "My artistic pursuits are dedicated to unveiling the international fiber and vigor of Americans within an extraordinary habitat. The robust flavor found in Western life offers an inexhaustible supply of forceful, sound character amidst challenging elements."

George Marks. Born in Conrad, Iowa, in 1923, Marks now resides in Albuquerque, New Mexico. As a professional illustrator, he devotes himself to portraying the cowboy life and is a former vice president of the Cowboy Artists of America. "To me," says Marks, "the cowboy symbolizes a man born free, an individualist who loves his country in its natural state. The different phases of cowboy life offer unlimited subject matter for an esthetic manner of self-expression and a recording of a way of life."

Frank McCarthy. Born in New York City in 1924, McCarthy lives in Sedona, Arizona. Long a successful freelance commercial artist, McCarthy now devotes full time to paint-

ing. Winner of the Franklin Mint's gold medal for Western painting, he has shown his work in many exhibitions, including the National Academy of Western Art. McCarthy writes, "To me, beauty is the eroded, jagged rocks, the gnarled and bleached-out logs and stumps, the dirt and the sage as well as a horse galloping full tilt, or the play of light on muscles levering a carbine or wielding a war club. All this, in its infinite variations of patterns of light, shade, and color, is beauty to me."

R. Brownell McGrew. Born in 1916 in Columbus, Ohio, McGrew now lives in Quendo, New Mexico. Winner of numerous first prizes and gold medals, R. Brownell McGrew's specialty is the Navaho Indians. "When asked why I am a Western painter, I generally reply that I consider myself a classical painter who happens to be a lifelong Westerner. Abstract and theoretical considerations are to me mere adjuncts to painting, not always very useful ones, either, and 'art for art's sake' I consider one of the most vacuous and sterile vagaries that ever warped the mind of man."

William Moyers. Born in Georgia in 1916, Moyers grew up on a ranch in Colorado, where he entered rodeos to help pay for his education. He now lives in Albuquerque, New Mexico. Former President of the Cowboy Artists of America, he has won two gold medals for his work. "I suppose I paint what I do because I find the working cowboy of the past and present such a harmonious outgrowth of his whole environment. He accepts the rough action, the wild weather, the periodic loneliness, and the hard responsibilities of his job as normal existence. Put this direct man in the vast settings in which he lives and he is a fit subject to try an artist's skill."

Newman Myrah. Born in Holdfast, Canada, in 1921, Myrah now lives in Portland, Oregon. For many years a freelance illustrator and art director for several advertising agencies, Myrah's work has appeared in numerous exhibitions as well as in magazines such as the *Saturday Evening Post*, *Time*, and *Life*. "Being raised in Montana," says Myrah, "gave me a great fondness for and interest in the outdoors and the ranch life centered there. My style of painting was dictated, I feel, by the subjects' need for a realistic portrayal."

Jeannie Pear. Born in 1922 in Las Vegas, New Mexico, Pear lives in Englewood, Colorado. She studied at the Corcoran School of Art in Washington, D.C., and the University of Denver and is a freelance artist. Illustrated many books and winner of several awards, Pear tries to keep her paintings "as frugal as possible, leaving out as many lines as I can, using an economy of color."

Don Perceval. Born in Woodford, England, in 1908, Perceval now makes his home in Santa Barbara, California. A freelance artist and author, Perceval is a careful student of the Western scene. His work is in the collections of several museums and private collections, and he has illustrated numerous books. "To me," says Perceval, "the West is sky and a wide land beneath which and upon which the comings and goings of men and animals are distant and momentary."

Gordon Phillips. Born in 1927 in Boone, North Carolina, Phillips now lives in Crofton,

Maryland. He studied and later taught at the Corcoran School of Art in Washington, D.C., and has worked as a professional illustrator for several advertising agencies. He won two gold medals from the Franklin Mint for distinguished Western art. Phillips says, "The ultimate objective is to paint beyond the detail. My main goal in every painting and sculpture is to convey a single emotion, from the more stimulating ones such as fear or competition with animals to simple pleasures such as a moment's rest in a day of hard work."

Burt Procter. Although born in Gloucester, Massachusetts, Procter went West at an early age and now lives in Corona del Mar, California. Long a successful commercial illustrator, his work has been shown in New York, Chicago, and the principal cities of the Southwest. His paintings hang in homes in every state of the Union. Intensely interested in composition and design as the basis of all painting, his impressionistic renderings of the Western scene are at once colorfully balanced and boldly executed.

J. K. Ralston. Born in Choteau, Montana, in 1896, Ralston now lives in Billings, Montana. He has exhibited in several galleries throughout Montana, painted murals in public buildings within the region, and illustrated several books devoted to the Western scene. "I have a good library of choice material on the history of the West," says Ralston, "and have spent many hours of research on my historical paintings."

James Reynolds. Born in 1926 in Taft, California, Reynolds now lives in Sedona, Arizona. Vice president of the Cowboy Artists of America, he has won both gold and silver medals for his paintings of the West. His work has been featured in many magazines and hangs in prominent collections. Reynolds says, "I simply try to paint one of the most exciting periods of our history as honestly as I can."

Kenneth Riley. Born in Missouri in 1919, Riley now lives in Tombstone, Arizona. He studied at the Kansas City Art Institute and the Art Students League of New York, and his work hangs in the collections of the West Point Museum, the Air Force Academy, the Custer Museum, and the White House. A member of the National Academy of Art, Riley says of his work, "I am challenged by the dramatic and varied elements of the West and the ways they are affected by moods of weather and qualities of light."

Morris Rippel. Born in Albuquerque, New Mexico, in 1930, Rippel lives there still. He is a professional architect. His paintings capture the flavor of northern New Mexico village life. His watercolors have been shown in many exhibits, including the National Academy of Western Art and the American Watercolor Society. "I find most of the New Mexico landscape austere," says Rippel, "therefore I stress this in my painting with extra emphasis on the strong light, timelessness, and stillness.

Robert Rishell. Born in Oakland, California, in 1917, Rishell lives there now. His work has been shown in many juried exhibitions including the M. H. De Young Memorial Museum in San Francisco, the Oakland Art Museum, and the Los Angeles County Museum. A winner of many awards, he is recognized for his sunwashed landscapes and his

eloquent portraits. Rishell believes it is the artist's responsibility to offer inspiration and beauty to the viewer, particularly in a world of unhappiness and confusion.

Alfredo Rodriguez. Born in 1951 in the pueblo of Tepic, Mexico, Rodriguez now lives in El Toro, California. A student of Santiago Rosas, his favorite subjects are the Indians of the Southwest. Self-employed as an artist since childhood, his first paintings sold for five dollars. He has since had showings in such cities as Houston, Fort Worth, Dallas, Los Angeles, San Francisco, and Santa Fe. Rodriguez says, "To me, the Indians are the true Americans and when I paint them I feel I am painting the early heartbeat of the Southwest."

Peter Rogers. Born in 1933 in London, England, Rogers now resides in San Patricio, New Mexico. He has held exhibitions of his work at the Royal Society of British Artists and the Birmingham Museum of Art in Alabama. He is the author and illustrator of *Quest* and *The Man on the Blue Horse.*

Tom Ryan. Born in Springfield, Illinois, in 1922, Ryan now lives in Stamford, Texas. He studied at the Art Students League of New York and has been self-employed ever since. He has exhibited his work at the Phoenix Art Museum, the Whitney Gallery of Western Art, the Tucson Art Center, and the Franklin Mint in Philadelphia. He has won both gold and silver medals and is a former President of the Cowboy Artists of America. Ryan has this to say about his work: "It is my conviction to portray the cowboy with a realistic approach, unfolding my ideals and impressions on canvas. Realism allows me to abstract areas or to fulfill the characterization of things in depth."

David Sanders. Born in San Antonio, Texas, in 1936, Sanders now lives in Austin. A self-employed artist, his work has been exhibited in one- and two-man shows throughout Texas and hangs in several private and public collections across the country. Sanders says, "In my work I try to capture the character of an earlier West and the elusive traces of it that linger on today."

William B. Schimmel. Born in 1906 in Olean, New York, he now lives in Scottsdale, Arizona. He is a self-employed artist who prefers landscapes in the medium of watercolor. His work hangs in various museums, including the Phoenix Art Museum, the Cincinnati Art Museum, and the Historical Society of Montana as well as in the private collections of the late Henry Luce and Walter Chrysler. "My philosophy about art is to integrate what I feel about what I see. I guess I could be called a romantic impressionist."

Conrad Schwiering. Born in Boulder, Colorado, in 1916, Schwiering makes his home in Jackson, Wyoming. Recipient of scholarships at the Grand Central School of Art and the Art Students League of New York, Schwiering has been self-employed since 1946. His works have been shown in several galleries including the Whitney Gallery of Western Art and the National Cowboy Hall of Fame. He is a charter member of the National Academy of Western Art. Schwiering comments, "Nothing can be allowed to interfere with the impression translation. Meticulous planning, thorough familiarization with the

subject, and careful consideration of available forms in the composition must precede any undertaking."

William E. Sharer. Born in Ridgeland, Mississippi, in 1934, Sharer now lives in Santa Fe, New Mexico. He studied at the American Academy of Art and has exhibited at the Museum of New Mexico, the Wichita Art Association, and the Museum of Oklahoma. His work has been in publications such as *American Artist, Western Review, Southwest Art,* and *Empire Magazine.* He has won several awards and is a member of the National Academy of Western Art. His impressionistic figure paintings, such as in *Rain Dance* (p.112) and *Crow Chief* (p.116), are powerful and moving.

A. Wellington Smith. Born in 1917 in Cambridge, Massachusetts, Smith now lives at Dana Point, California. A painter, teacher, and lecturer, Smith has had one-man shows from Hyannis Port, Massachusetts, to San Diego, California, and has exhibited at the American Artists Professional League's Grand National and the Laguna Beach Festival of Arts. His preferred media are oils and egg tempera. "I have always been fascinated by light, atmosphere and the prismatic progression of color, and my whole thrust in painting is to express these aspects. I lean toward subjects that project a feeling of peace and serenity. Certainly there is enough harshness in the world today."

Cecil Smith. Born in 1910 in Salt Lake City, Utah, Smith now lives in Somers, Wyoming, where he works as a freelance artist. He grew up on an Idaho ranch and sold his first painting at the age of thirteen. His work has been exhibited in galleries throughout the nation and Europe, and his illustrations have appeared in numerous publications including *Western Horseman, Quarter Horse Journal,* and *McCall's.* "I feel that an artist should paint the subjects he knows and loves," says Smith. "Feeling in a work of art is a demonstration of the love the artist has for the subjects he paints."

Gordon Snidow. Born in 1936 in Paris, Missouri, Snidow now lives in Belen, New Mexico. He studied at the Art Center School in Los Angeles and later won silver and gold medals in drawing, mixed media, and sculpture. A former President of the Cowboy Artists of America, he has chosen the contemporary cowboy for his subject matter. Snidow explains, "I admire the earthy people that don't ask much and expect less. They have the guts to face nature on her own terms and are able to scratch out a living."

Bettina Steinke. Born in Diddeford, Maine, in 1913, Steinke now lives in Santa Fe, New Mexico. As a freelance portrait painter and illustrator, she has exhibited her works, among other places, at the New Rochelle Art Center in New York, the Philbrook Art Center, and the National Academy of Western Art. Her paintings of American Indians, such as *Corn Husking, Taos Pueblo* (p.60), are especially convincing, due in part to her observation that "the Indian's uncut thread with the past shows clearly in his face and actions. Bringing beauty of line, reflection of sunlight, and the shimmer of light on surfaces, as well as good composition to the untrained eye is part of my philosophy."

Ross Stefan. Born in Milwaukee, Wisconsin, in 1934, Stefan now lives in Tucson, Ari-

zona. His work has been exhibited at the Grand Central Galleries in New York City and the Thomas Gilcrease Institute of American History and Art. His illustrations have appeared in *Arizona Highways, American Artist,* and *Western Horseman.* Stefan sold his first picture at the age of seven for "two bits, cash." Today his gentle paintings of the Southwest, such as *Magic Ways* (p.63) and *Graywhisker's Granddaughter* (p.61), bring considerably more.

J. N. Swanson. Born in Minnesota, in 1927, Swanson now runs a ranch in Carmel Valley, California. Swanson has worked as a cowboy most of his life and trains stock horses. His work has been shown at the M. H. De Young Memorial Museum in San Francisco and Stanford University and are part of the permanent collection of the National Cowboy Hall of Fame. He is vice-president of the Cowboy Artists of America. Swanson comments: "Training stock horses and painting them is my life. Attempting to put life into an animal on canvas is the most challenging and rewarding thing I can do."

Ray Swanson. Born in Alcester, South Dakota, in 1937, Swanson lives in Prescott, Arizona. He has a B. S. degree in aeronautical engineering from the Northrup Institute of Technology, and is a self-employed artist. He has won many prizes, such as the Franklin Mint Gold Medal for Western Art, and awards at the All California Juried Art Exhibition, and the Death Valley Invitational. "During my years of painting the Indians I have seen many changes in their lifestyle with regretfully many more to come. These changes are, for the most part, away from their old traditional way of life. Because of this, I paint in an effort to document and record this passing scene with our native people."

Donald Teague. Born in Brooklyn, New York, Teague moved to Colorado where he lived on a cattle ranch. He now resides in Carmel, California. He was a student at the Art Students League of New York and later studied in London. His illustrations have appeared in many national magazines, including the *Saturday Evening Post, McCall's, Collier's,* and the *American* under the pseudonym of Edwin Dawes. Teague's work has been exhibited in various places: The Metropolitan Museum of Art, the National Academy of Design, the Kyoto Museum, the Watercolour Society in London, and The Art Institute of Chicago. He has won many first prizes and gold and silver medals. Teague's aim is to "re-create the color and action of the Old West as accurately as diligent research and enthusiasm could make it."

Bernard Thomas. Born in 1918 in Sheridan, Wyoming, Thomas now lives in Boyton, Florida. As a teacher, he operated a private art school in Florida for fourteen years. He has exhibited at the Grand Central Galleries in New York City and has painted murals in twelve states. Thomas writes, "I ate at the chuck wagon, I slept on the ground, I wrangled my share of horses, and I trailed cattle many a mile. The urge to paint what I experienced plus the rip-roarin', action-packed days before me is an urge like a smolderin' fire."

Harold Von Schmidt. As a young man, Harold Von Schmidt spent several summers cowboying in the West and later attended the California School of Arts and Crafts. After

studying under Maynard Dixon and Harvey Dunn, he devoted himself to a successful career in commercial illustration. His paintings, such as *A Fight for the Cabin* (p.101) and *Gun Runners* (p.75). convey the spirit of the historic West. Born in Alameda, California, in 1893, he now lives in Westport, Connecticut.

Melvin C. Warren. Born in Los Angeles in 1920, Warren now lives in Clifton, Texas. As a boy he punched cows on a ranch in west Texas and took a correspondence course in art. Later, he spent over four years in the Army Air Force. After a successful career as a commercial artist, he has devoted the past fifteen years to fine arts. He has won several medals for his work and is a former vice-president of the Cowboy Artists of America. "I paint the West because this is what I know best. I have lived and traveled in the West and Southwest all my life. . . . My philosophy of art is that you have to have something to say before doing a painting."

Kenneth Watson. Born in 1933 in Clinton, Oklahoma, Watson lives there now. He is a professional illustrator and Dean of the Oregon College of Art. He has won several awards for his watercolors and is an Honorary Member of Los Artesanos Unidos of Santa Fe, New Mexico. "Painting our great Southwest," says Watson, "with its beautiful plains and ever-towering mountains has always been a challenge. . . . I paint to satisfy myself, which I hope will give enjoyment to others."

Olaf Wieghorst. Born in Jutland, Denmark, in 1899, Wieghorst now lives in El Cajon, California. This self-taught cowboy, rodeo bronc rider, and former United States cavalryman began drawing and painting at an early age. Today his work is in many private collections and museums, including the Whitney Museum of Western Art and the Museum of Fine Arts in Phoenix, Arizona.

Eileen Monaghan Whitaker. After four years of study at the Massachusetts College of Art in Boston, Eileen Whitaker began a career as a commercial artist. Since 1947 she has devoted herself to fine arts in the medium of watercolor. Her work is represented in many museums, including the Atlanta Art Museum and the Springfield Museum of Fine Art, Springfield, Massachusetts. Winner of scores of major awards, she is an Associate Member of the National Academy of Design. She says, "To qualify as a creative work, a watercolor painting should have all of the same components that are required of any other major art form. It must have design or composition, values, harmony, color balance, sound drawing, and last in line, technique. . . . But perhaps more important than any of these is *conception.* This is what the artist brings of himself to the viewer: his personal observations, reflections; his own message." Born in Holyoke, Massachusetts, in 1911, Eileen Whitaker now lives in La Jolla, California.

Frederic Whitaker. A former student of the Rhode Island School of Design, Whitaker is an Academician of the National Academy of Design, a Fellow of the Royal Society of Arts, and Honorary President of the American Watercolor Society. Winner of many awards, his works are in the collections of The Metropolitan Museum of Art, the Mu-

seum of Fine Arts in Boston, and scores of other museums throughout the country. "Any painting that presumes to be a serious work should be distinctive," says Whitaker. "It should be distinctive through excellence, not through stridence." He was born in Providence, Rhode Island, in 1891, and now lives in La Jolla, California.

Nick Wilson. Born in Seattle in 1947, Wilson now lives in Tucson, Arizona. With no formal art education, it was in his capacity as Acting Curator of Exhibits at the Arizona-Sonora Desert Museum that Wilson perfected his technique in animal renderings. His work has been shown, among other places, at the National Cowboy Hall of Fame and the C.M. Russell Auction. "Art became a study aid early in life that went hand in hand with my interests in animal life. The two developed together, and for me, are inseparable."

Henriette Wyeth. Born in Wilmington, Delaware, in 1907, she now resides at the Sentinel Ranch in San Patricio, New Mexico. Her sensitive oil paintings, such as *Young Peter* (p.38), show a close affinity in mood and style to those of her husband, Peter Hurd. Winner of several first prizes at the Wilmington Society of Fine Arts, and the Pennsylvania Academy of Fine Arts, her work has been exhibited in many museums, including the Museum of New Mexico, The Columbus Museum of Art, and The Metropolitan Museum of Art. Examples of her paintings may be found in the collections of Mrs. Lyndon B. Johnson and Mr. and Mrs. Nelson A. Rockefeller.

Location of Exhibitions and Collections of Artists' Work

Buffalo Bill Historical Center Cody, Wyoming

Franklin Mint Gallery of American Art Franklin Center, Pennsylvania

Thomas Gilcrease Institute of American History Tulsa, Oklahoma

Historical Society of Montana Helena, Montana

Museum of New Mexico Santa Fe, New Mexico

National Academy of Western Art Oklahoma City, Oklahoma

National Cowboy Hall of Fame Oklahoma City, Oklahoma

Philbrook Art Center Tulsa, Oklahoma

C.M. Russell Gallery Great Falls, Montana

Whitney Gallery of Western Art Cody, Wyoming

Woolaroc Museum Bartlesville, Oklahoma

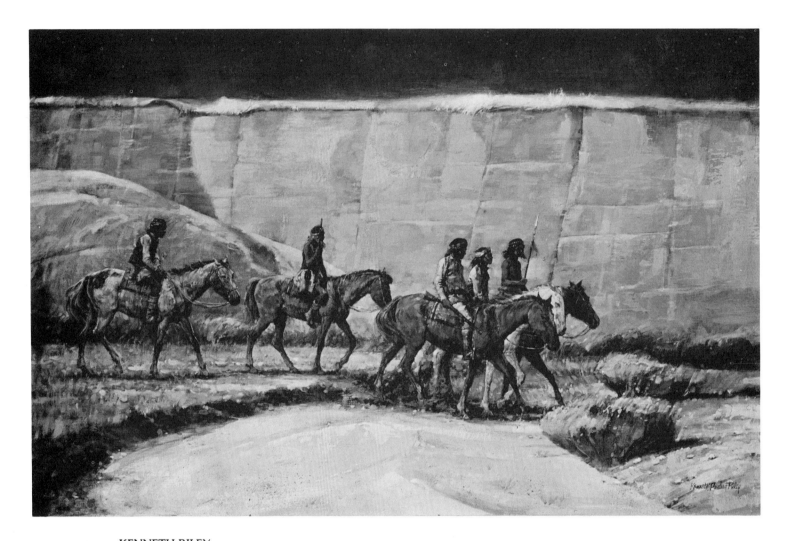

KENNETH RILEY

Apache Patrol, 1974
Acrylic on panel, 15″ x 24″
Collection of the artist

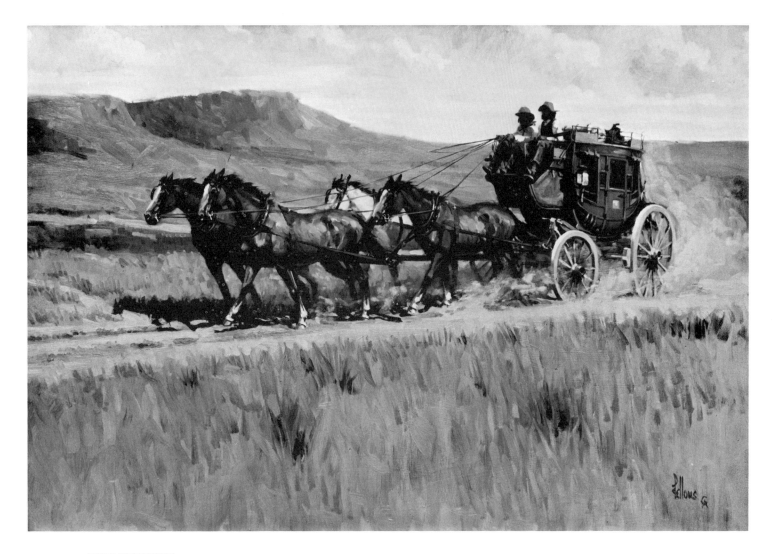

FRED FELLOWS

Overland Stage, 1974
Oil on panel, 24″ x 36″
J.O. Morrisey Collection, St. Louis

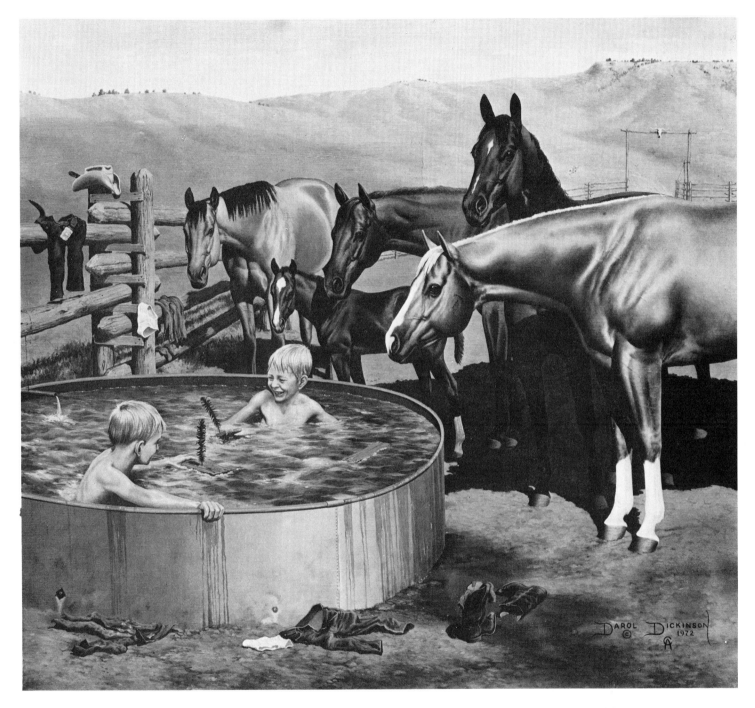

DAROL DICKINSON

Horse Tank Armada, 1972
Oil on canvas, 26″ x 32″
Collection of the artist

HENRIETTE WYETH

Young Peter, 1939
Oil on canvas, 50″ x 38″
Mr. and Mrs. Peter Wyeth Hurd

TOM LOVELL

The Buffalo Caller, 1973
Oil on panel, 20″ x 40″
Private collection

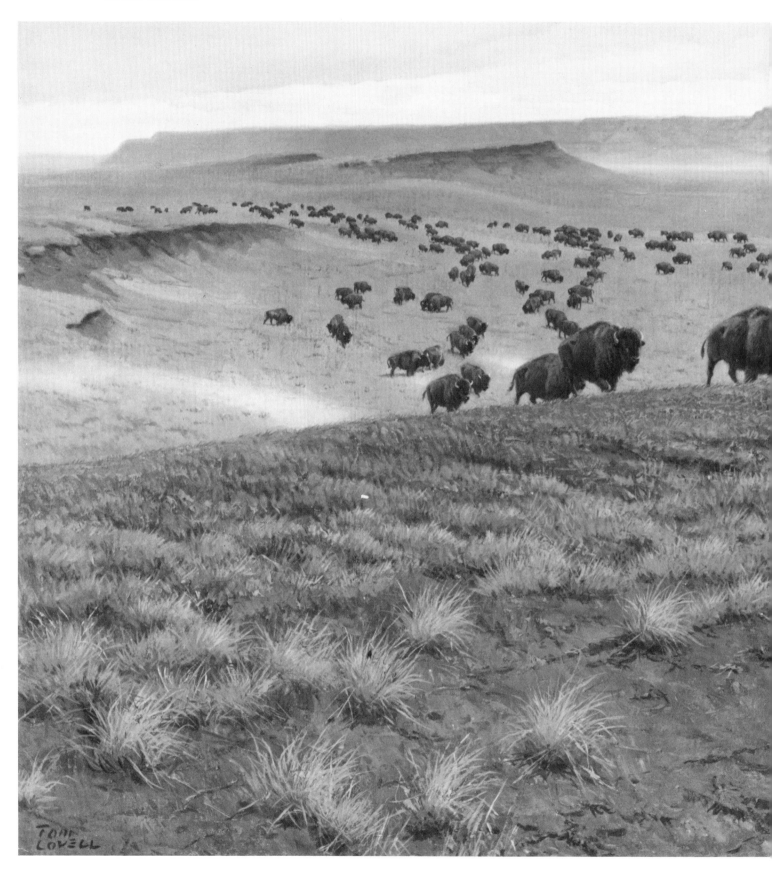

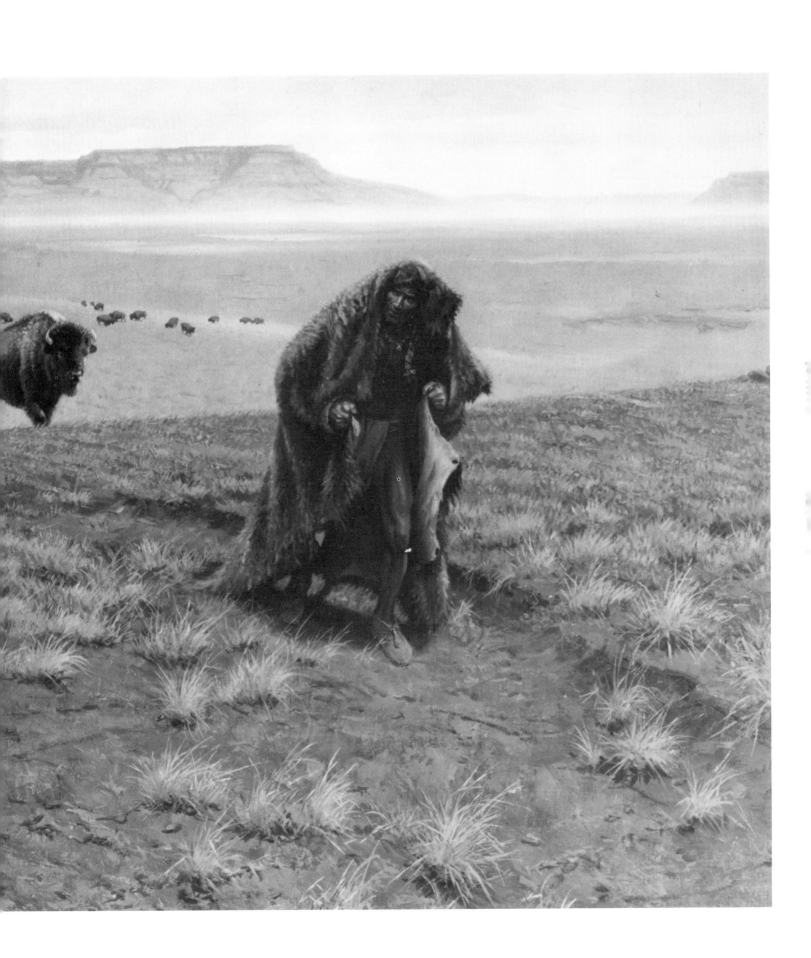

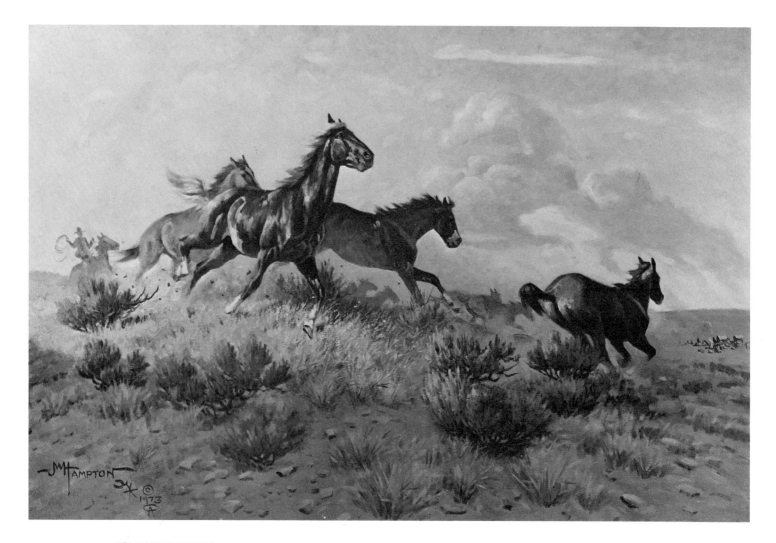

JOHN HAMPTON

The Saddle Bunch, 1973
Oil on canvas, 28″ x 42″
Mr. and Mrs. Joseph Arace

CONRAD SCHWIERING

Switchin' Flies, 1970
Oil on board, 30″ x 40″
Mr. and Mrs. Gerald D. Wilson
Ross, California

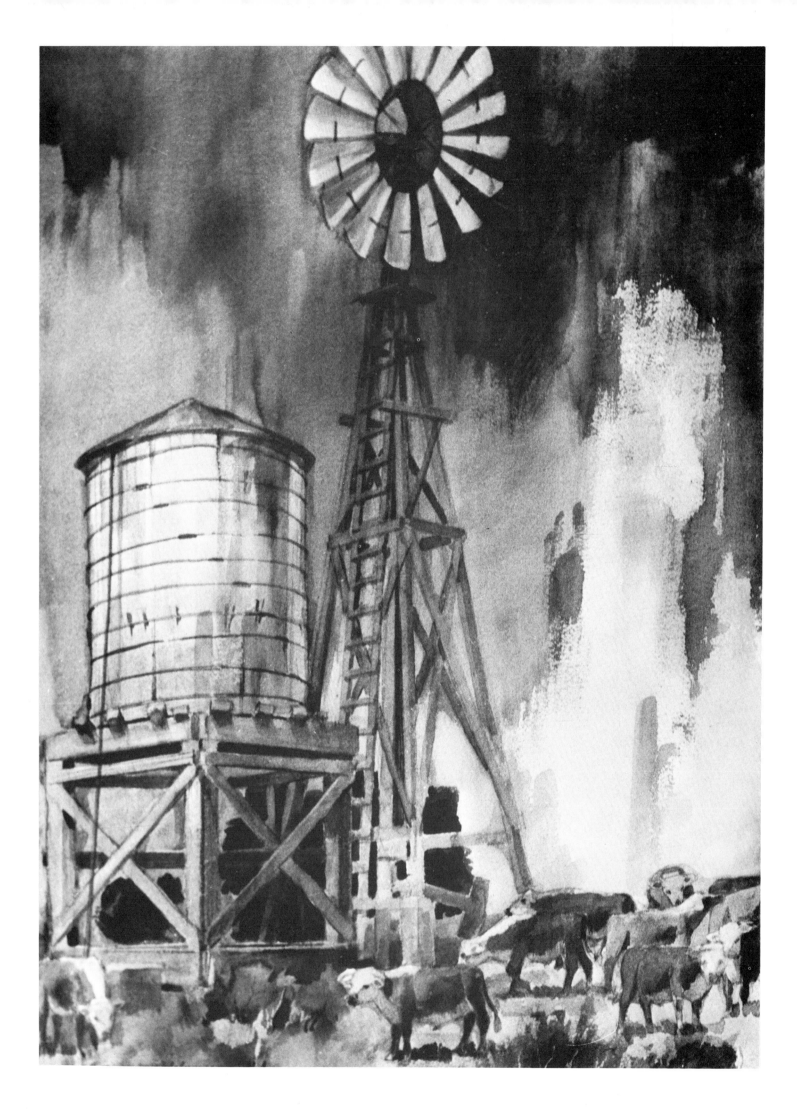

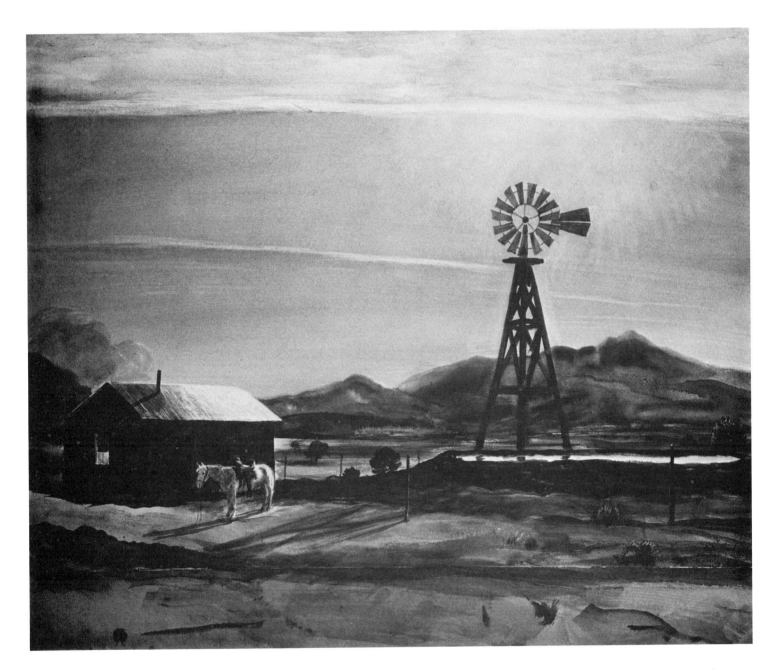

PETER HURD

The Late Visitor,
Watercolor, 25½" x 39"
Private collection.

FREDERICK WHITAKER

Bovine Hangout, 1968
Watercolor, 30" x 21"
Col. Donald A. Stevnig
Indio, California

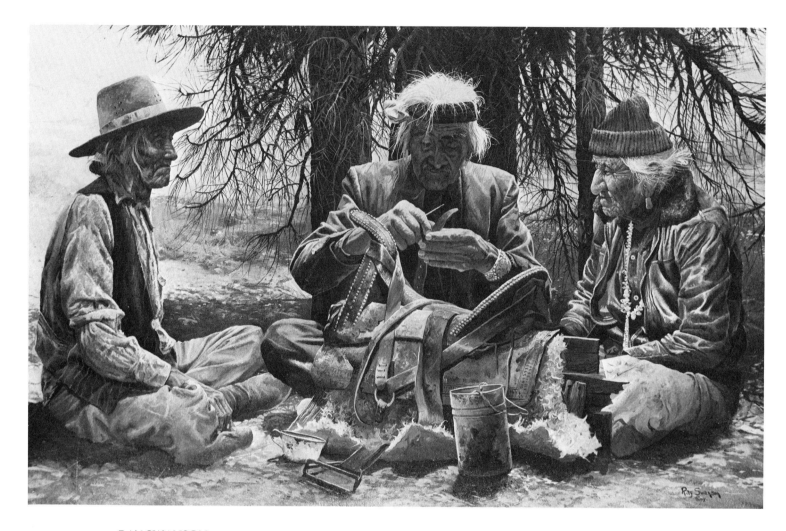

RAY SWANSON

Fixing the Squaw Saddle, 1972
Oil on canvas, 30″ x 50″
Don Burger, Riverside, California

R. BROWNELL McGREW

Old Ones Talking, 1967
Oil, 36″ x 48″
Private collection, Lubbock, Texas

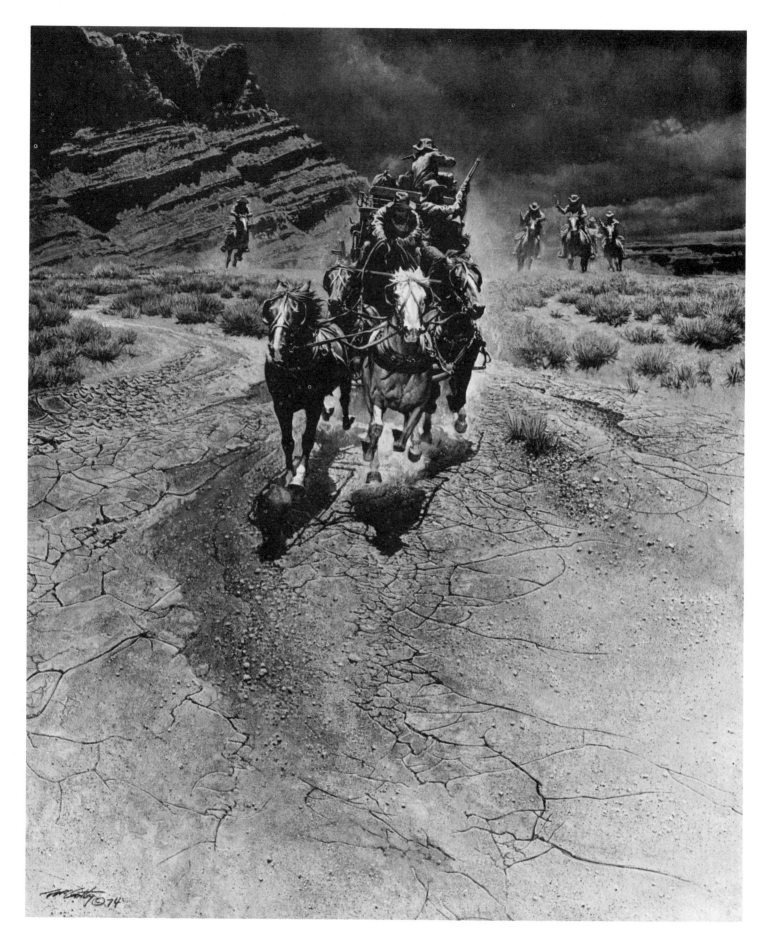

FRANK McCARTHY

The Night they Needed a Good Ribbon Man, **1974**
Oil and casein on Masonite, 30" x 22"
Private collection

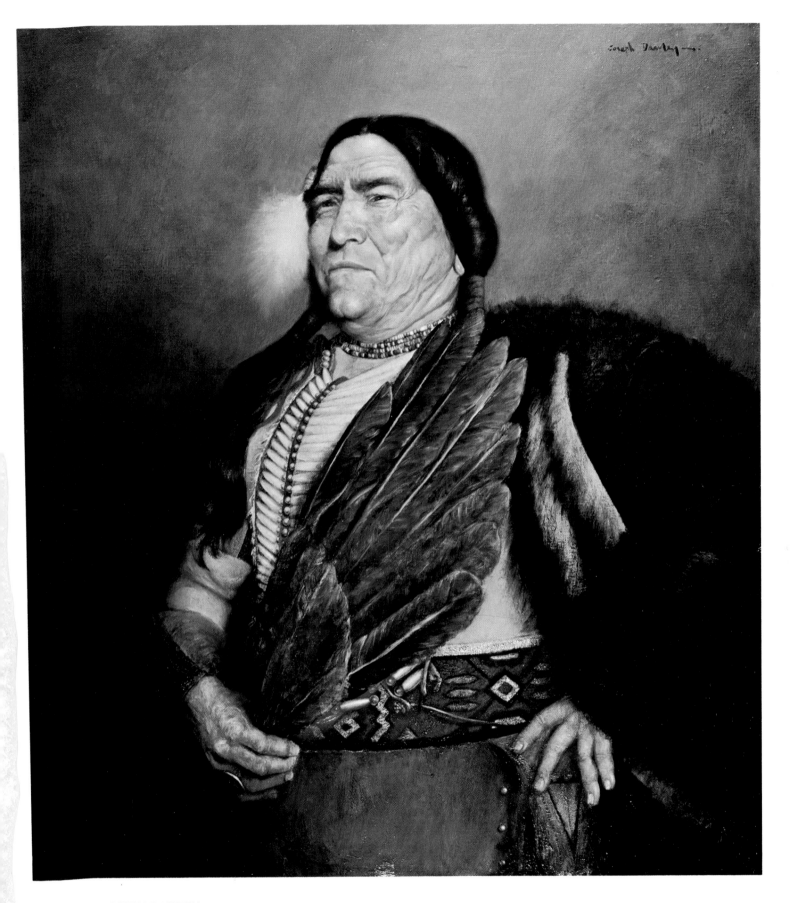

JOSEPH DAWLEY

An American King, 1974
Oil on canvas, 32″ x 20″
Charles Macaluso

50

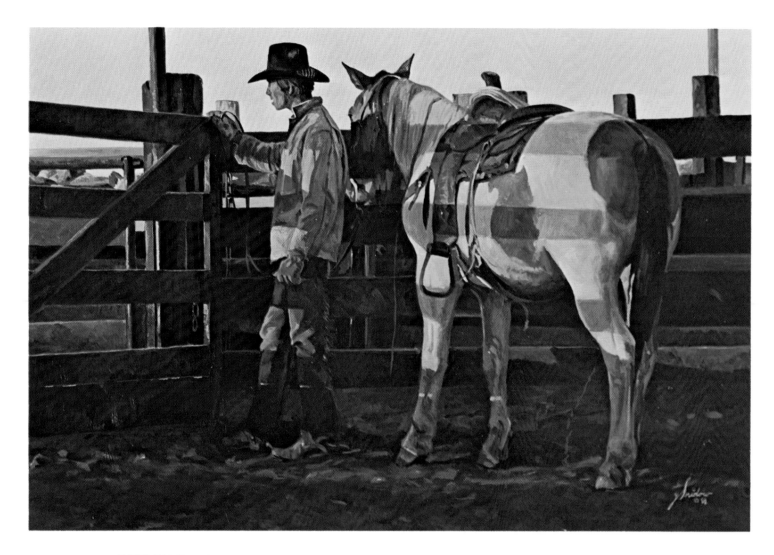

GORDON SNIDOW

The American Paint, 1974
Oil on board, 20″ x 30″
Private collection

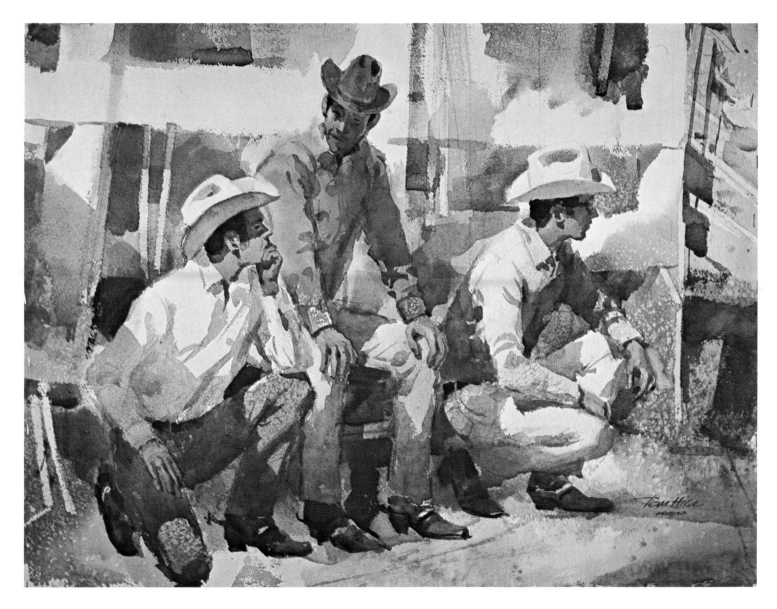

TOM HILL

Behind the Chutes, 1974
Watercolor, 22" x 30"
Collection of the artist

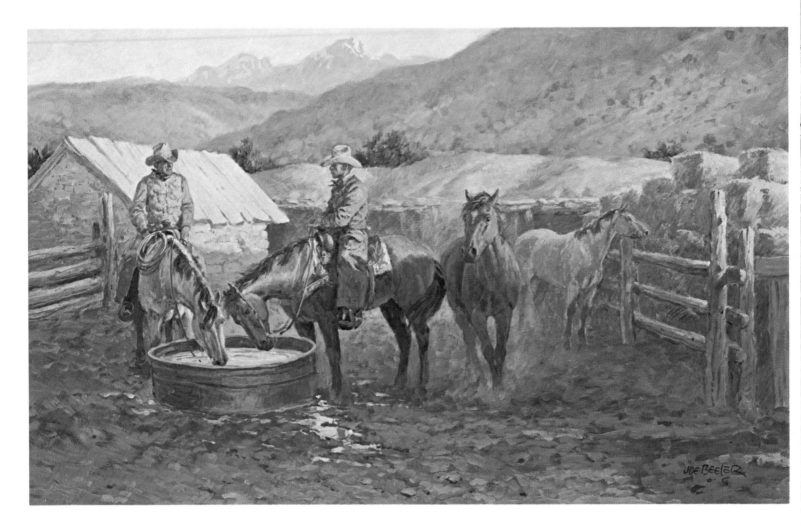

JOE BEELER

Rocky Mountain Cow Camp, 1974
Oil on panel, 22" x 36"
Private collection

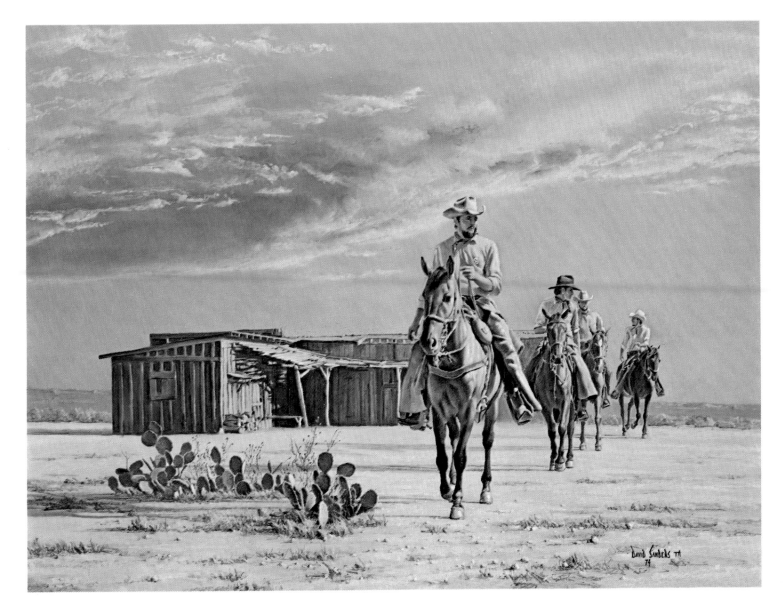

DAVID SANDERS

The Posse, 1974
Pastel on matboard, 30″ x 40″
Cloyce Box, Dallas

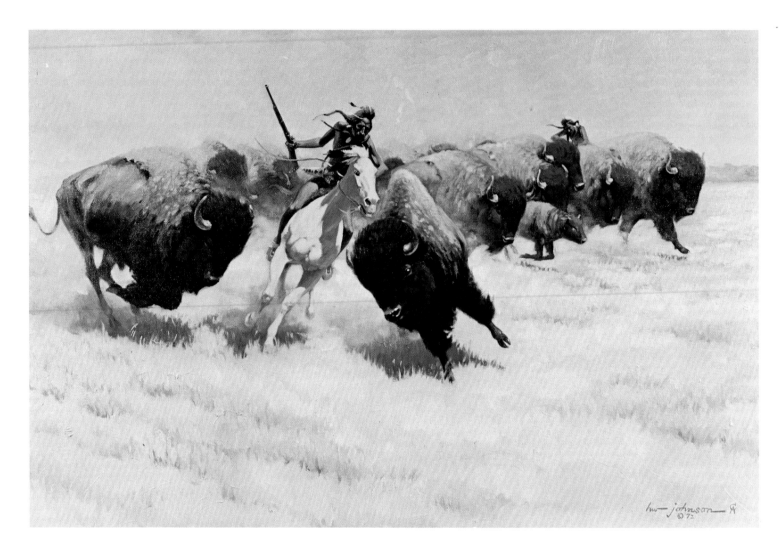

HARVEY W. JOHNSON

When Meat Turns Bad, 1972
Oil on canvas, 24″ x 36″
Favell Museum of Western Art and Artifacts
Klamath Falls, Oregon

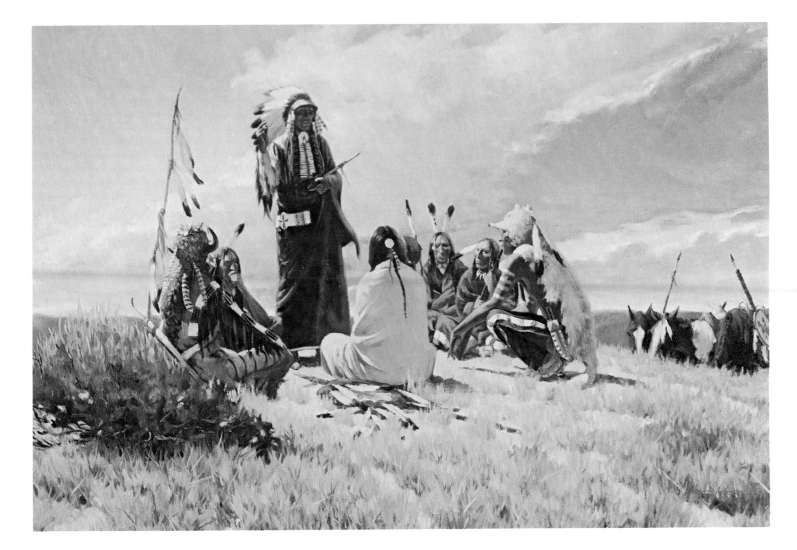

HARVEY W. JOHNSON
Council of the War Party, 1974
Oil on canvas, 20" x 30"
Robert L. Kern

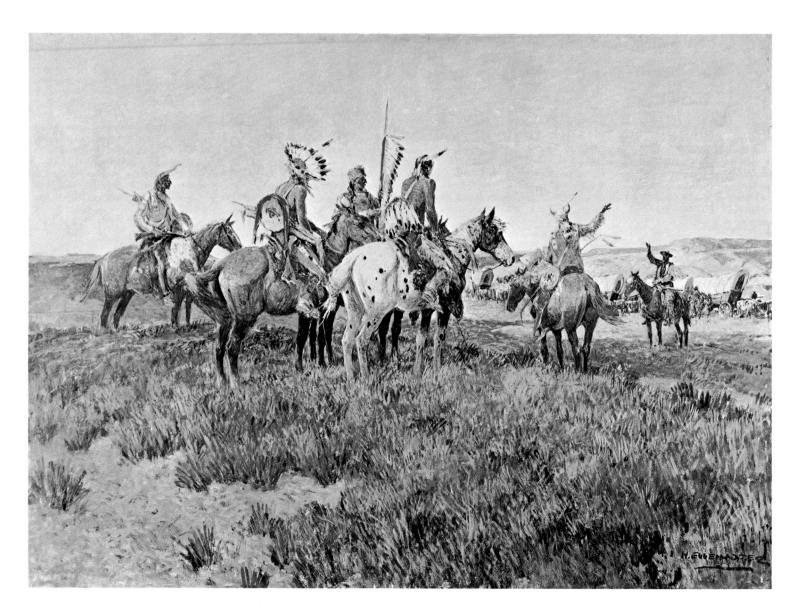

NICK EGGENHOFER

Dakota Country, 1959
Watercolor on board, 20″ x 30″
Rockwell Foundation, Corning, New York

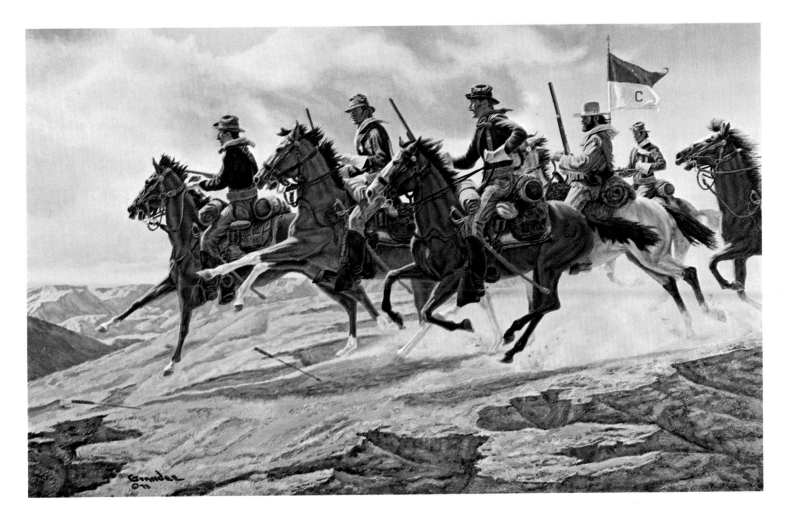

JOE RUIZ GRANDEE

Pursuit and Attack, 1973
Oil on Masonite, 30″ x 40″
Gene Favell, © Franklin Mint, 1974

A. WELLINGTON SMITH

The Sheepherders, 1973
Oil on canvas, 22″ x 28″
Collection of the artist

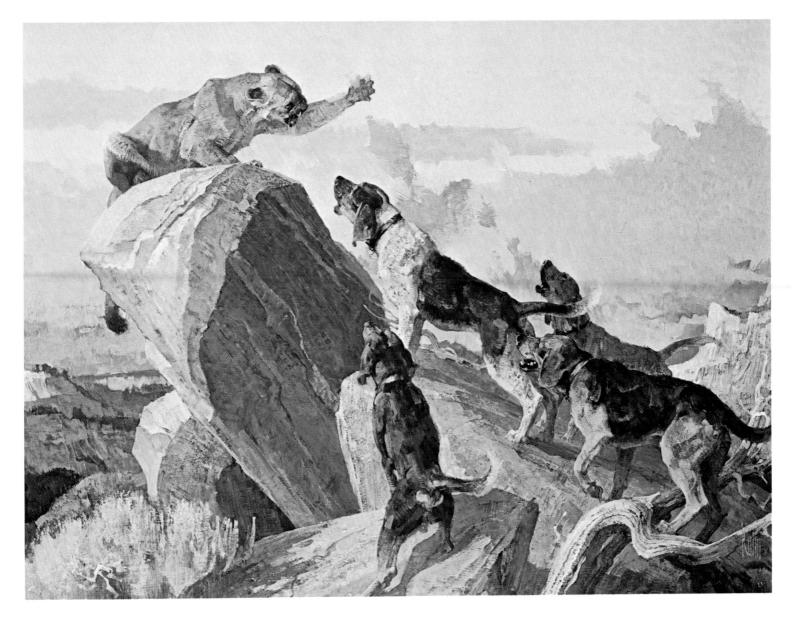

BOB KUHN

A Din in the Rimrock, 1974
Acrylic on Masonite, 30″ x 40″
Guy Shown, San Antonio, Texas

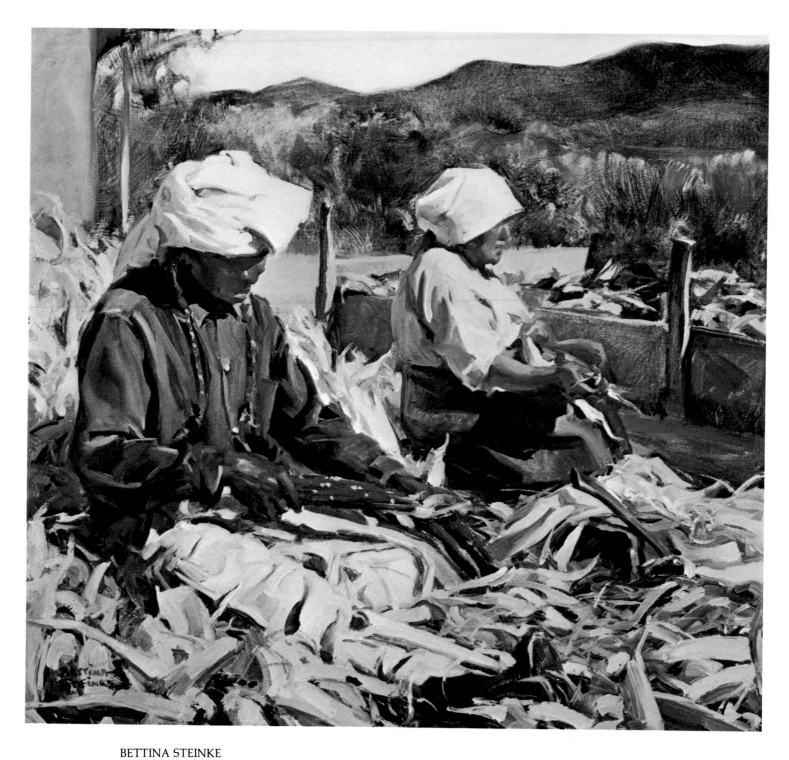

BETTINA STEINKE
Corn Husking, Taos Pueblo, 1972
Oil on canvas, 18″ x 24″
Mr. and Mrs. David Williams

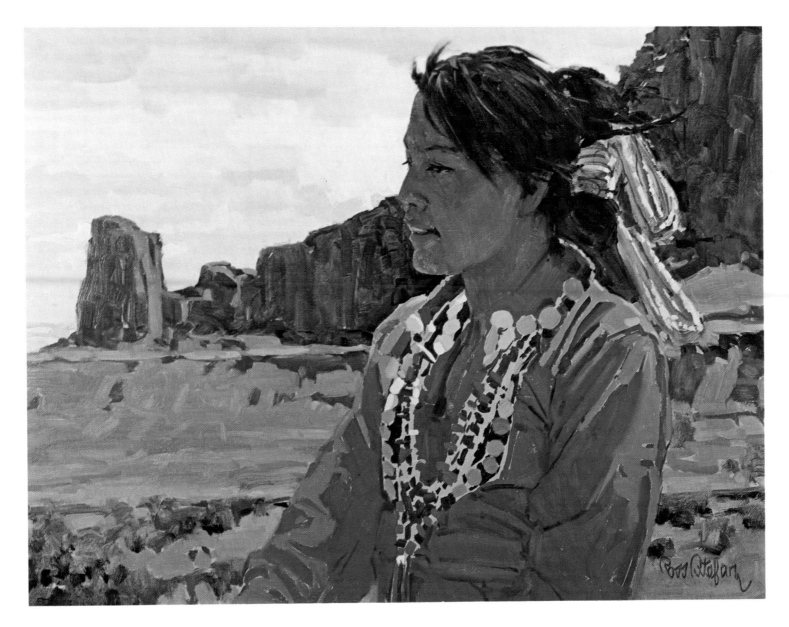

ROSS STEFAN

Greywhisker's Granddaughter, 1970
Oil on canvas, 18″ x 24″
Private collection

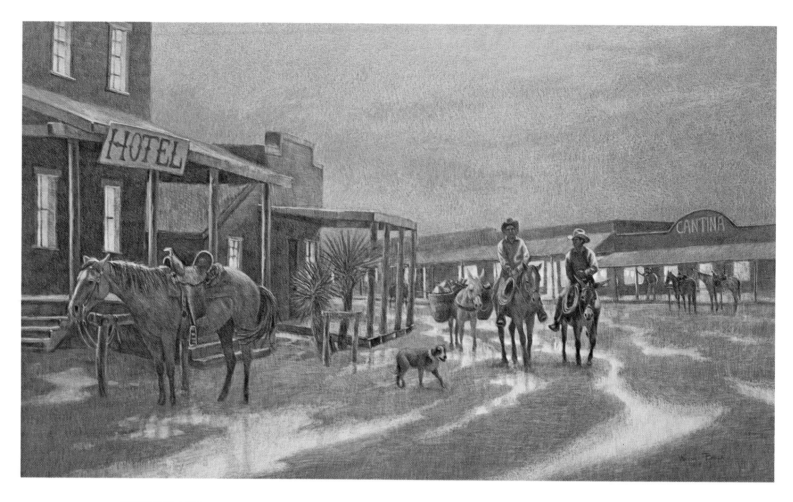

WAYNE BAIZE

Home from the Hills, 1973
Colored pencil on matboard, 18″ x 26″
Private collection

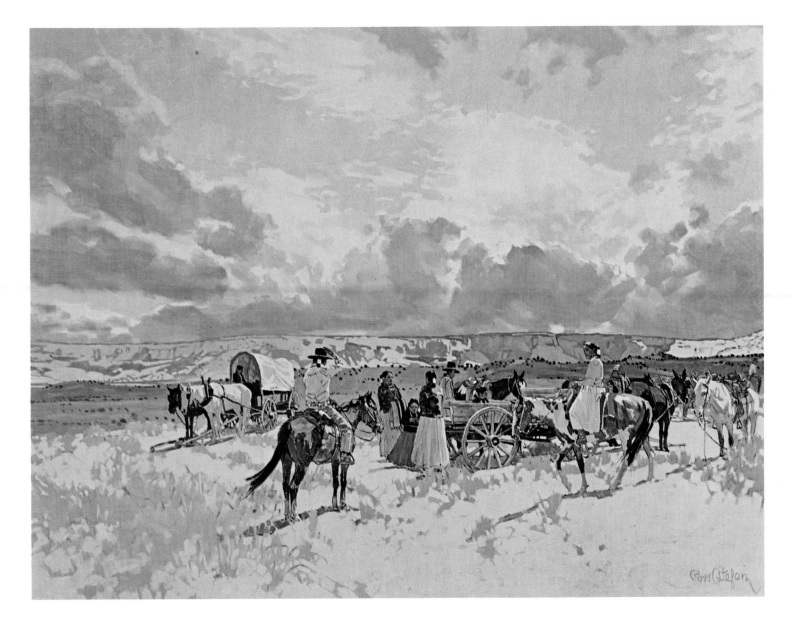

ROSS STEFAN

Magic Ways, 1971
Oil on canvas, 32″ x 42″
Private collection

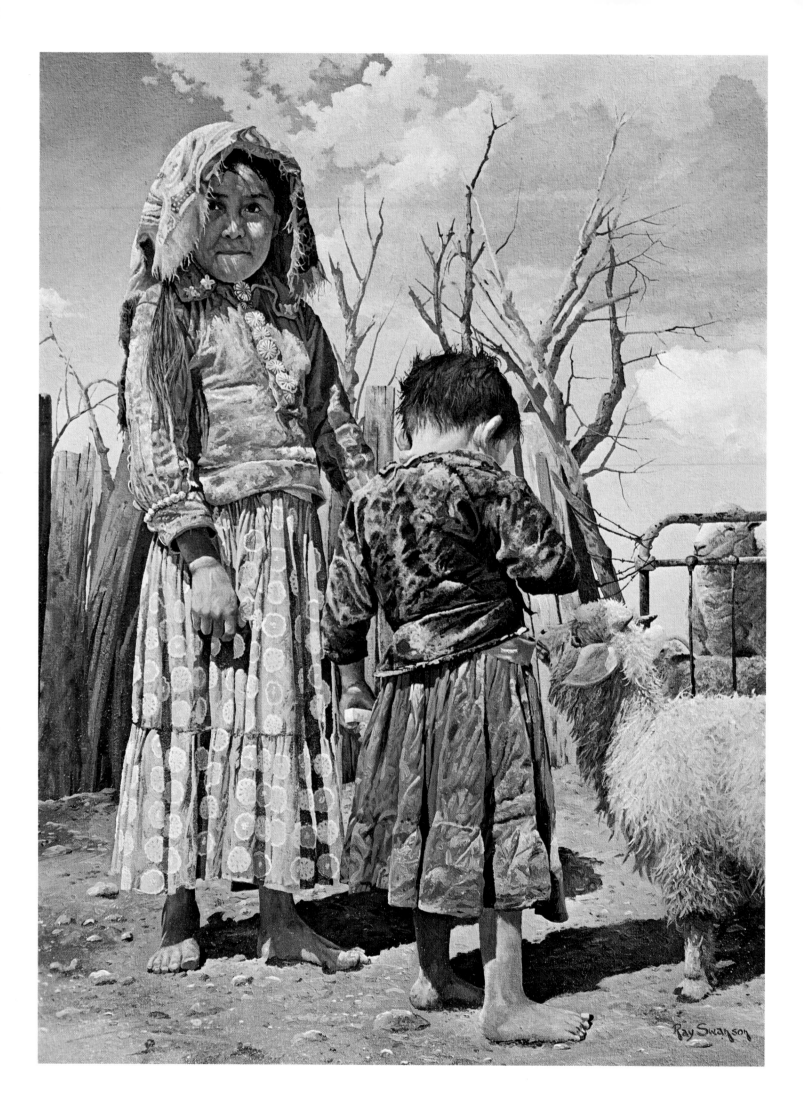

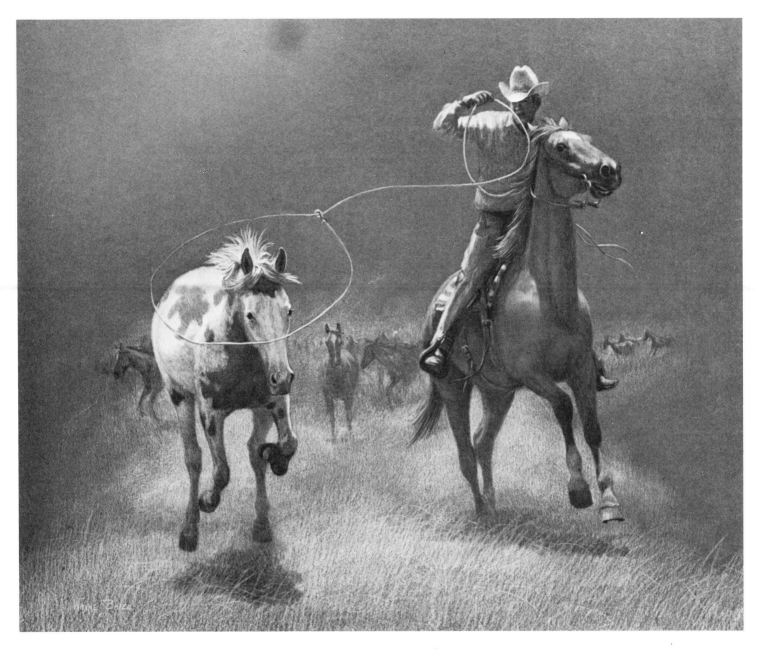

WAYNE BAIZE

Got Away, 1973
Colored pencil on matboard, 18″ x 22″
Private collection

RAY SWANSON

Navaho Friends, 1972
Oil on canvas, 30″ x 40″
Private collection

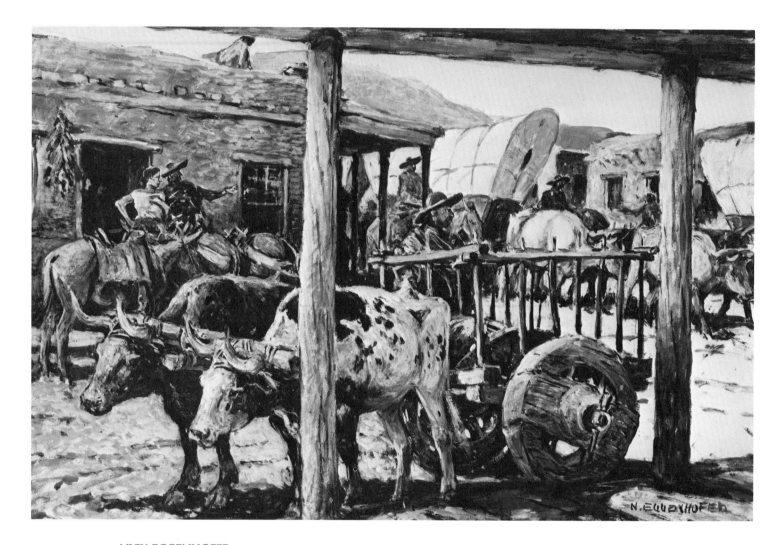

NICK EGGENHOFER

Trader's Wagons Arriving in Santa Fe, 1961
Watercolor on board, 12" x 17"
Collection of the artist

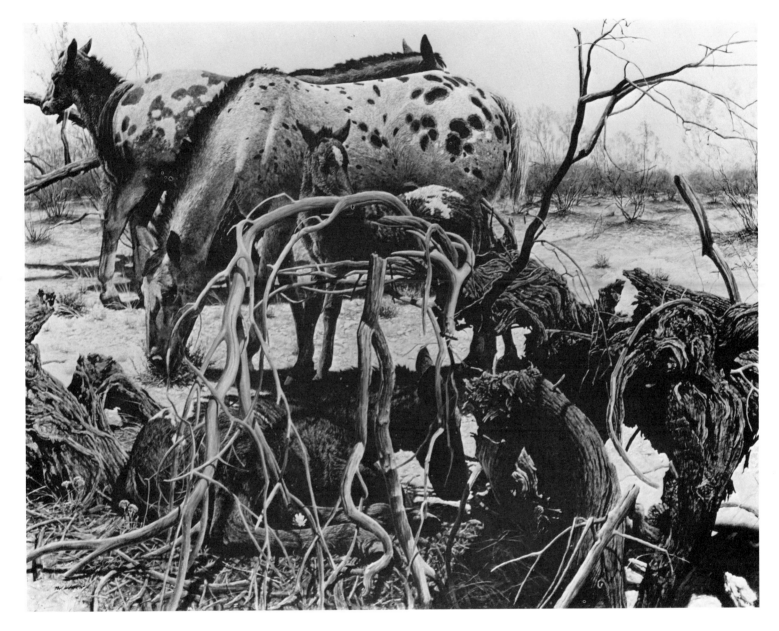

NICK WILSON

Appaloosa Heritage, 1974
Gouache on Masonite, 30″ x 40″
Collection of the artist

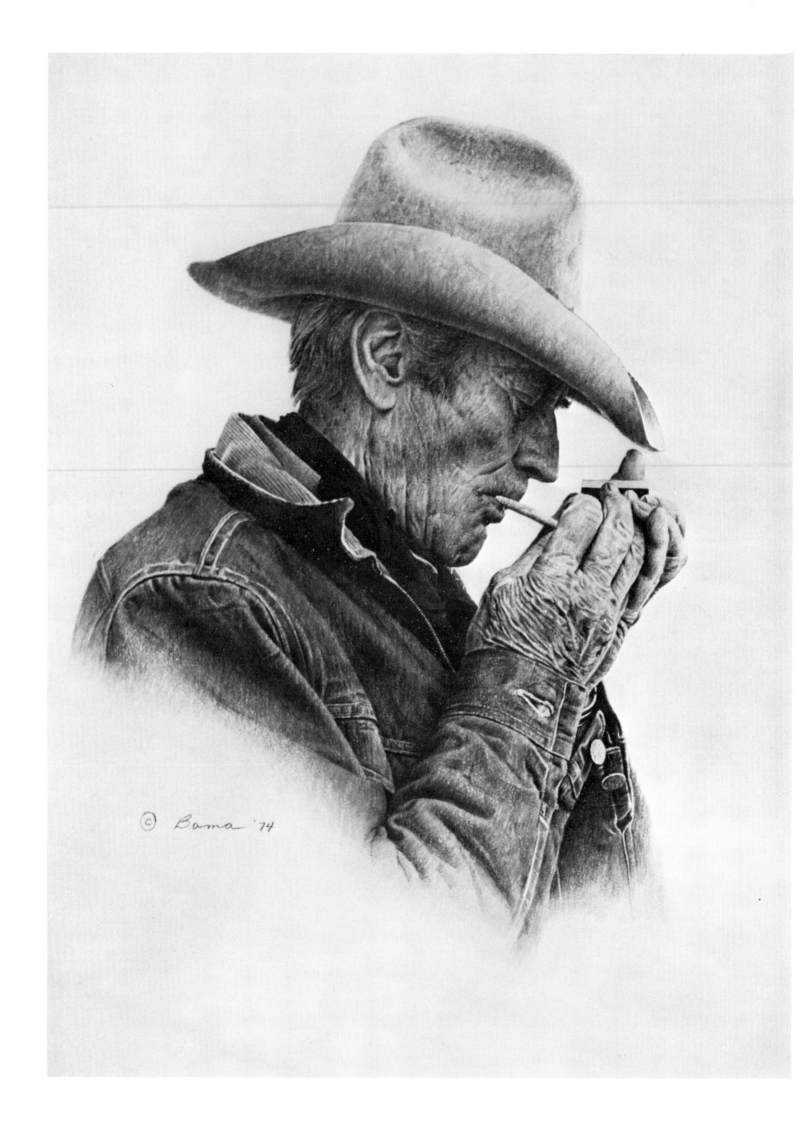

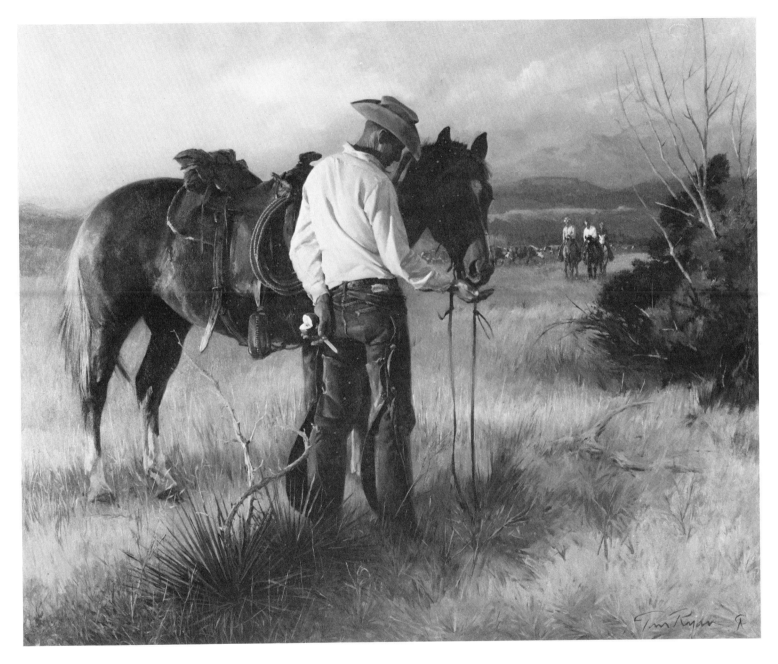

TOM RYAN

Sharing an Apple, 1969
Oil on canvas, 24″ x 30″
©Brown & Bigelow, St. Paul, Minnesota

JAMES BAMA

Slim Lighting Up, 1974
Watercolor, 18⅛″ x 14¾″
Dean Beemer

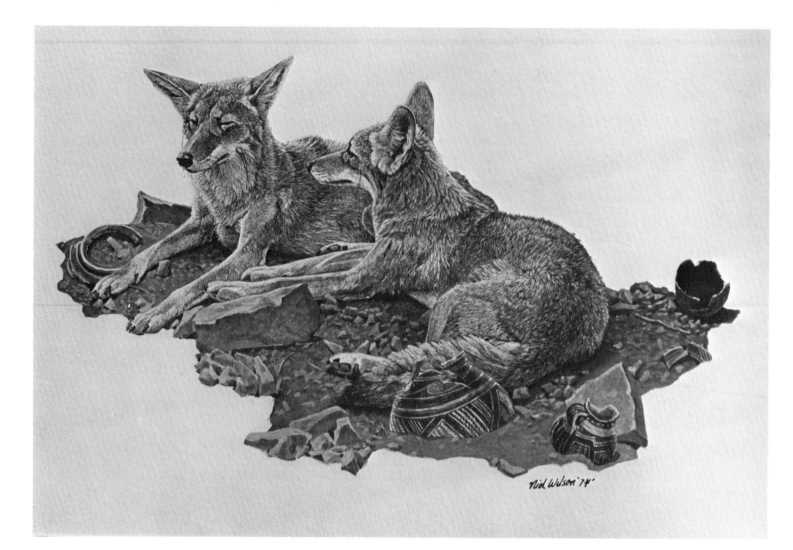

NICK WILSON

Coyotes, 1974
Gouache on Masonite, 14" x 18"
Private collection

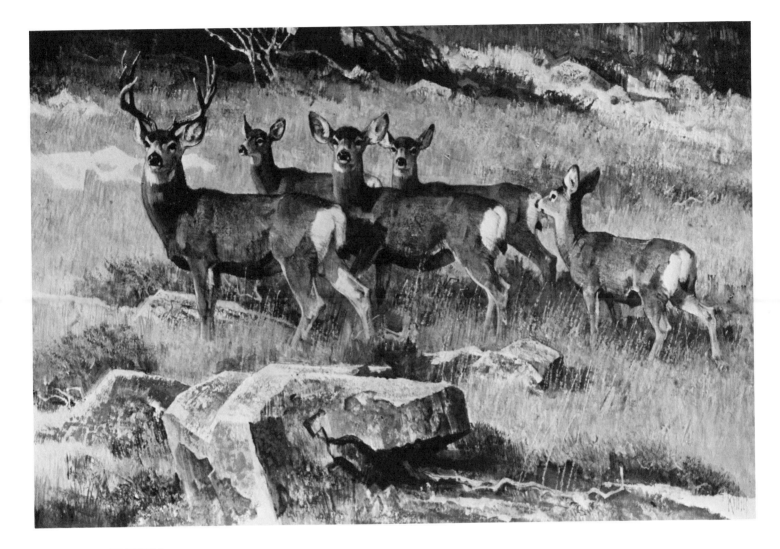

BOB KUHN

Last Look, 1974
Acrylic on board, 19" x 26"
National Cowboy Hall of Fame
Oklahoma City

72

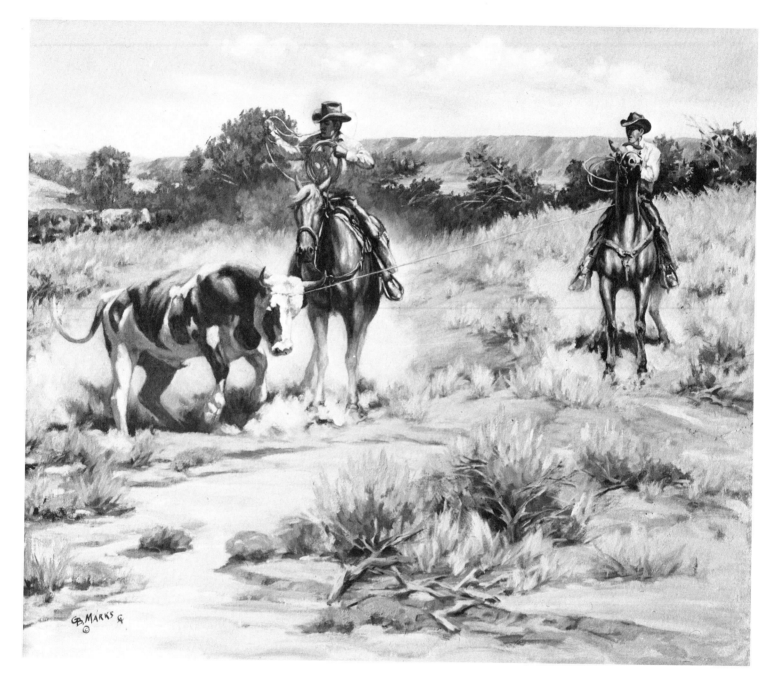

GEORGE MARKS

The Rebel, 1973
Oil on canvas, 23″ x 28″
Virgil Lair, Erie, Kansas

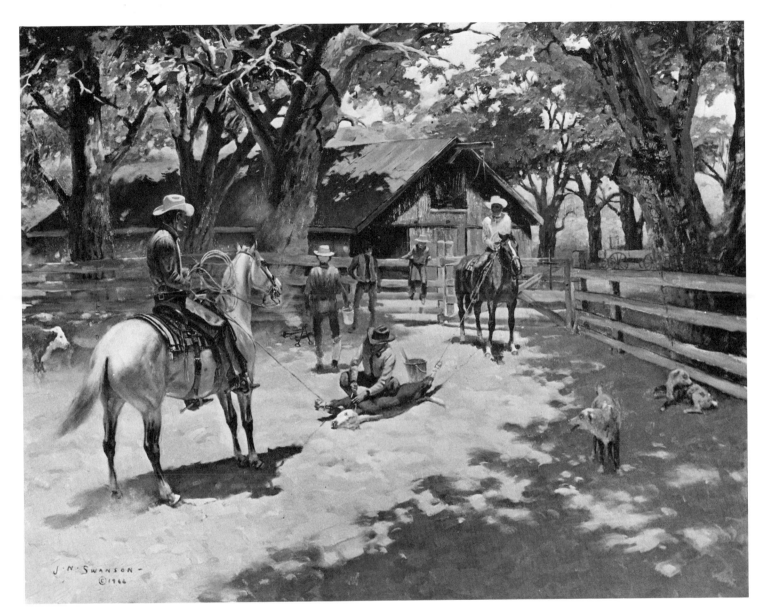

J.N. SWANSON

Branding Scene, 1969
Oil on panel, 30″ x 42″
Thomas J. Hudson

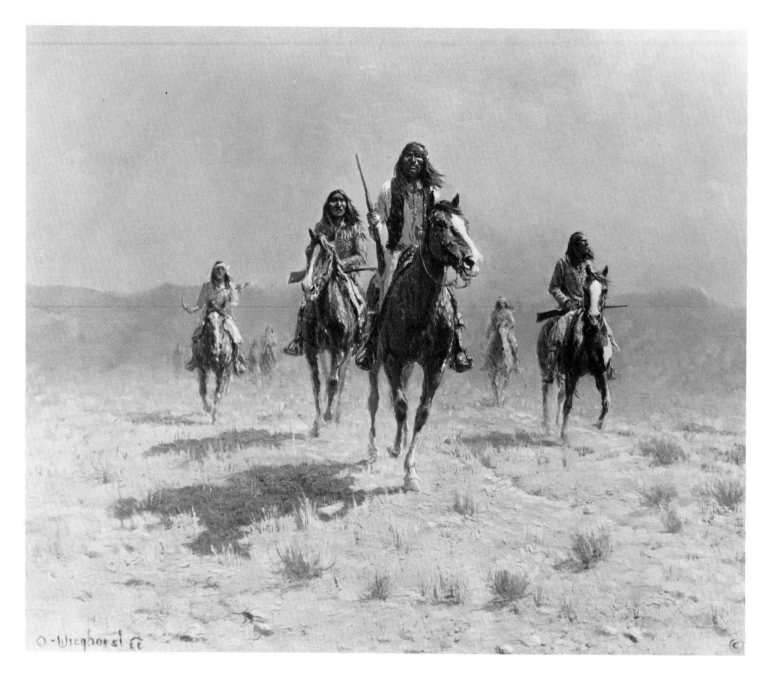

OLAF WIEGHORST

Apache Renegade, 1965
Oil, 20″ x 24″
Miles Nickles

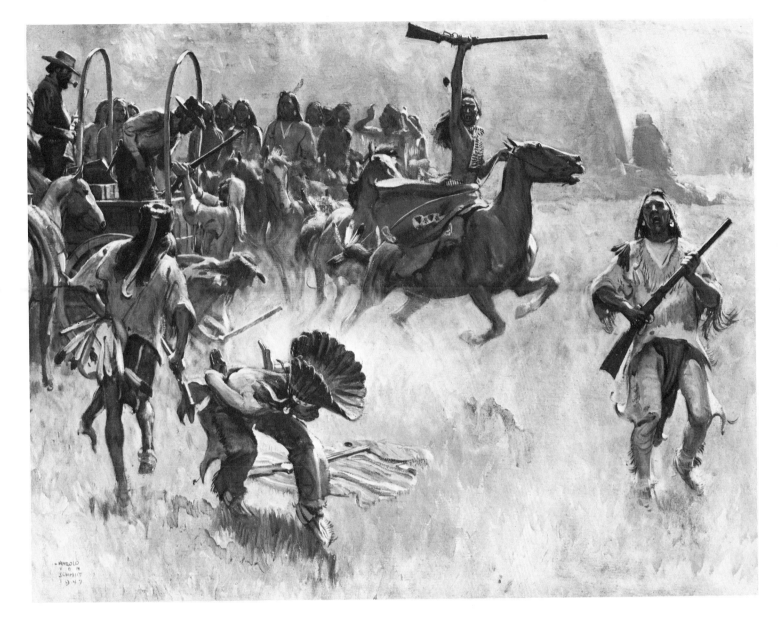

HAROLD VON SCHMIDT

Gun Runners, 1947
Oil on canvas, 30″ x 40″
Richard Garrett

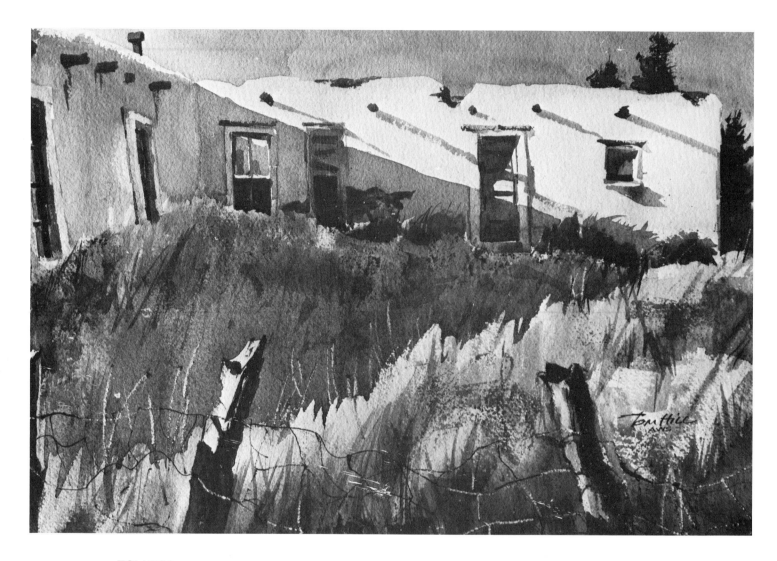

TOM HILL

Old Adobe, 1973
Watercolor, 15″ x 22″
Private collection

CHET ENGLE

Painted by Time, 1970
Oil on Masonite, 24″ x 18″
Dr. and Mrs. Larry R. Price

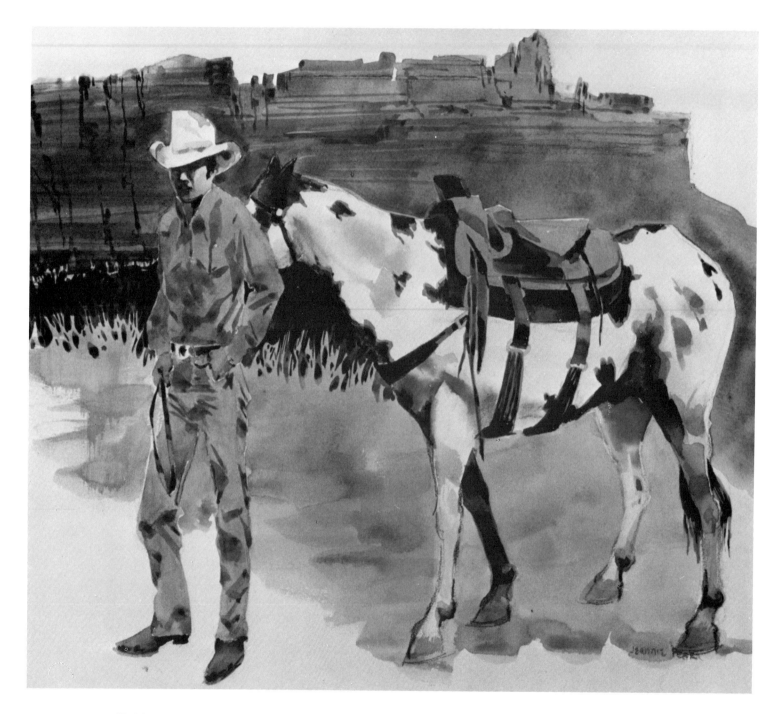

JEANNIE PEAR

Mutual Admiration, 1974
Watercolor on board, 15″ x 20″
Collection of the artist

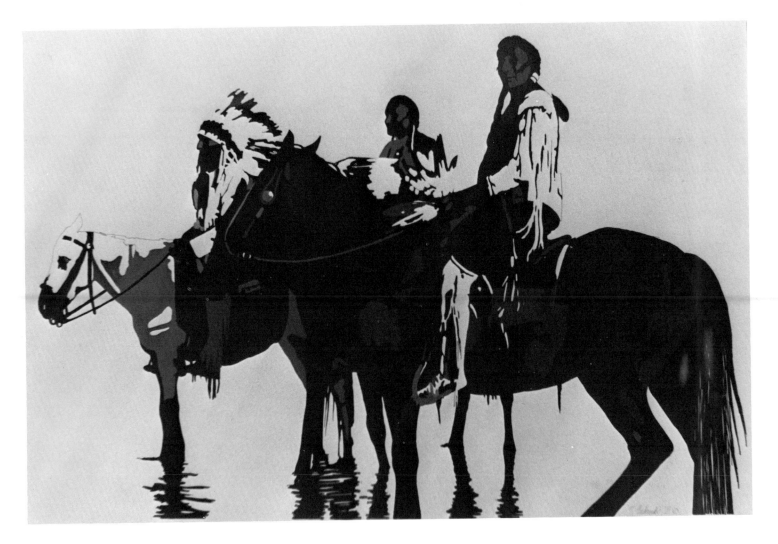

TONY EUBANKS

Three Comanches on the Canadian, 1973
Ink and gouache on board, 23″ x 30″
Private collection

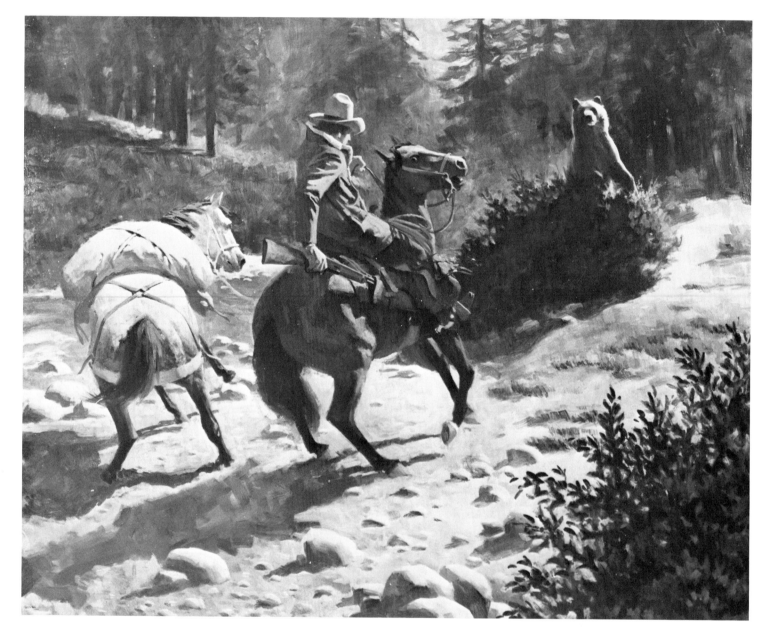

HANK FORD

The Intruders, 1974
Oil on board, 12″ x 15″
The Mongerson Gallery, Chicago

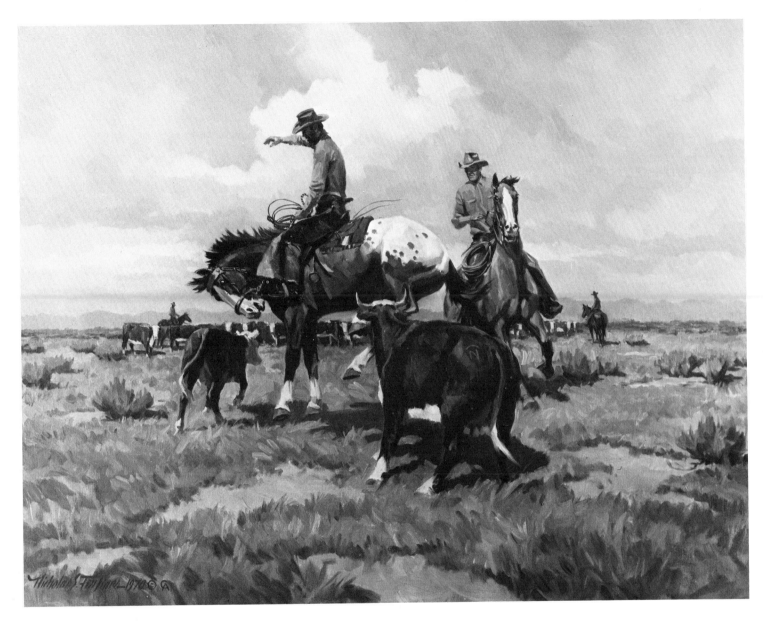

NICHOLAS FIRFIRES

No Cowhorse Yet, 1970
Oil on canvas, 30″ x 40″
Mrs. and Mrs. Paul Greene, Santa Barbara

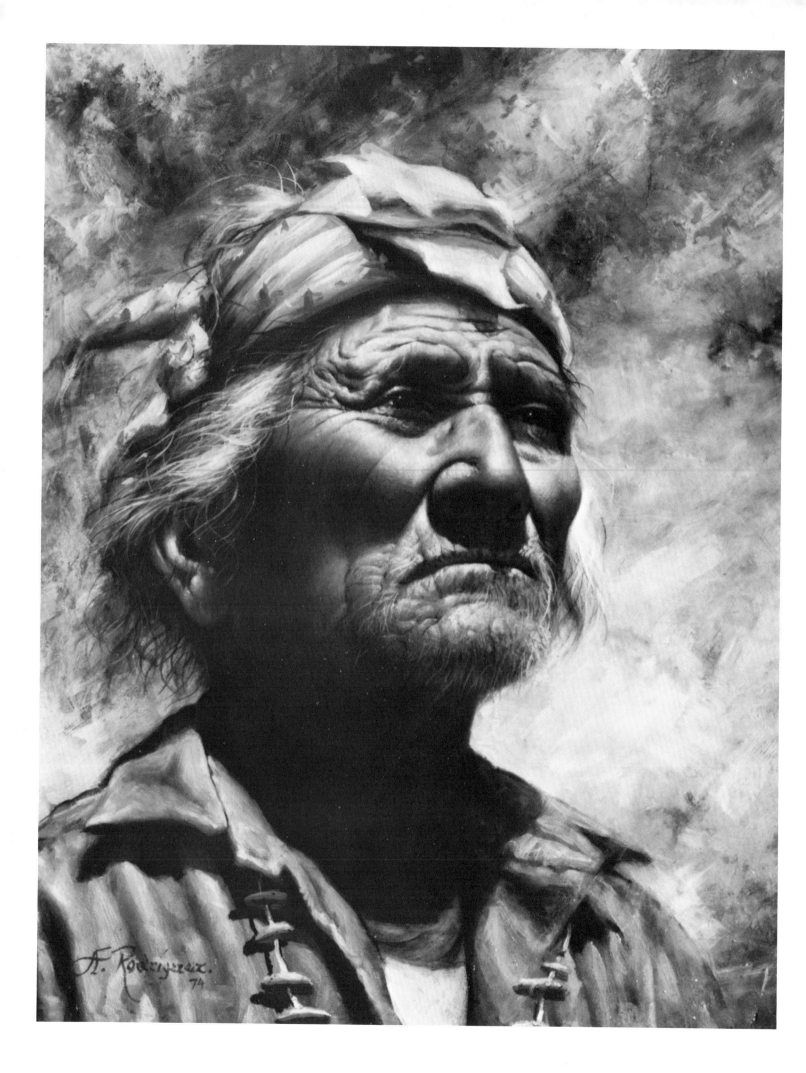

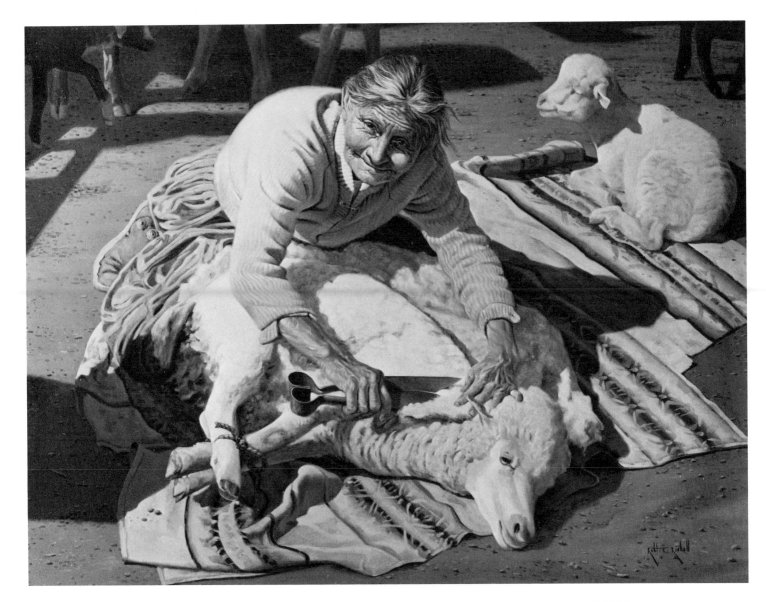

ROBERT RISHELL

Old Lady Many Goats, 1968
Oil on canvas, 36″ x 48″
City of Scottsdale Fine Arts Collection
Scottsdale, Arizona

ALFREDO RODRIGUEZ

Yellowbird (Navaho), 1974
Oil on board, 20″ x 24″
Private collection

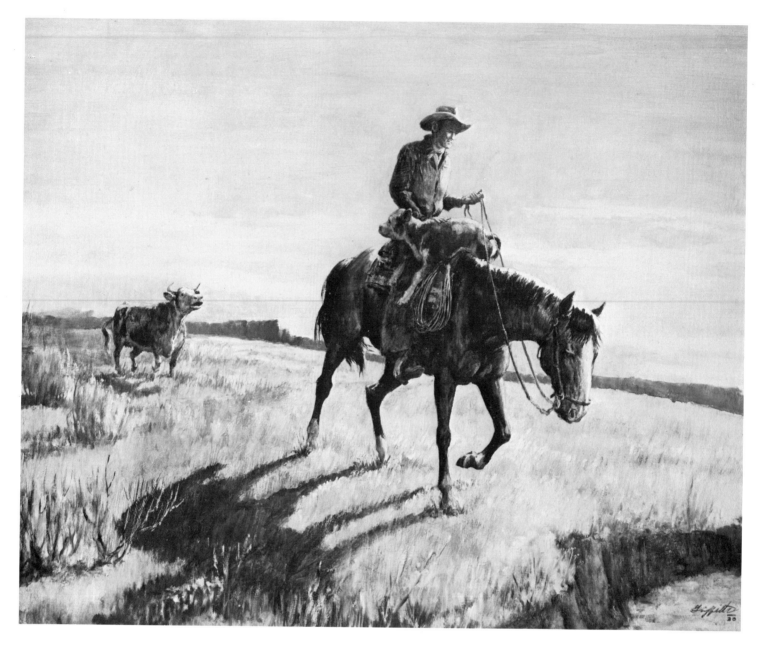

W. C. GRIFFITH

End of the Hunt, 1972
Oil on board, 30" x 36"
Kachina Gallery

BURT PROCTOR

Pair of Cowboys, 1974
Oil on Masonite, 36" x 21"
Private collection

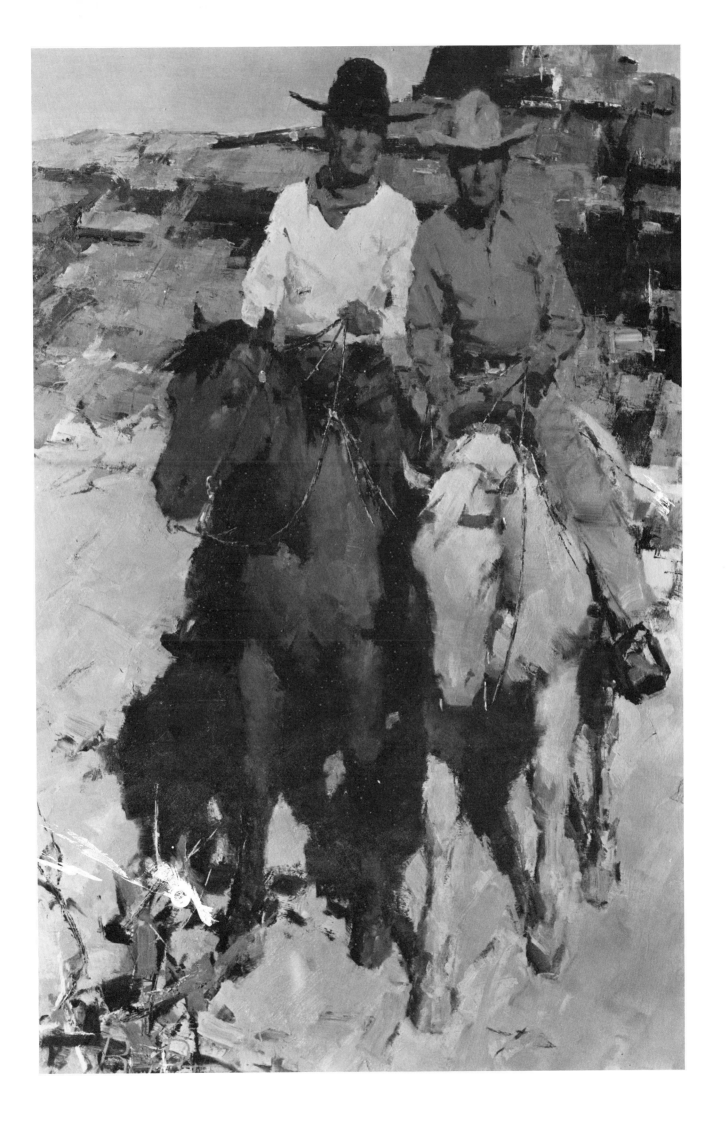

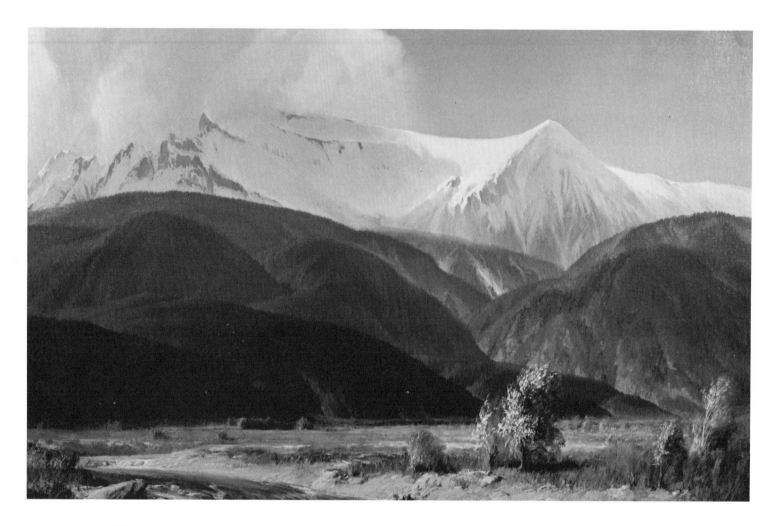

WILSON HURLEY

Mount Princeton, 1973
Oil on canvas, 30" x 40"
Mr. and Mrs. James Clark, Albuquerque

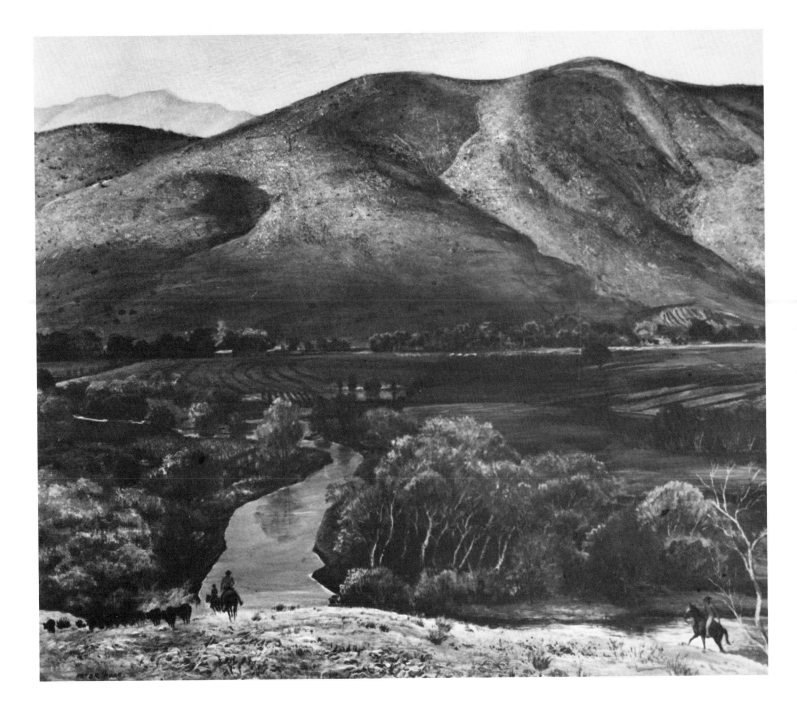

PETER HURD

October, 1970
Tempera on Masonite
Robert J., Patrick J., and Timothy T. Leonard

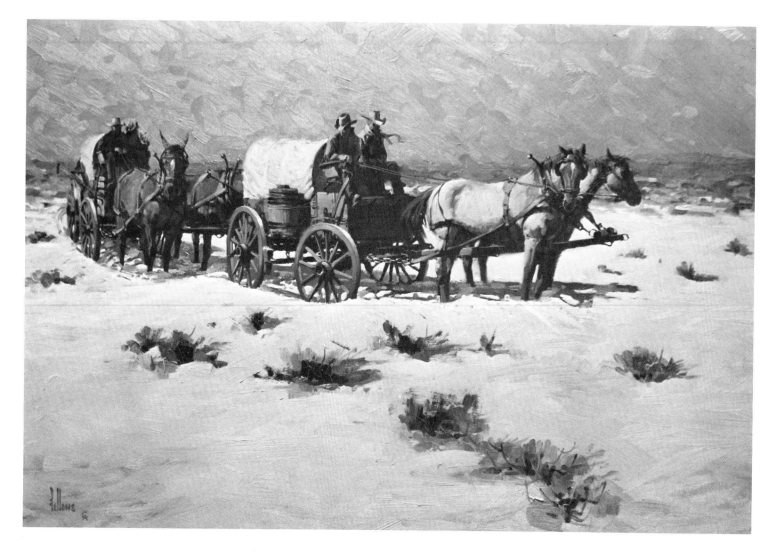

FRED FELLOWS

When Trails Disappear, 1974
Oil on panel, 24″ x 36″
J.O. Morrisey Collection, St. Louis

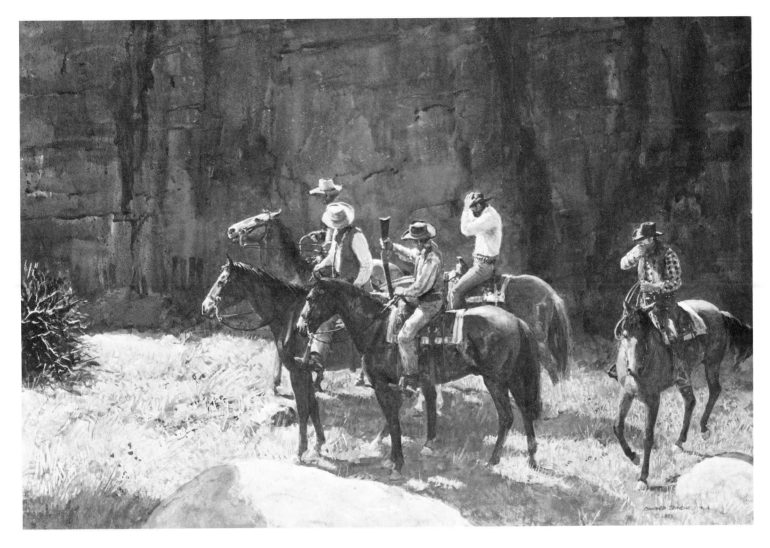

DONALD TEAGUE

Ambush, 1973
Watercolor, 20" x 30"
Harry A. Lockwood

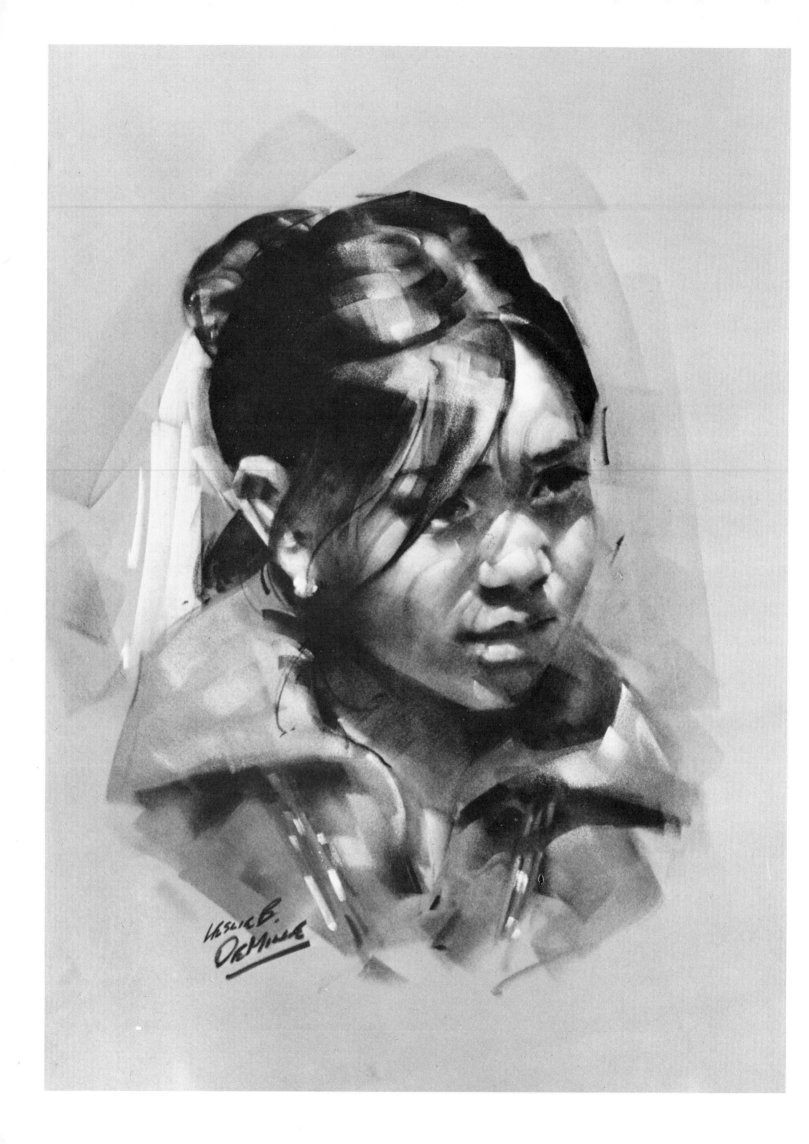

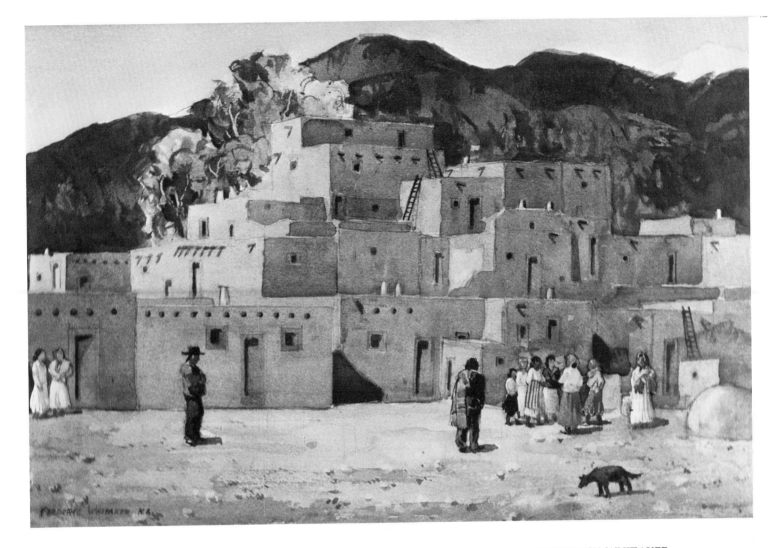

FREDERICK WHITAKER

Taos Pueblo, 1973
Watercolor, 20″ x 30″
Private collection

LESLIE B. DEMILLE

Navaho Girl, 1974
Pastel on velour, 20″ x 16″
Ernestine Nestler, Sedona, Arizona

92

HARRY JACKSON

Stampede, 1963
Oil on canvas, 10′ x 21′
Whitney Gallery of Western Art
Cody, Wyoming

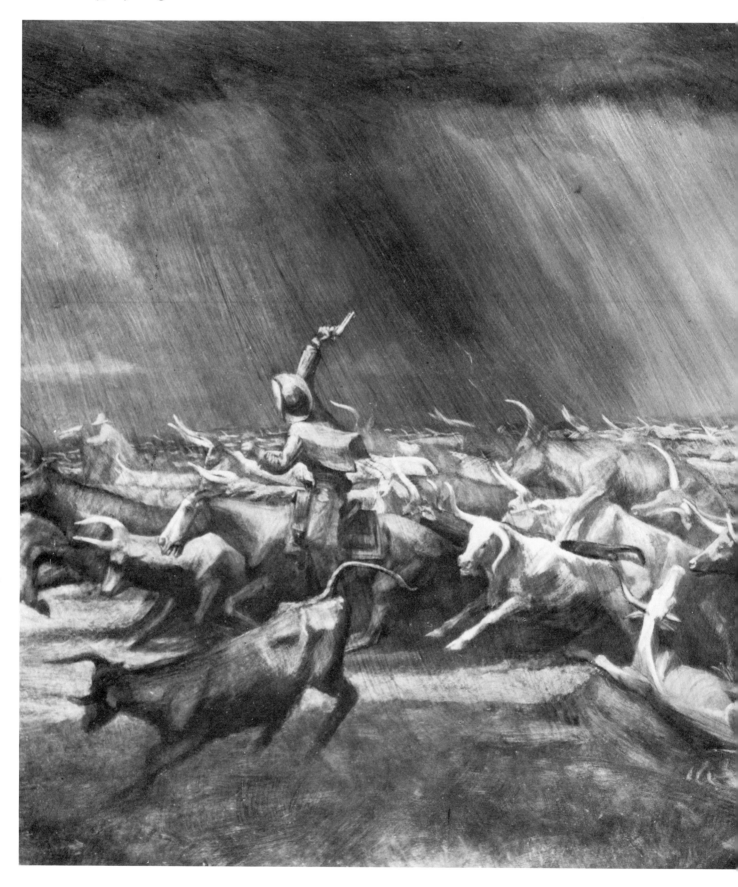

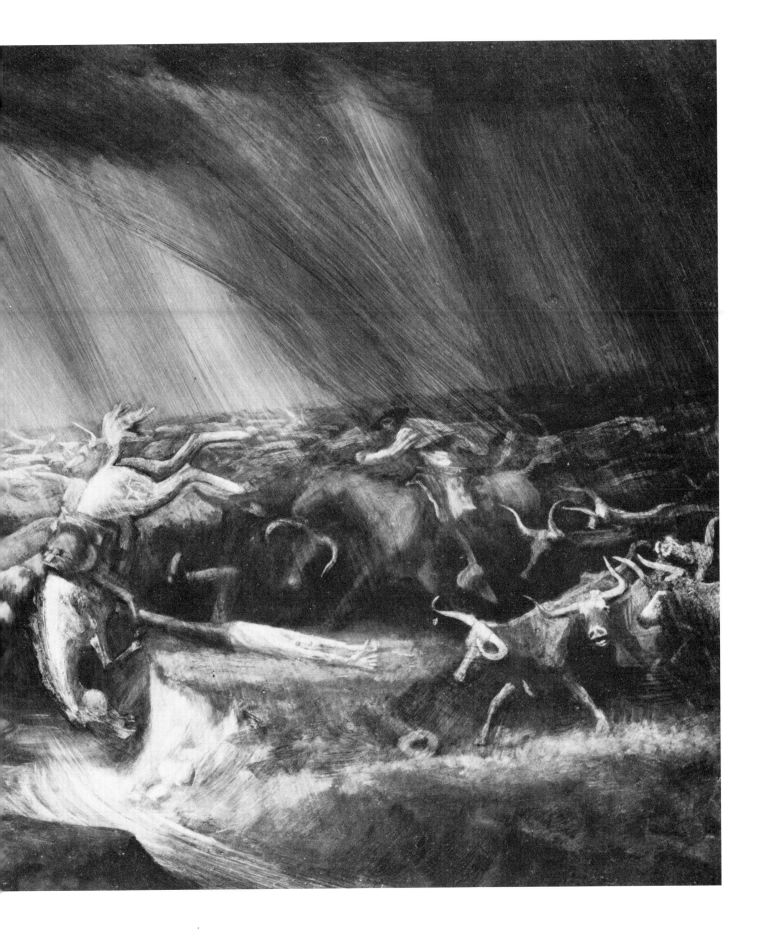

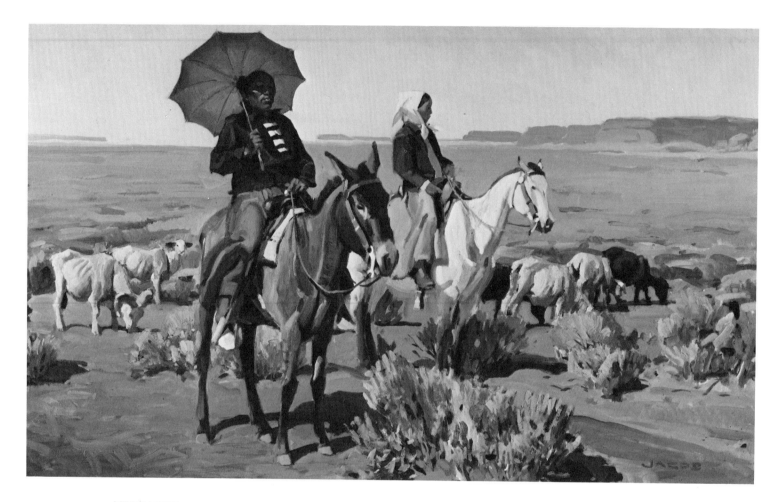

NED JACOB

Red Parasol, 1973
Oil on panel, 24″ x 48″
Arrowhead Petro Corporation

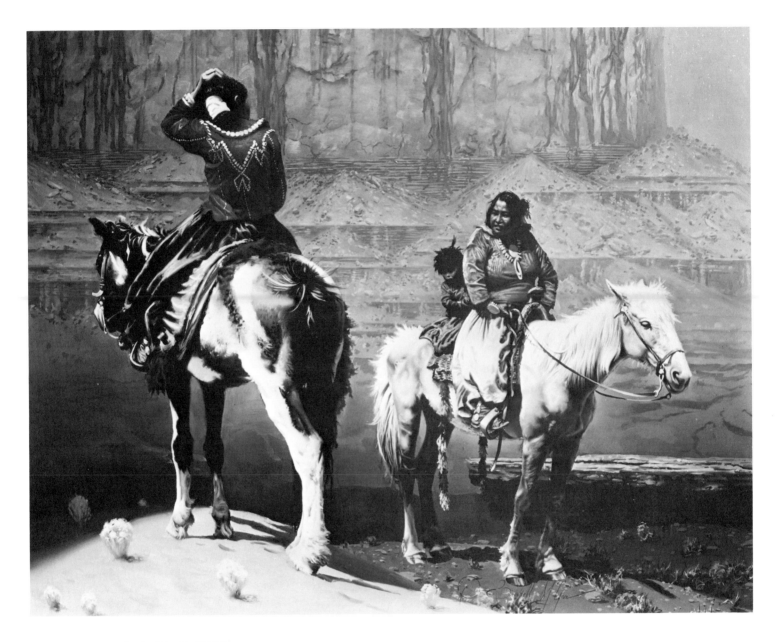

R. BROWNELL McGREW

In the Valley, 1970
Oil, 32" x 40"
Private collection, Scottsdale, Arizona

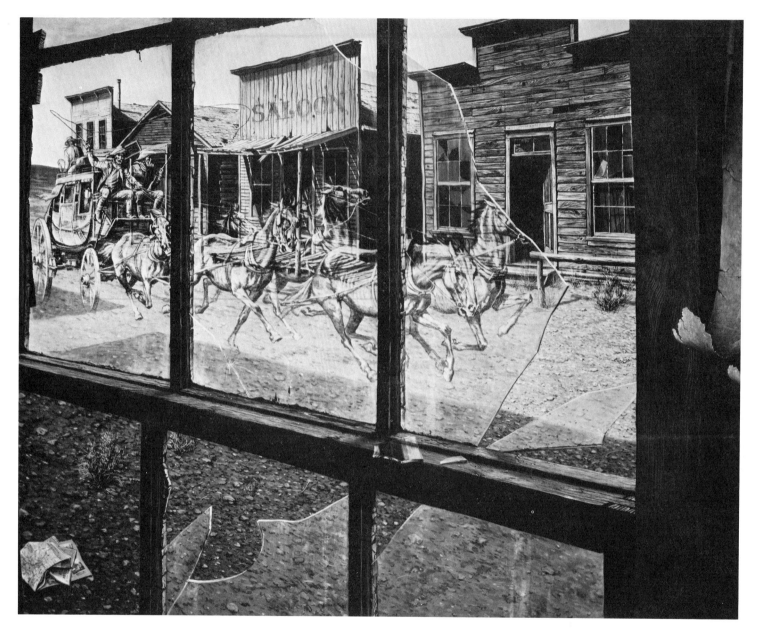

ERNEST BERKE

The Last Stage, 1964
Oil on canvas, 36″ x 42″
Private collection

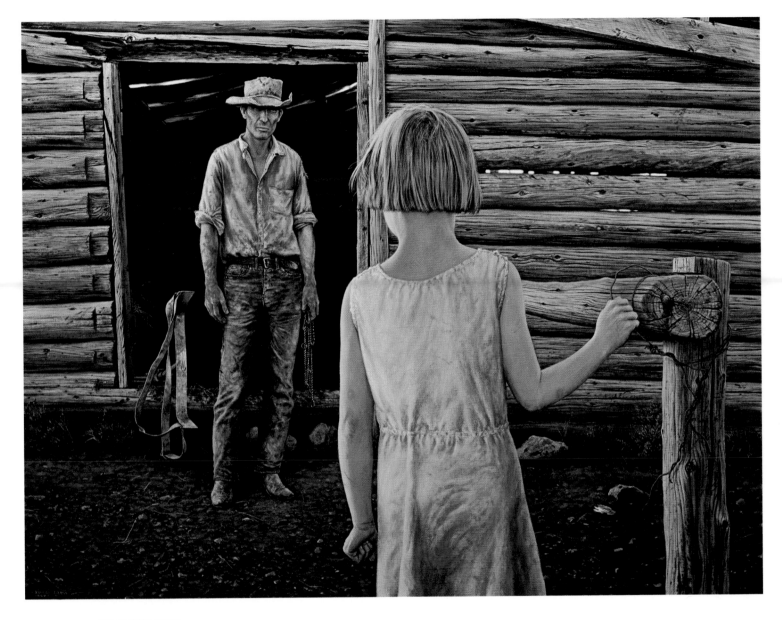

ERNEST BERKE

The Lost Colt, 1969
Oil on canvas, 36" x 44"
Private collection

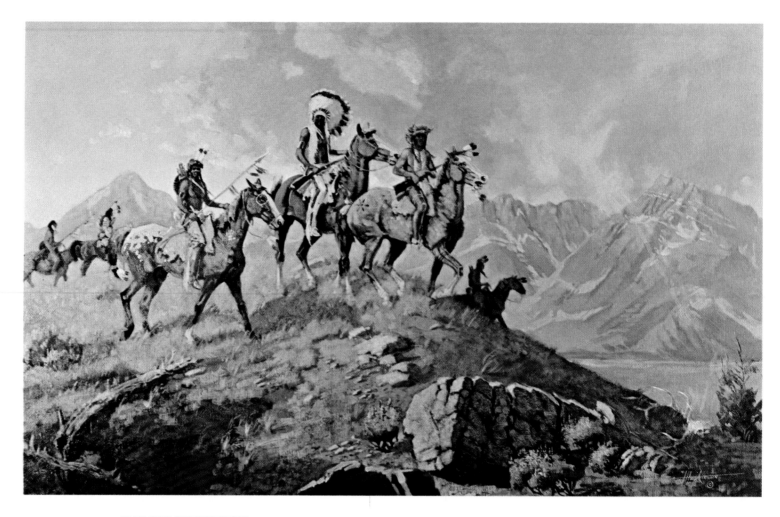

HAROLD HOPKINSON

Where is my Enemy, 1974
Oil on canvas, 30" x 48"
Collection of the artist

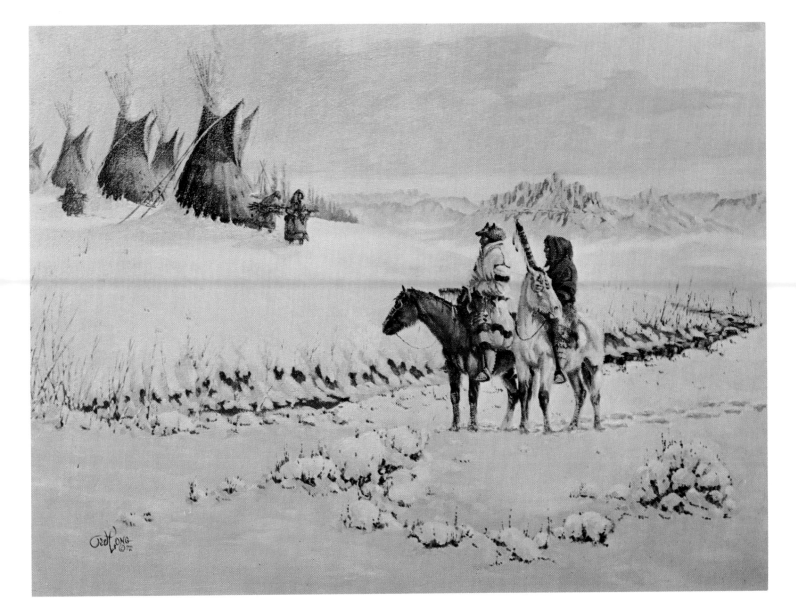

TED LONG

Cheyenne Winter, 1973
Oil on board, 18″ x 24″
Heinz Steenmans, Germany

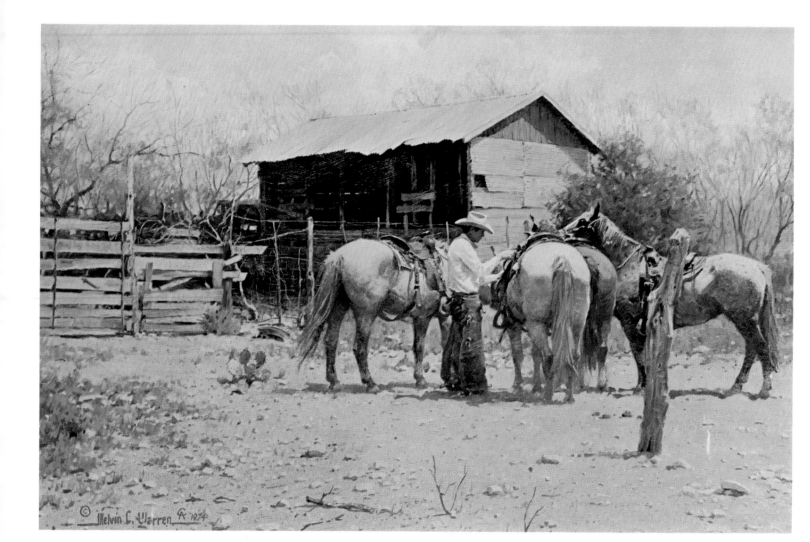

MELVIN C. WARREN

Top Hand of the Concho, 1974
Oil on canvas, 24″ x 36″
Collection of the artist

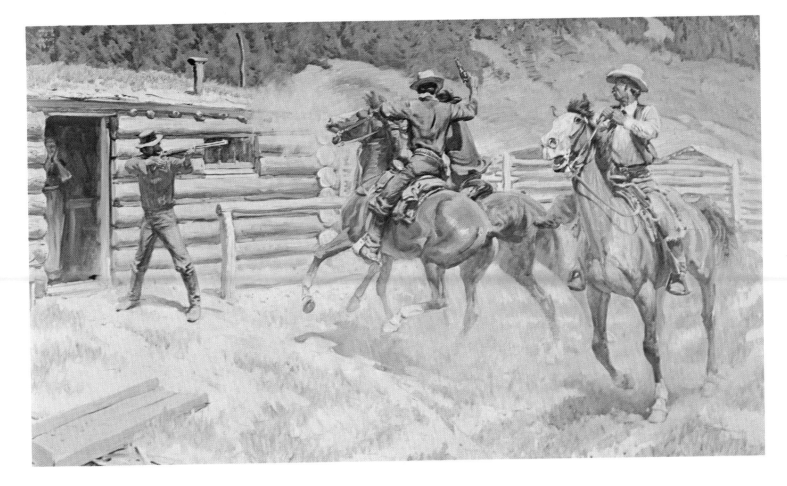

HAROLD VON SCHMIDT

A Fight for the Cabin, 1950
Oil on canvas, 30″ x 50″
Walt Reed, Westport, Connecticut

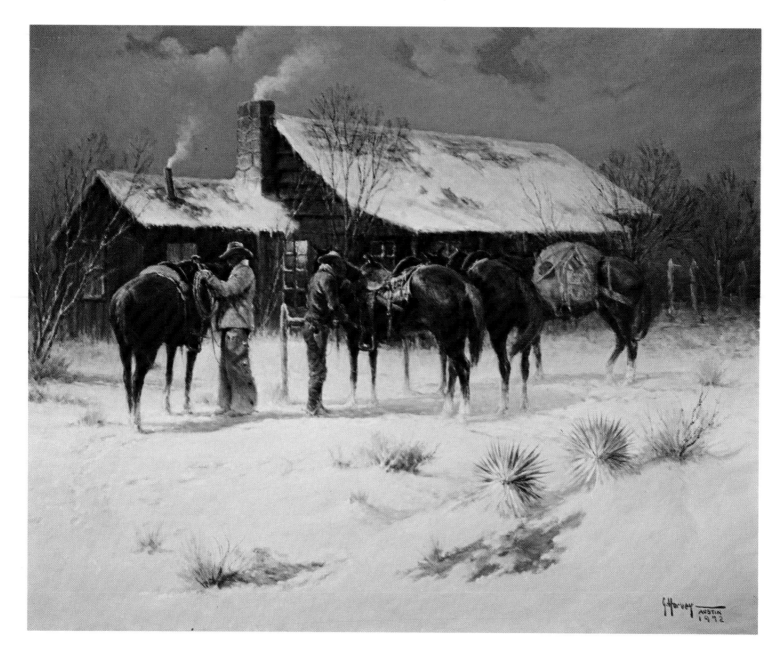

G. HARVEY

Night Patrol, Texas Rangers, 1972
Oil on canvas, 24″ x 30″
Private collection

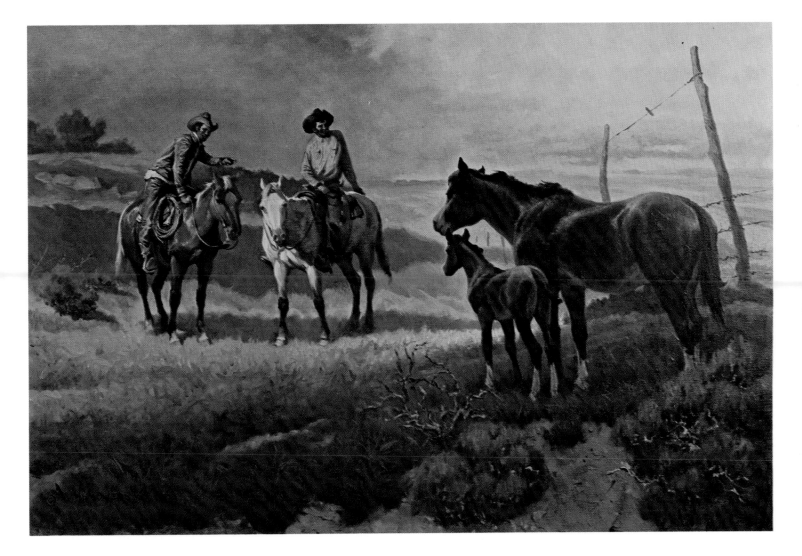

WILLIAM MOYERS

The Critics, 1970
Oil on canvas, 24" x 36"
Mr. and Mrs. C. F. Replogle

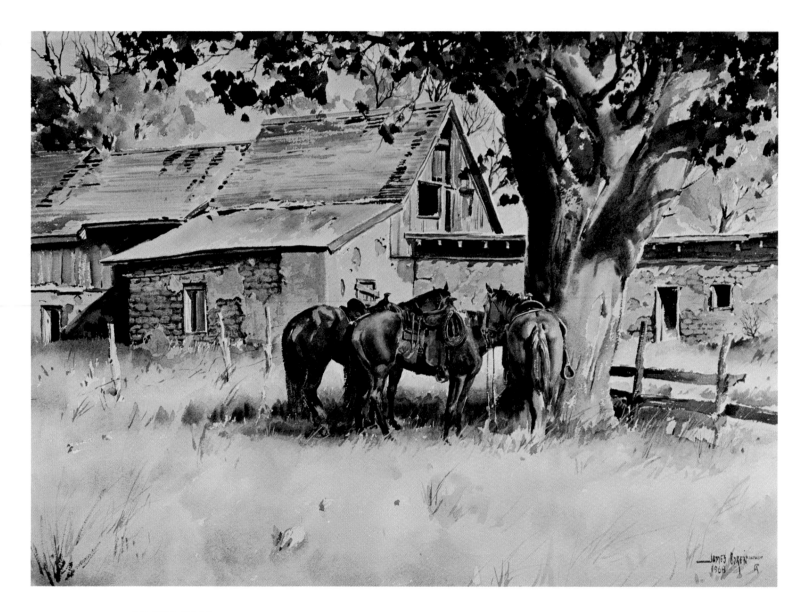

JAMES BOREN

Afternoon in New Mexico, 1968
Watercolor, 21″ x 29″
National Cowboy Hall of Fame
Oklahoma City

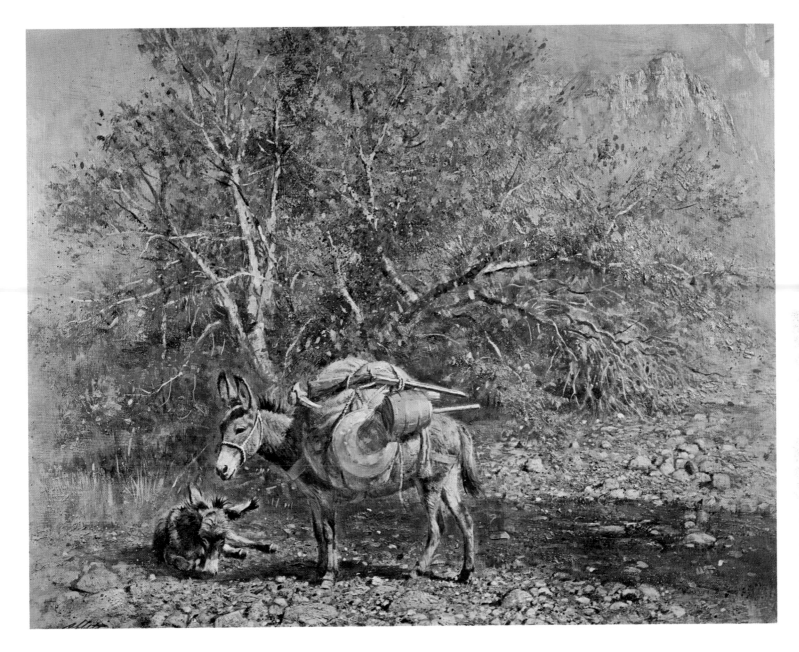

ROBERT ABBETT

Untitled, 1974
Oil on board, 24″ x 30″
W.R. Gibson, Fort Worth

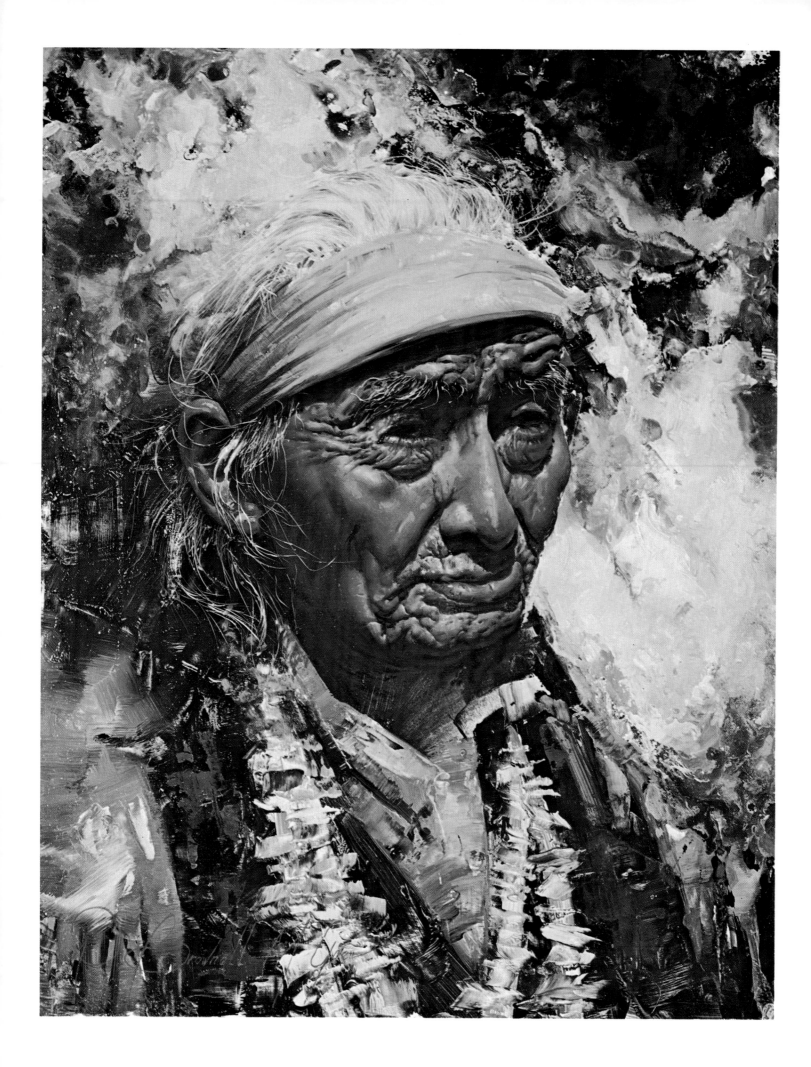

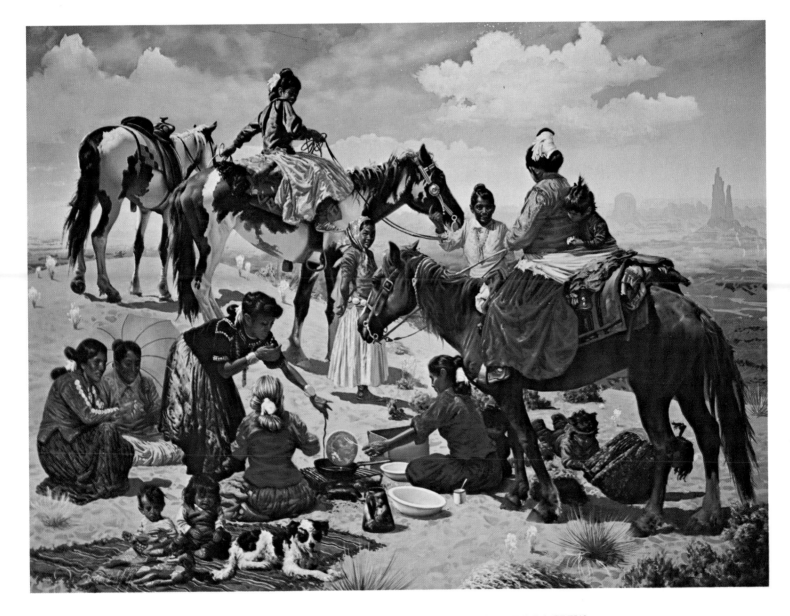

R. BROWNELL McGREW

Fry-Bread Time, 1973
Oil on tempered pressed-board, 36″ x 48″
National Academy of Western Art
Oklahoma City

R. BROWNELL McGREW

Hasti 'in Speck, 1968
Oil on tempered pressed-board, 20″ x 16″
Private collection, Scottsdale, Arizona

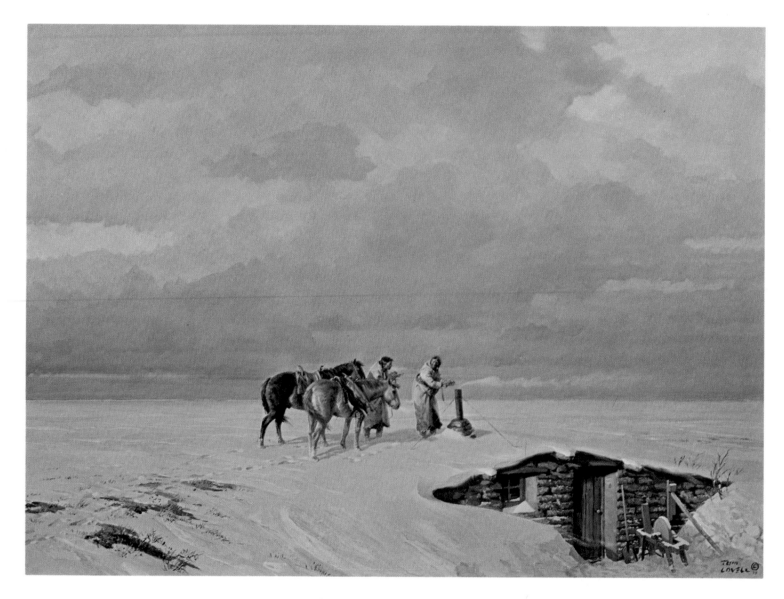

TOM LOVELL

The Handwarmer, 1973
Oil on panel, 28″ x 36″
National Cowboy Hall of Fame
Oklahoma City

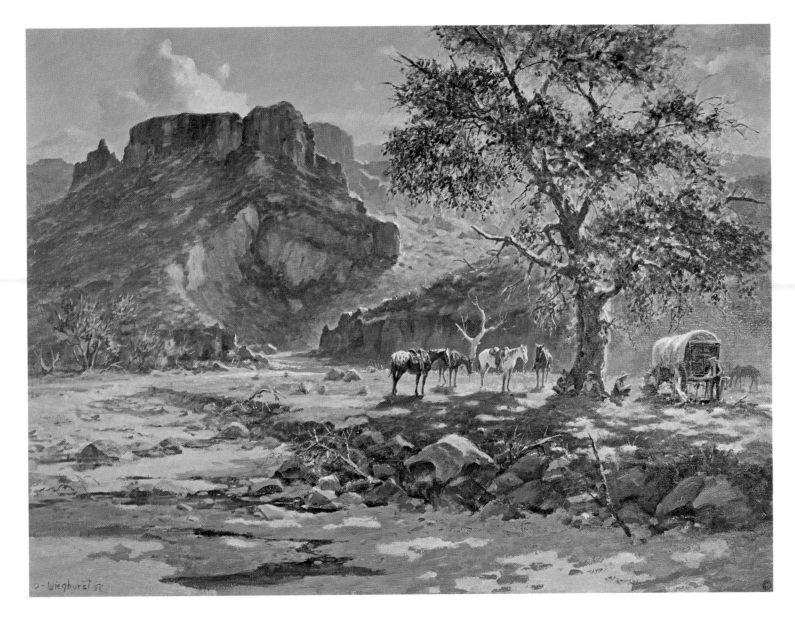

OLAF WIEGHORST

Range Chuck, 1960
Oil on canvas, 28″ x 38″
Mr. and Mrs. C. Windsby

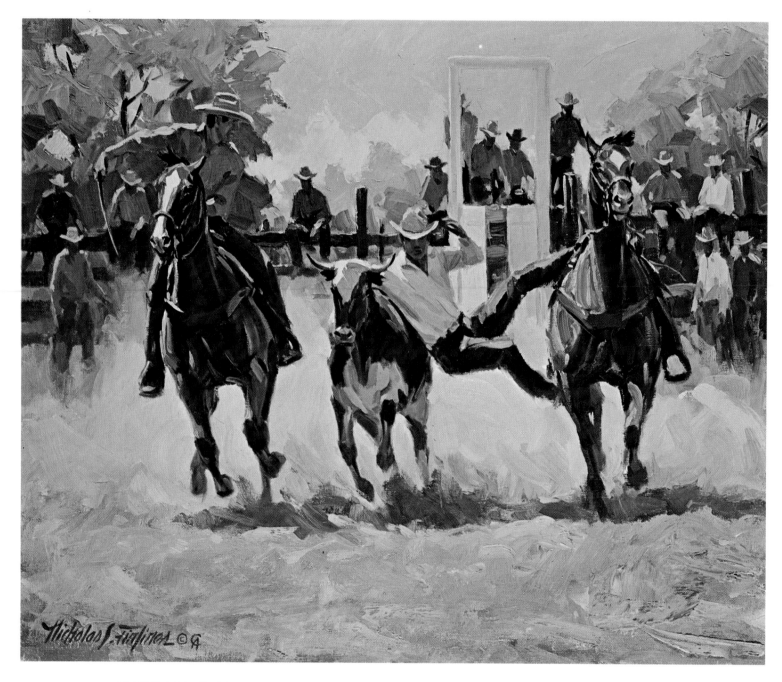

NICHOLAS FIRFIRES

The Dogger, 1973
Oil on canvas, 20" x 24"
First National Bank of Denver

EILEEN MONAGHAN WHITAKER

Ceremonial Gathering, 1969
Watercolor, 22″ x 30″
Mrs. Bailie Taylor, San Diego

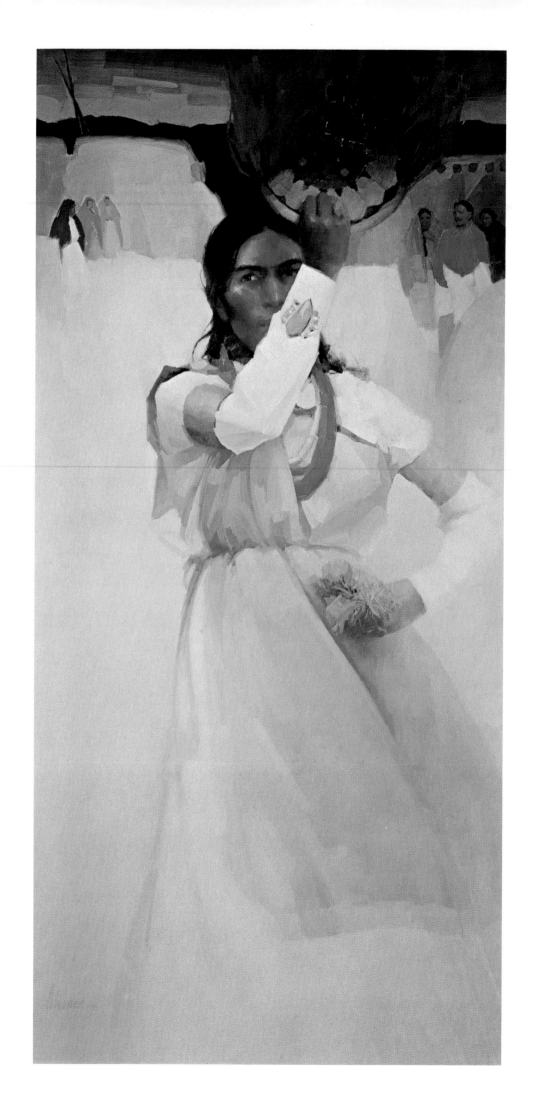

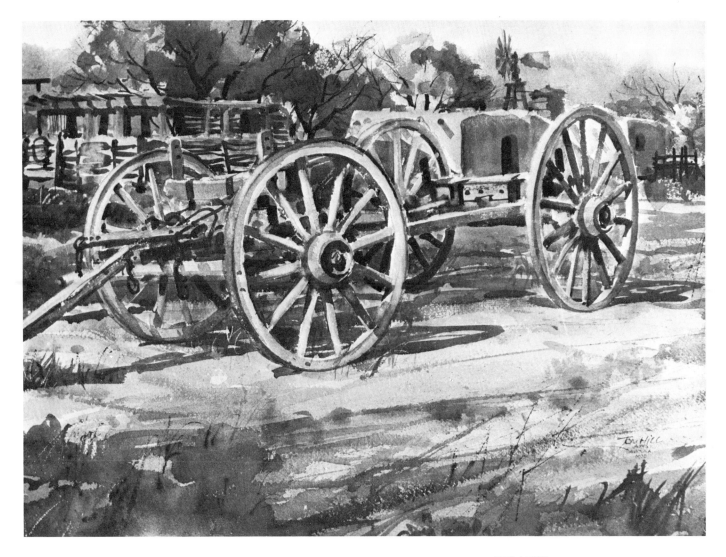

TOM HILL
Western Wagon, 1970
Watercolor, 22″ x 30″
Dr. Ross Chapin

WILLIAM E. SHARER
Rain Dance, 1973
Oil on panel, 48″ x 24″
Dr. and Mrs. R. Sukman

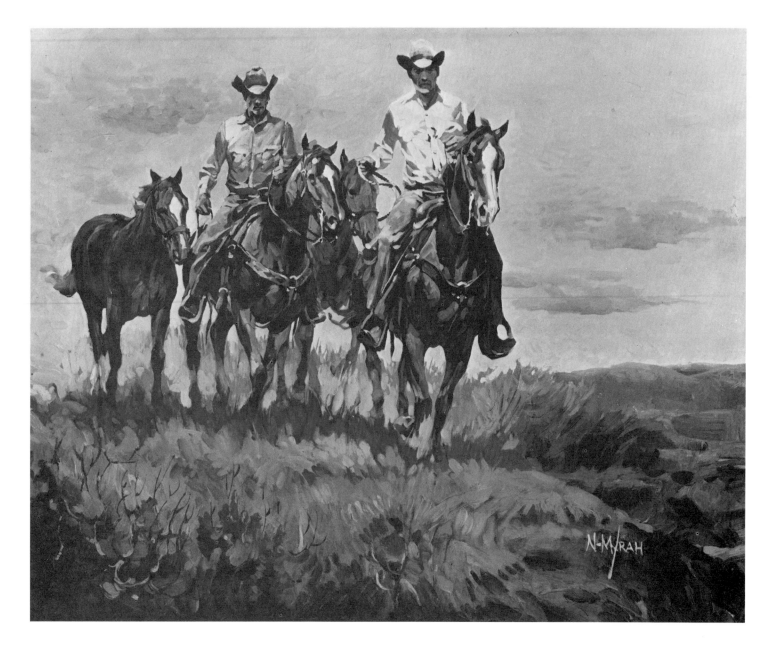

NEWMAN MYRAH

The Horse Wranglers, 1974
Acrylic on canvas, 24″ x 28″
Collection of the artist

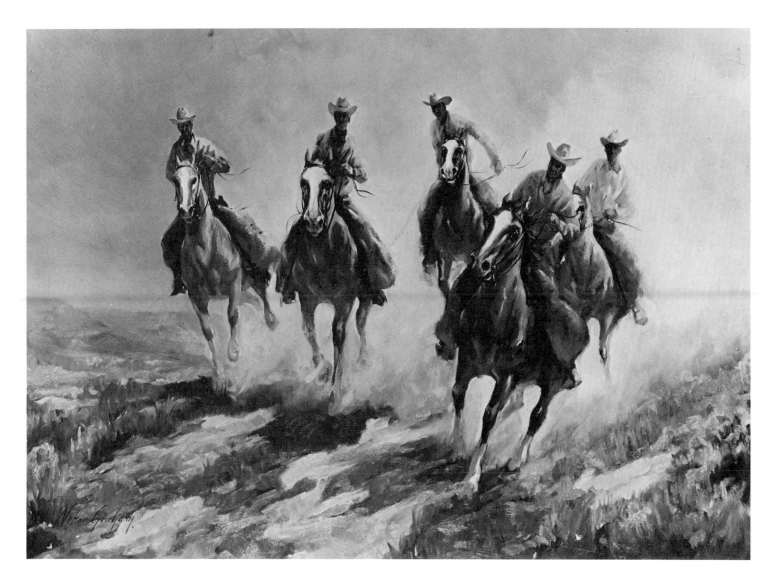

WALTER GRAHAM

Goin' to Town, 1974
Oil on canvas, 24" x 30"
Collection of the artist

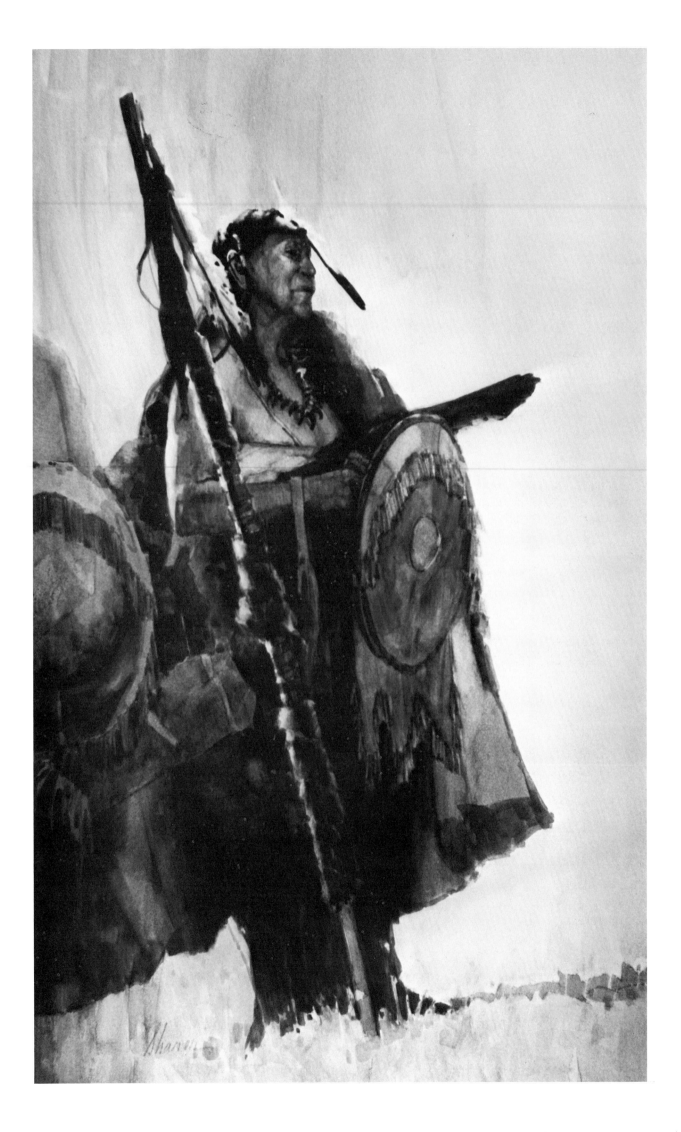

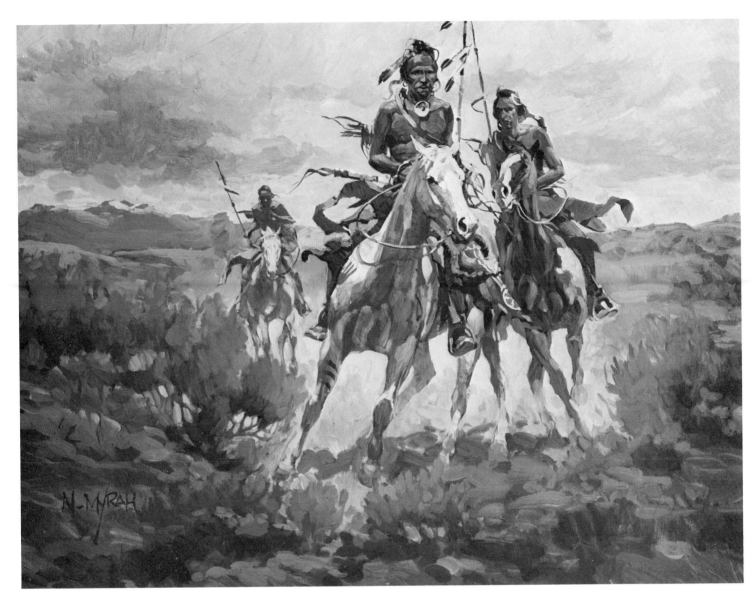

NEWMAN MYRAH

The Scouts, 1974
Acrylic on canvas, 18″ x 24″
Collection of the artist

WILLIAM E. SHARER

Crow Chief, 1972
Oil wash on paper, 22¼″ x 14″
Dr. David I. Olch

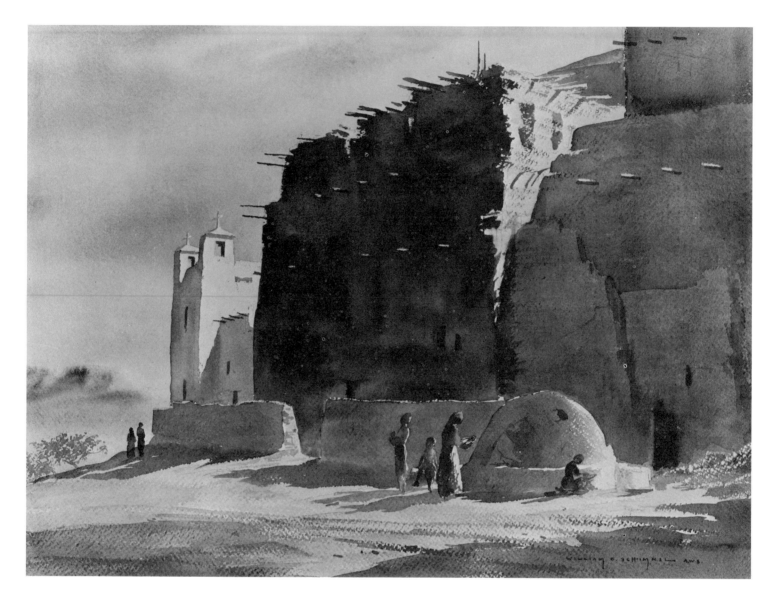

WILLIAM B. SCHIMMEL

Ruins of Acoma Pueblo, 1970
Watercolor, 21" x 18"
Mary Ramsel

FREDERICK WHITAKER

Baroque Facade, San Diego, 1968
Watercolor, 22" x 30"
Private collection

FREDERIC WHITAKER

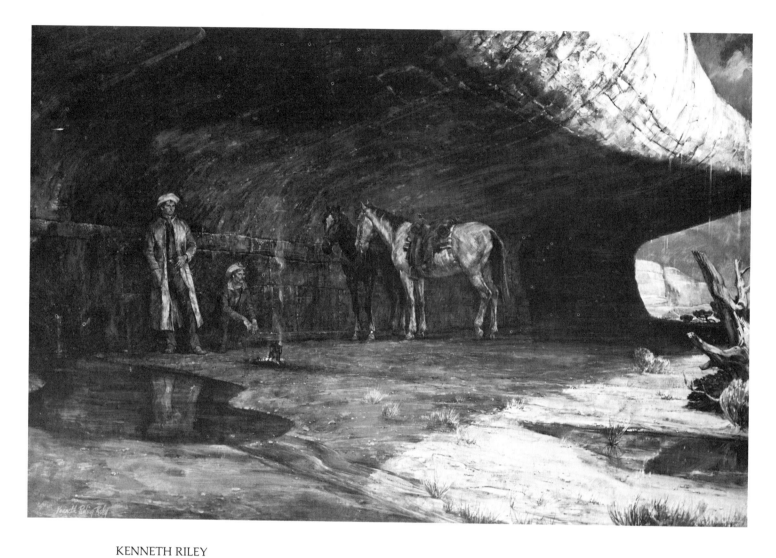

KENNETH RILEY

Anasazi Spring, 1974
Acrylic on panel, 24″ x 36″
Collection of the artist

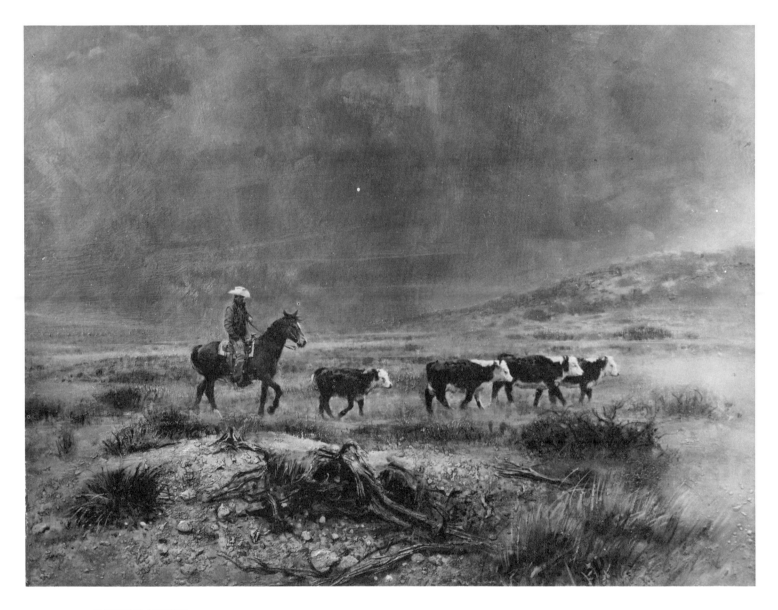

ROBERT ABBETT

Sandstorm on Flat Top, 1974
Oil on board, 24" x 30"
Dan Ryan, Jr., Dallas

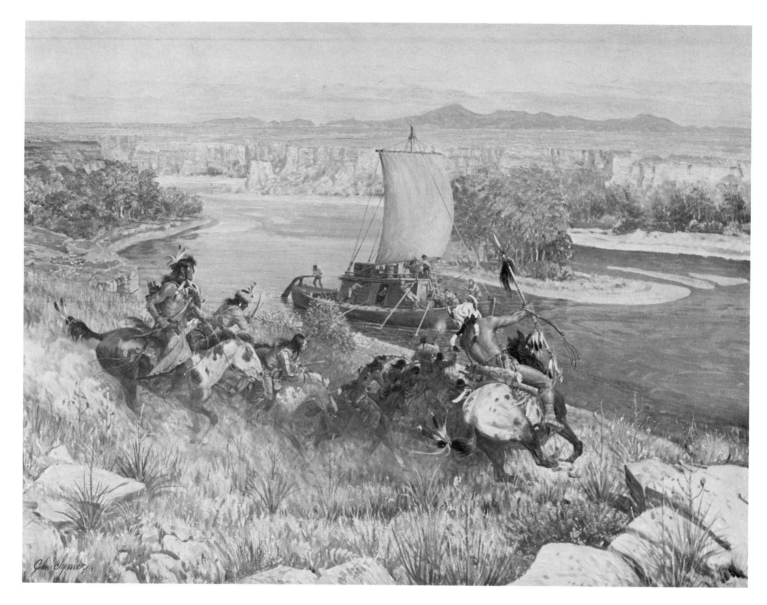

JOHN CLYMER

Skirmish on the River, 1965
Oil on canvas, 30″ x 40″
Private collection

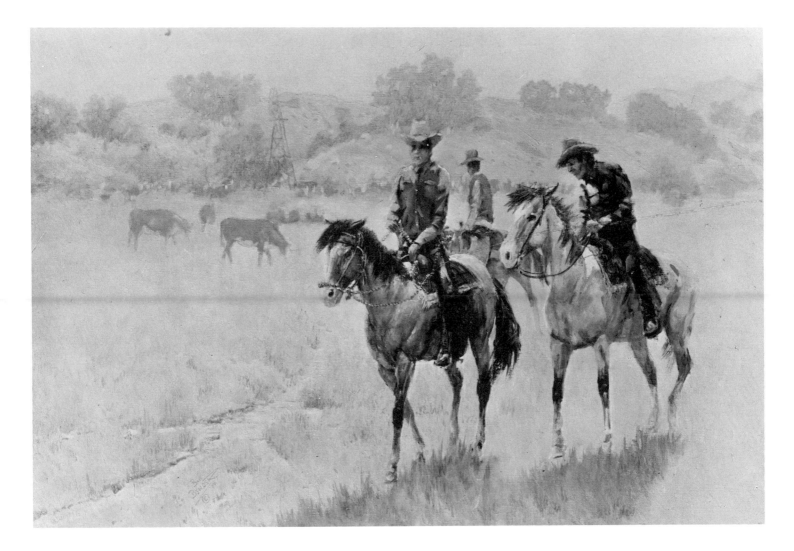

BILL BENDER

Old Hands on New Ponies, 1971
Oil on Masonite, 24″ x 36″
Private collection

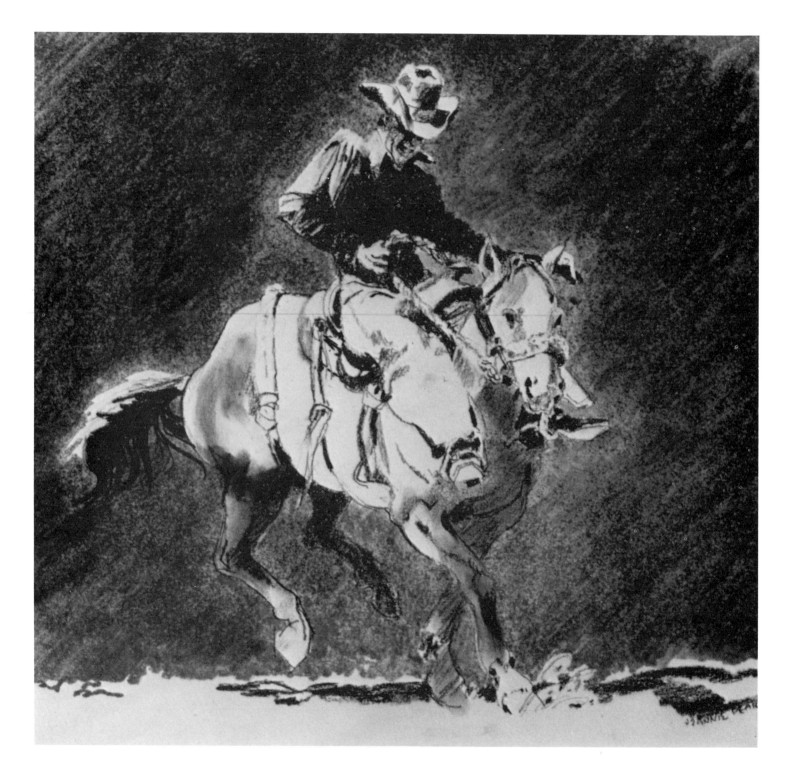

JEANNIE PEAR

Togetherness, 1974
Charcoal and ink on board, 11″ x 11″
Collection of the artist

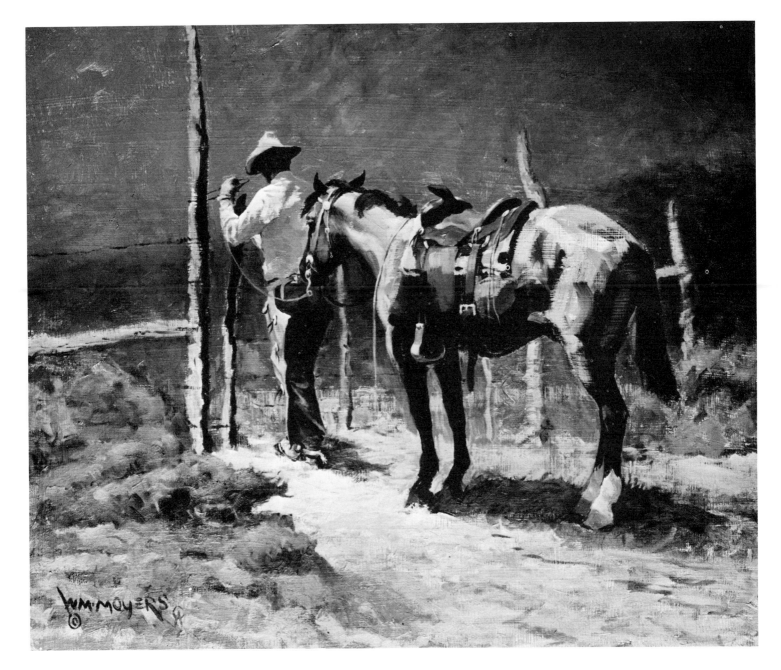

WILLIAM MOYERS

After Hours, 1972
Oil on Masonite 20″ x 24″
Harrison Eiteljorg

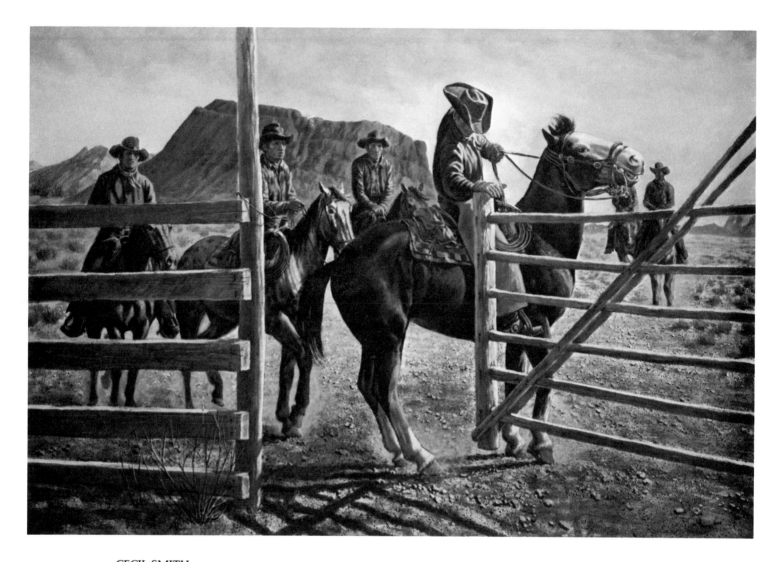

CECIL SMITH
Cowboys Aren't Lazy
Oil on Masonite, 24" x 36"
Dr. Frederick Allen

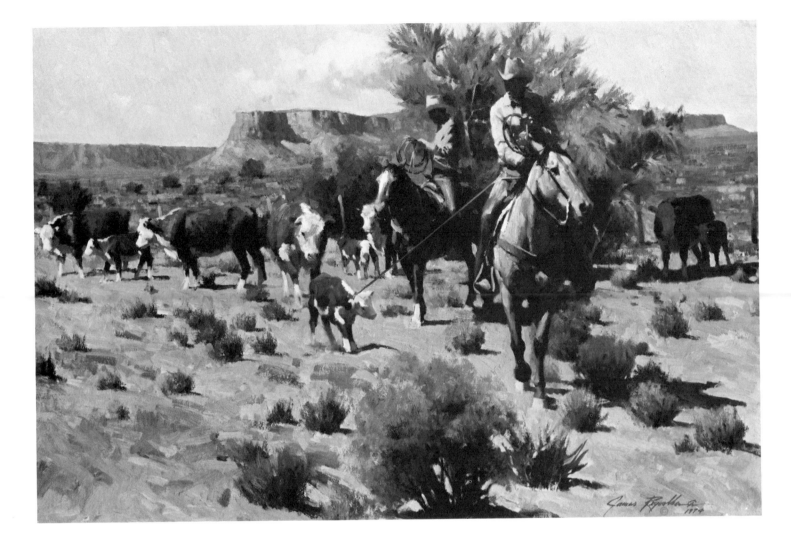

JAMES REYNOLDS

Three to Go, 1974
Oil on Masonite, 24″ x 36″
Private collection

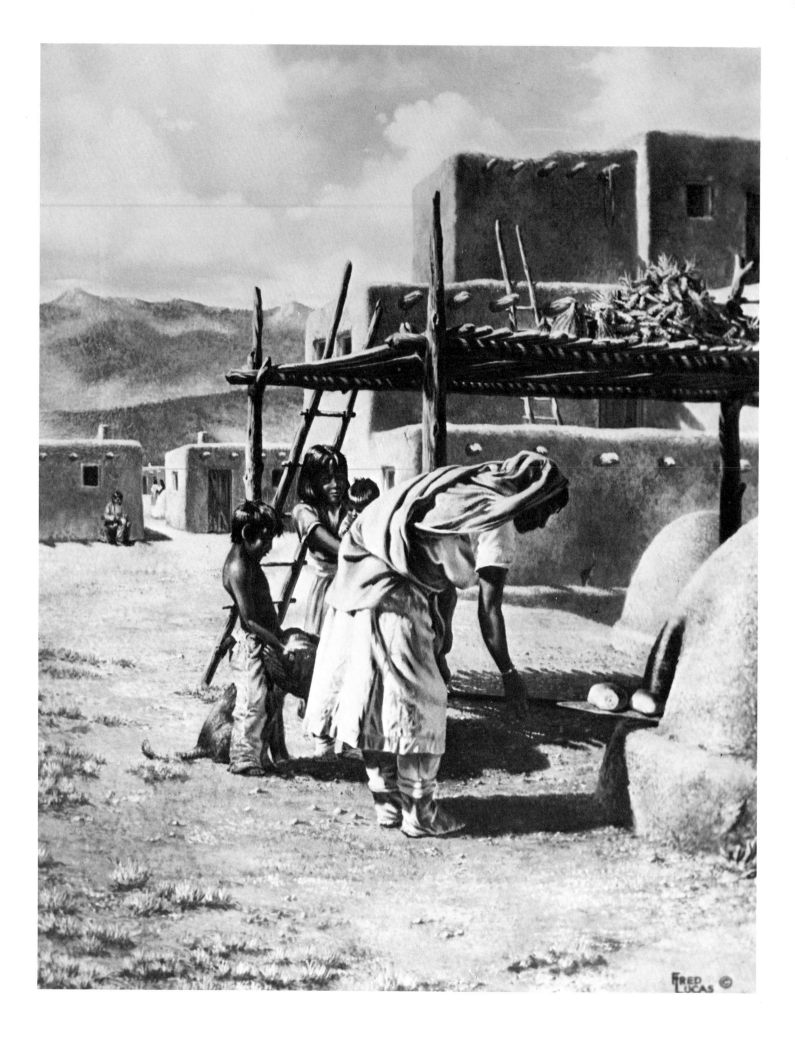

TOM HILL
Bread Baking, Taos Pueblo, 1974
Watercolor, 22′ x 30″
Collection of the artist

FRED LUCAS
Yield of their Labor, 1973
Oil on canvas, 24″ x 18″
Private collection

J.K. RALSTON
Muggins Taylor—Man with Custer Massacre Message, 1963
Oil on canvas, 3' x 5'
Kathryn Wright, Billings, Montana

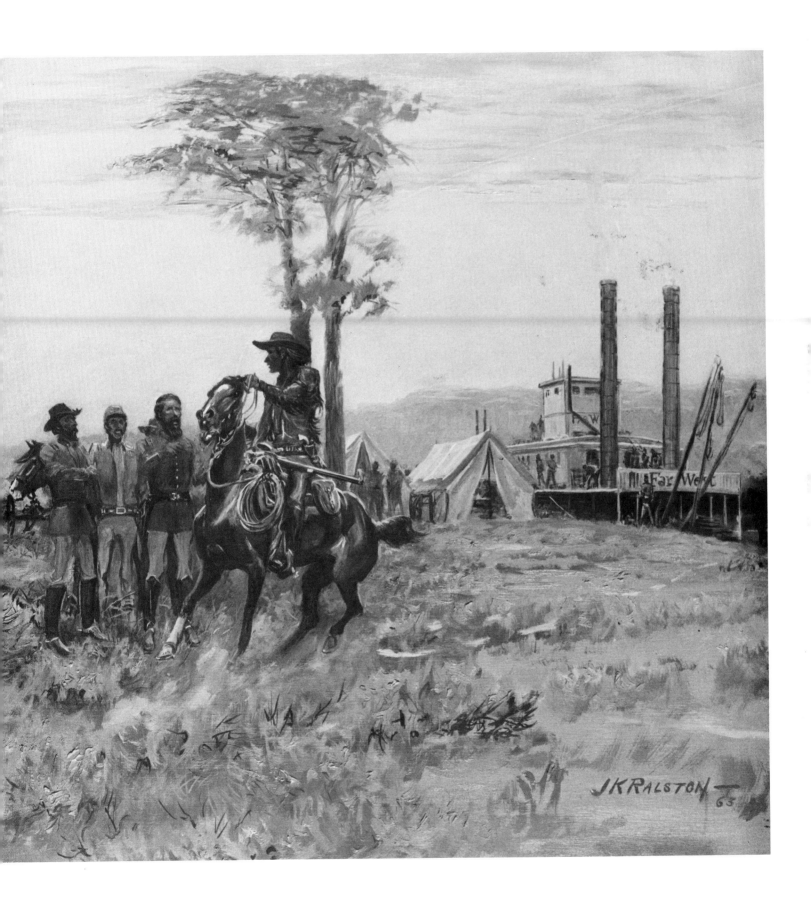

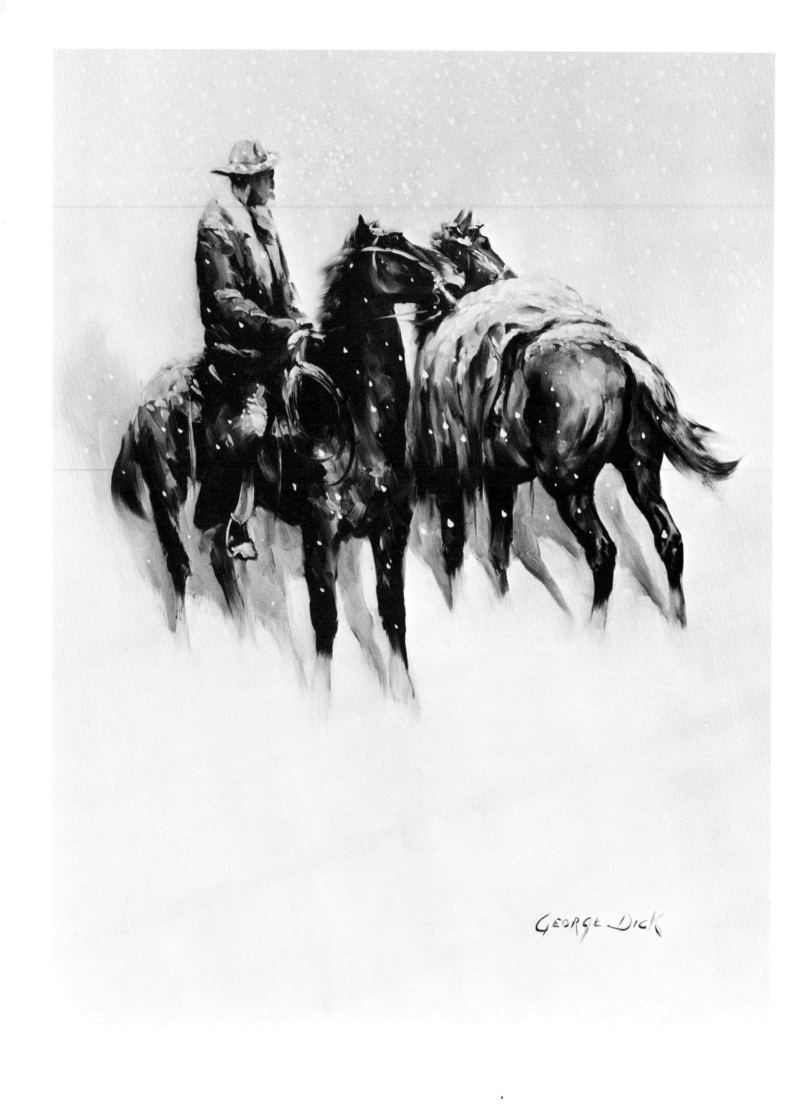

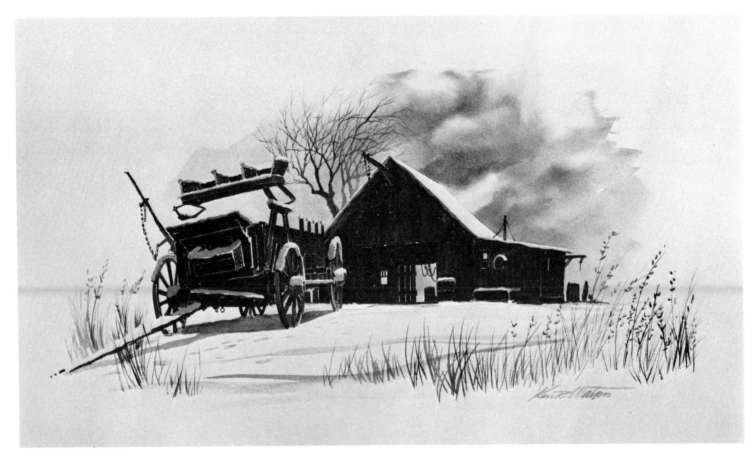

KEN WATSON

The Livery, 1974
Watercolor on board, 18″ x 30″
Private collection

GEORGE DICK

Checking the Back Trail, 1974
Oil on panel, 20″ x 16″
Collection of the artist

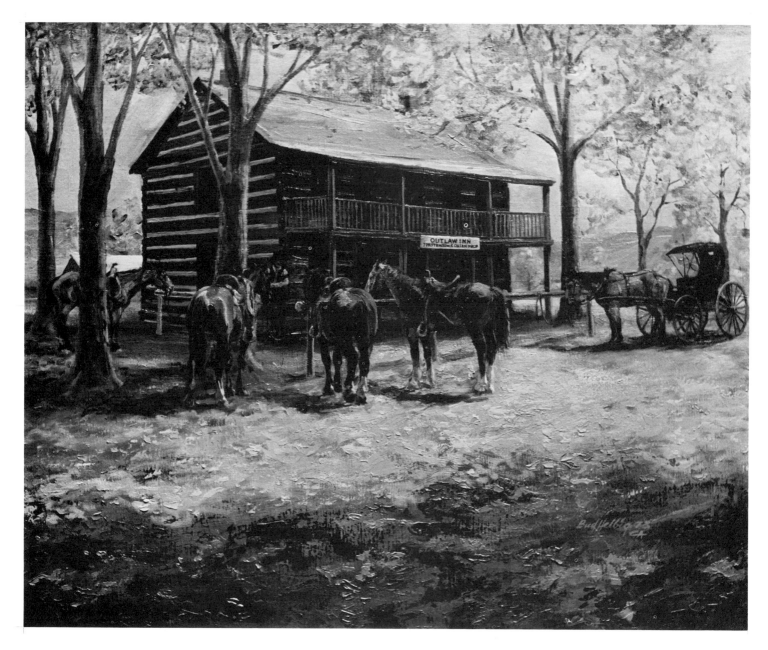

BUD HELBIG

Robber's Roost, 1973
Oil on canvas, 24" x 30"
Outlaw Inn, Kalsipell, Montana

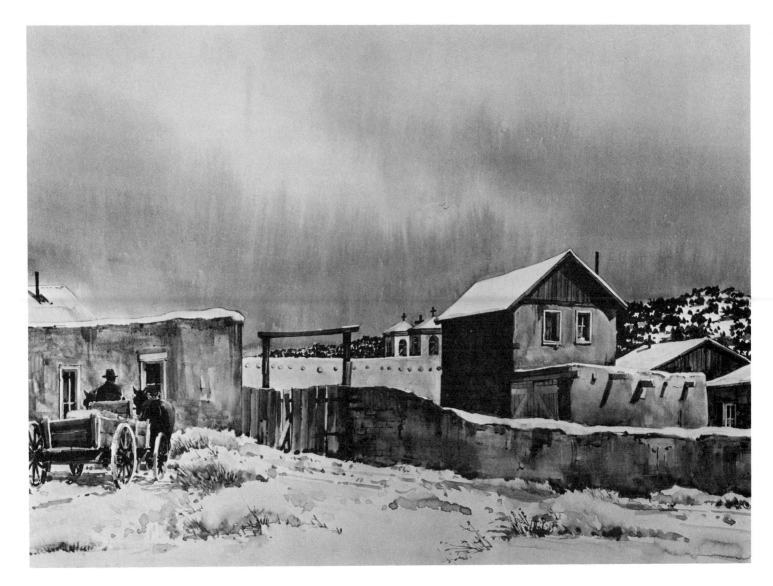

MORRIS RIPPEL

Backroad—Ranchos, 1974
Watercolor, 15" x 21"
Mr. and Mrs. Max D. Shriver
Taos, New Mexico

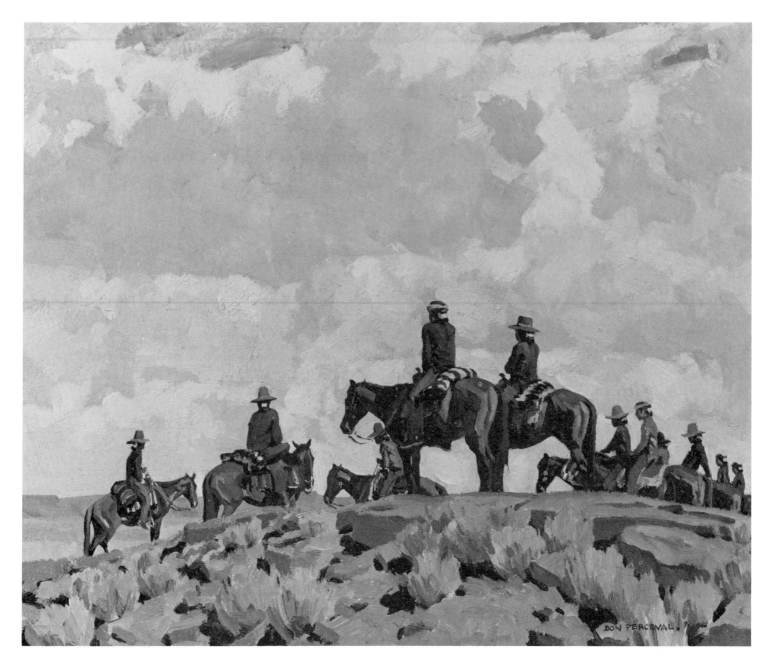

DON PERCEVAL

On the Mesa, 1971
Oil on Masonite, 16" x 20"
Mr. and Mrs. Einar H. Palmasan

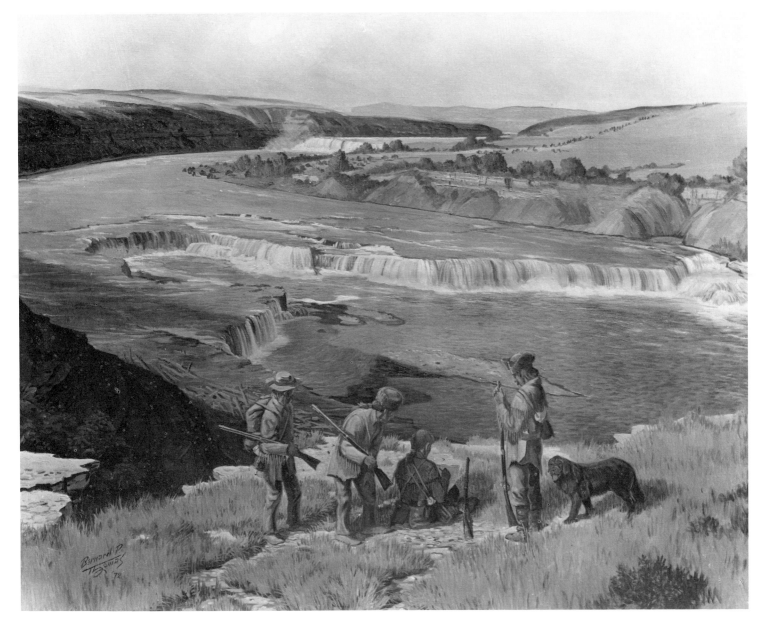

BERNARD THOMAS

Captain Lewis Charting Great Falls, 1971
Oil on canvas, 40″ x 50″
Private collection

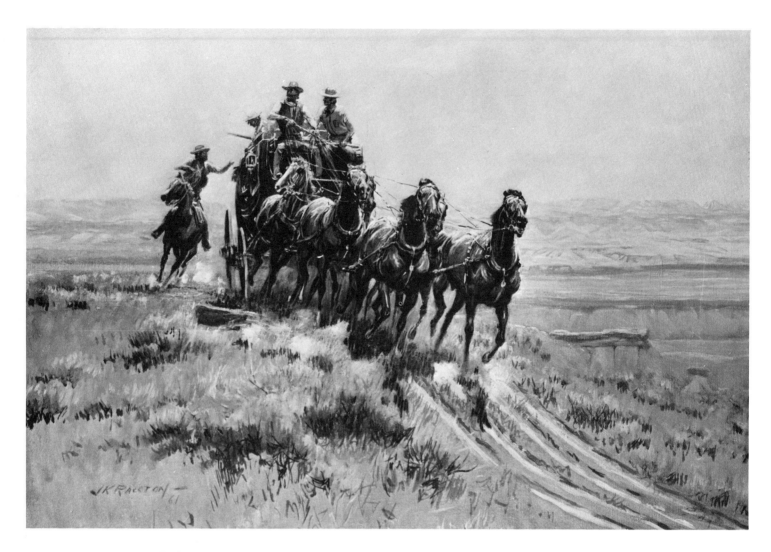

J.K. RALSTON

Pony Rider Passes the Stage, 1961
Oil on Masonite
Mrs. Jerri Covert, Billings, Montana

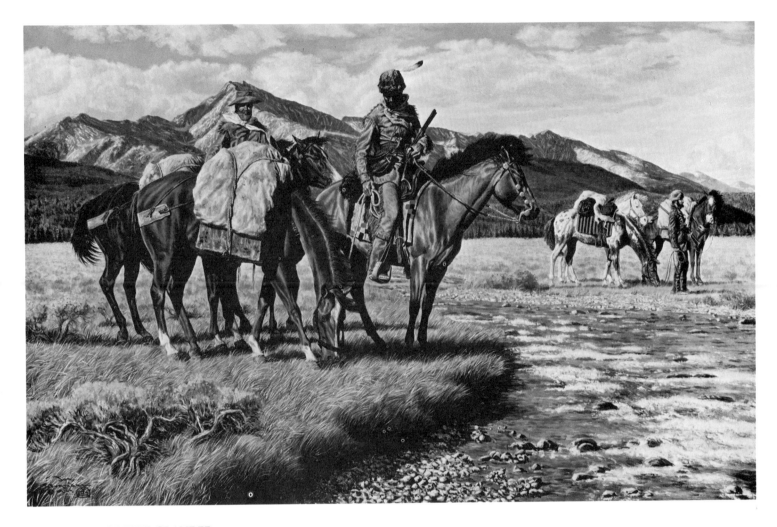

JOE RUIZ GRANDEE

At the Headwaters of the Arkansas, **1974**
Oil on Masonite, 30″ x 48″
Charles King

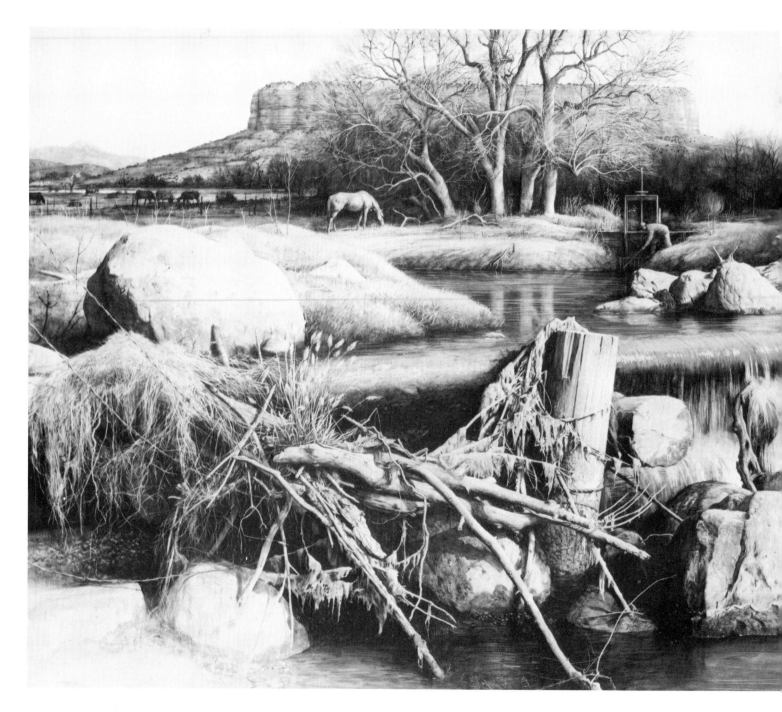

PETER ROGERS

Study for Mural, 1974
India ink on Masonite, 33″ x 80″
Texas Tech University
Lubbock, Texas

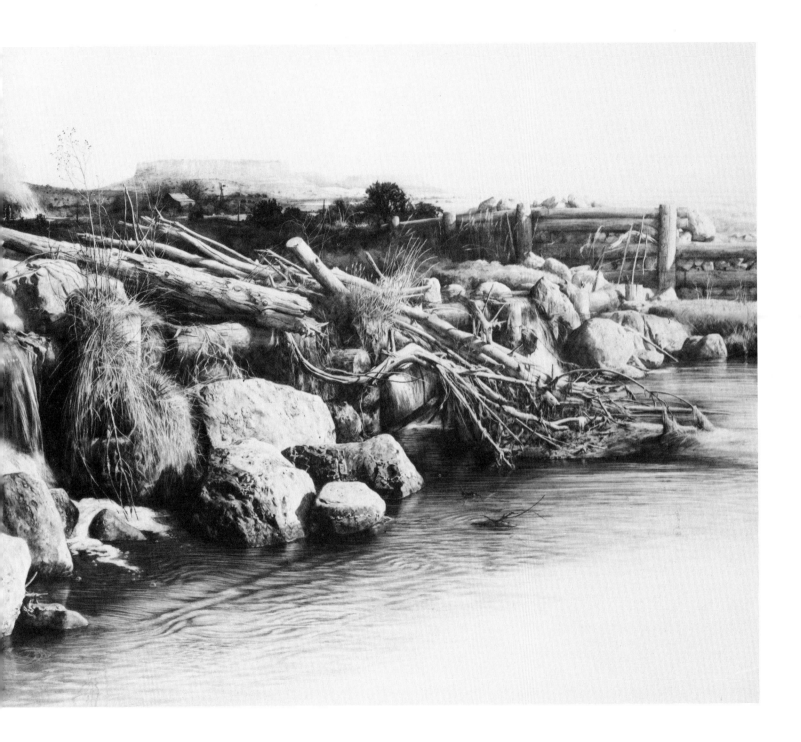

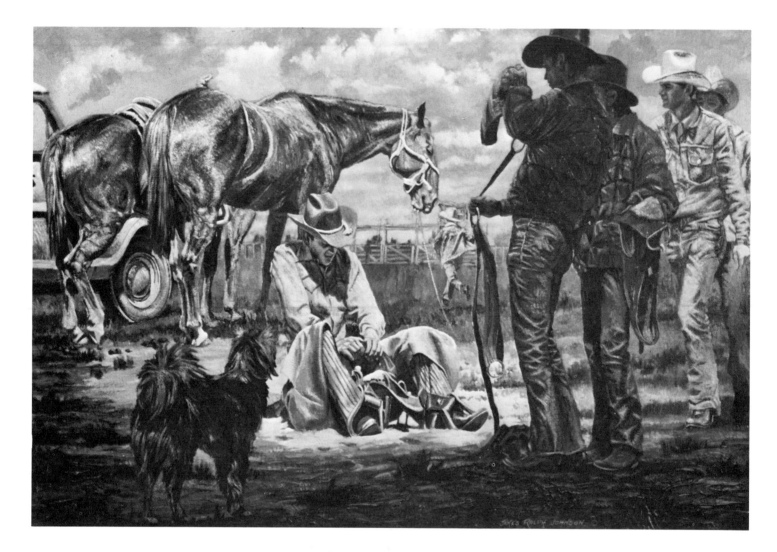

JAMES RALPH JOHNSON

Resining the Saddle, 1973
Acrylic on Masonite, 24" x 36"
National Cowboy Hall of Fame
Oklahoma City

GORDON SNIDOW

Cooking with Gas, 1974
Oil on board, 36" x 24"
Collection of the artist

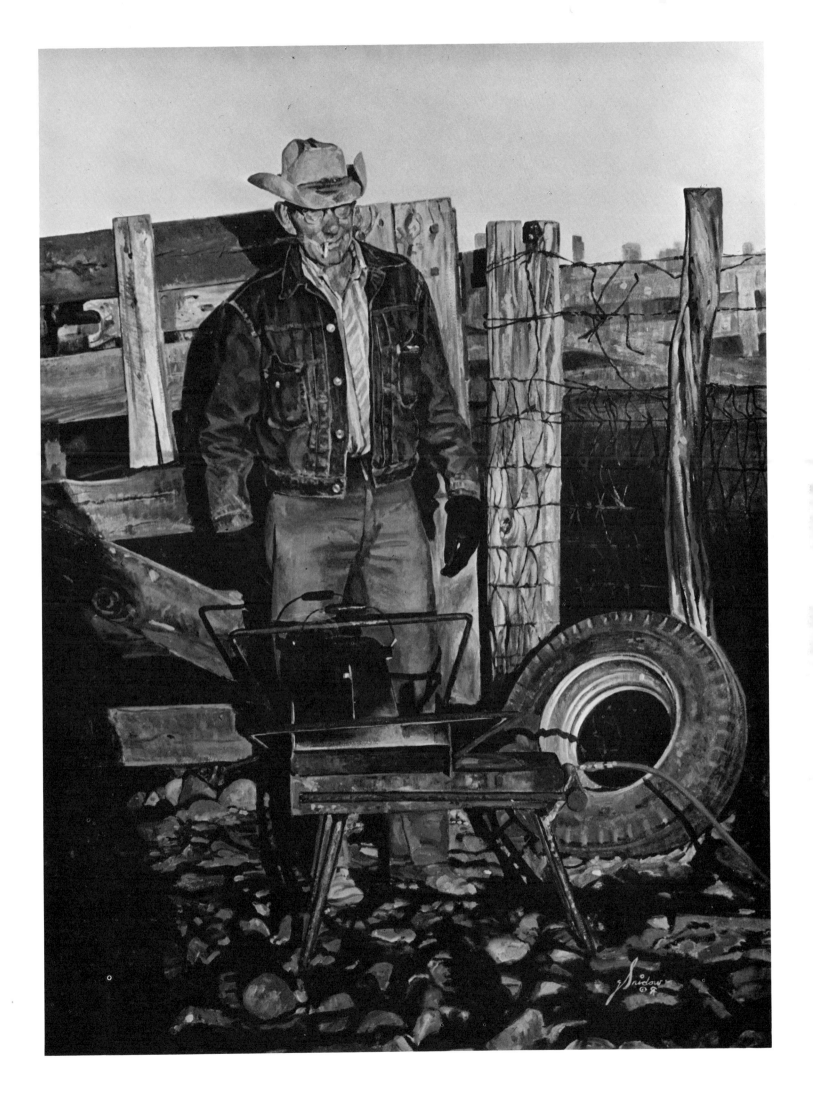

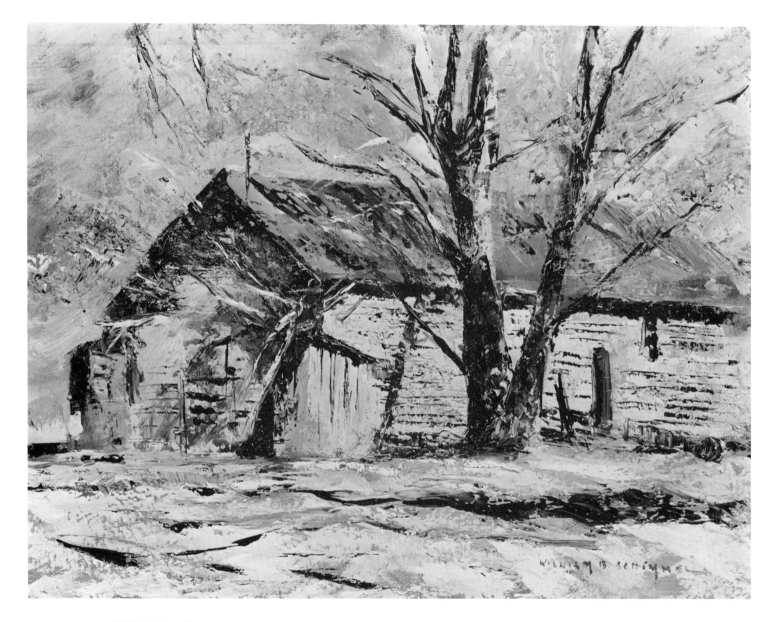

WILLIAM B. SCHIMMEL

On the Back Road to Santa Fe, 1973
Oil on canvas, 18″ x 24″
Collection of the artist

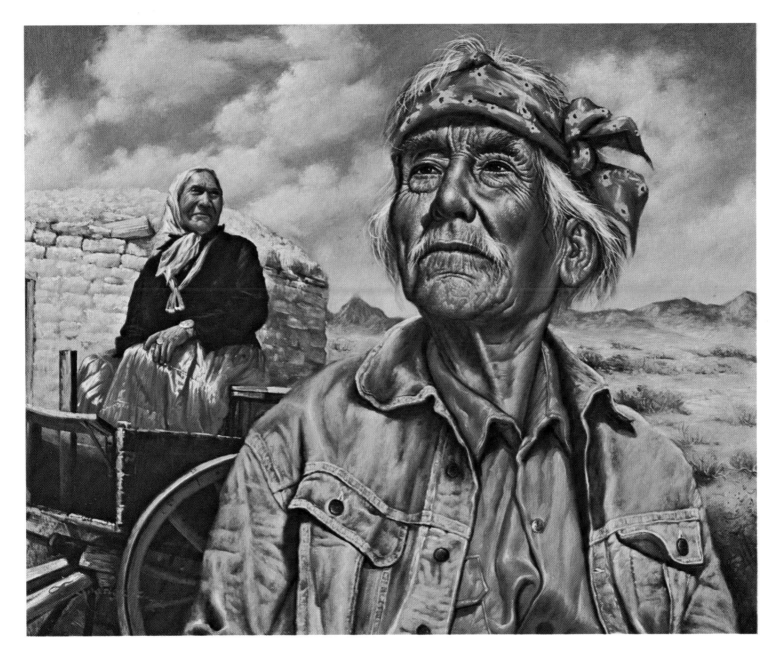

ALFREDO RODRIGUEZ

Our Land, 1974
Oil on board, 22″ x 28″
Private collection

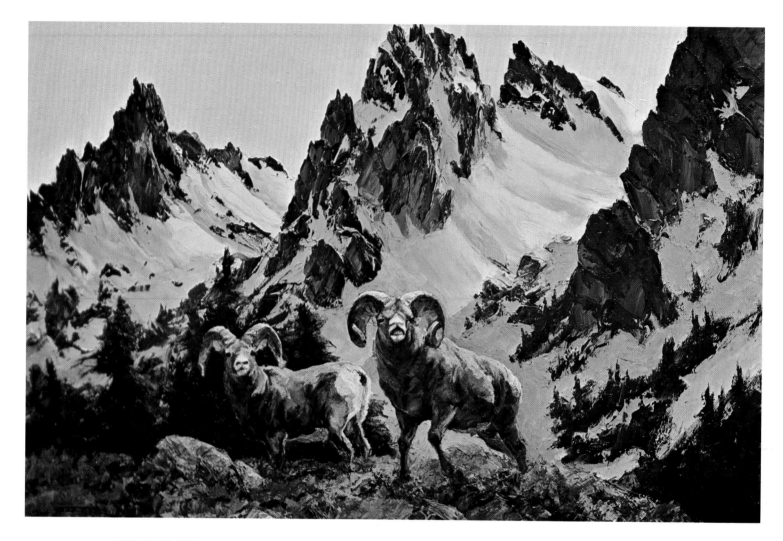

BILL FREEMAN

Big Horn Sheep, 1973
Oil on canvas . . .
Private collection

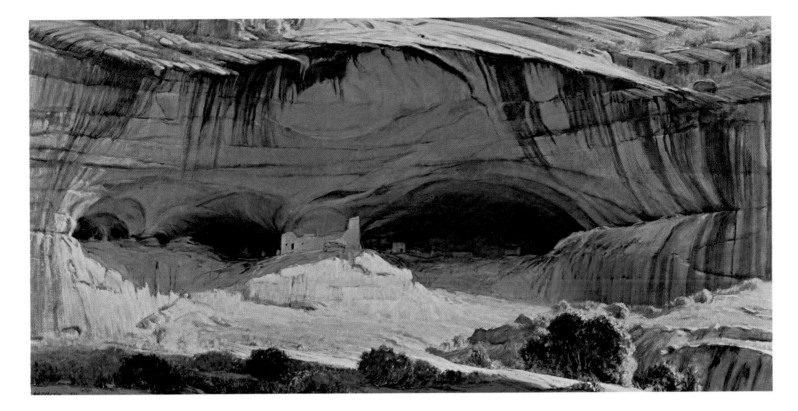

WILSON HURLEY

Mummy Cave, Cañon del Muerto, 1971
Oil on panel, 24″ x 48″
Dr. and Mrs. Albert Simms, Albuquerque

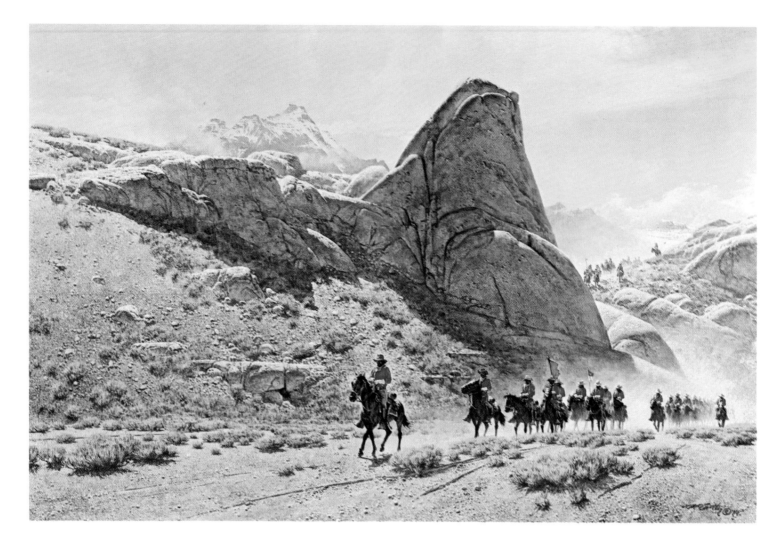

FRANK McCARTHY

The Long Column, 1974
Oil and casein on Masonite, 24″ x 36″
Private collection

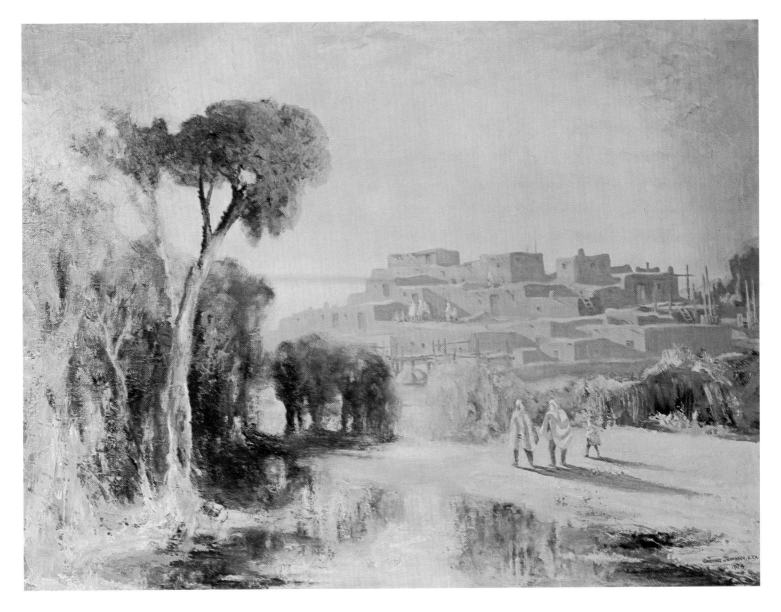

GEOFFREY JENKINSON

Autumn Sunset at Taos Pueblo, 1974
Oil on canvas, 30″ x 40″
Mission Gallery, Taos, New Mexico

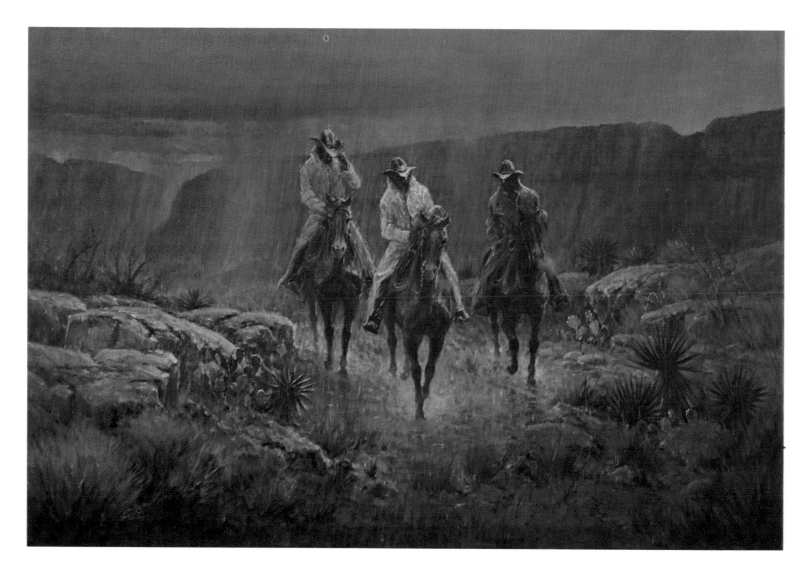

G. HARVEY

Crossing the Canyon, 1974
Oil on canvas, 24" x 36"
Private collection

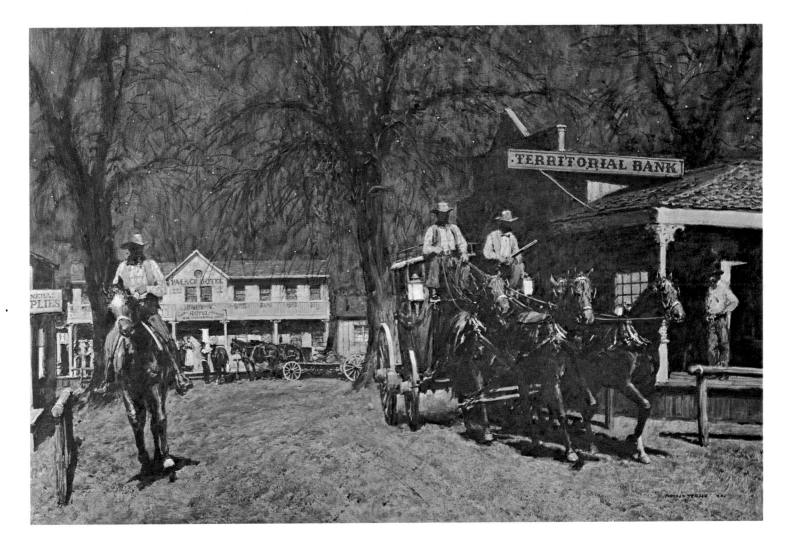

DONALD TEAGUE

The Night Mail, 1973
Watercolor, 20" x 30"
Collection of the artist

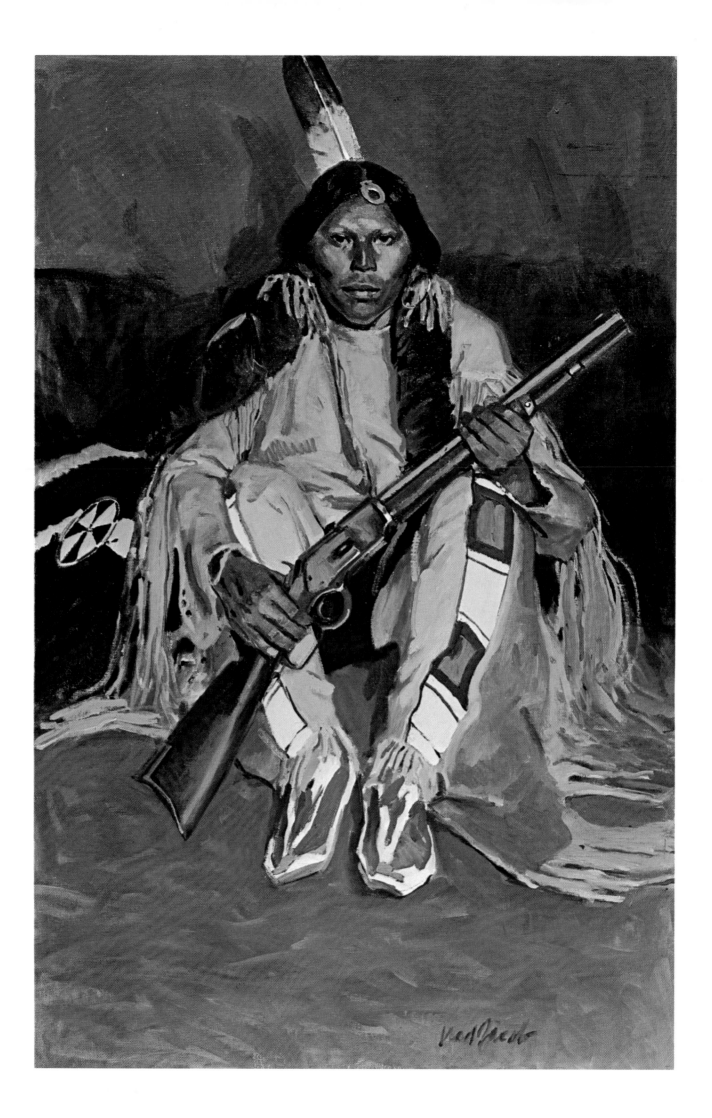

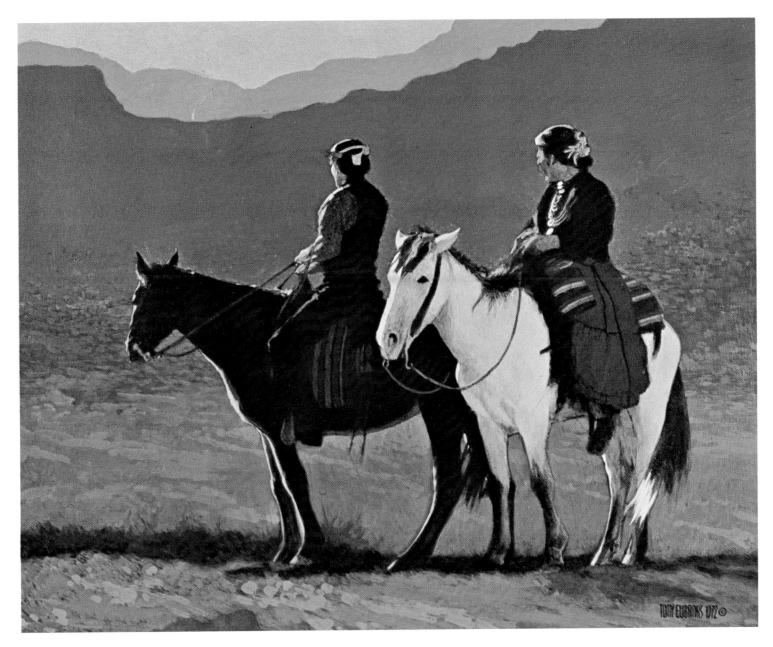

TONY EUBANKS

Two Navahos in Sunset, 1973
Acrylic on panel, 24″ x 30″
Dr. and Mrs. Jerry L. Simmons

NED JACOB

Young Man's Way, 1974
Oil on canvas, 36″ x 24″
Collection Mr. and Mrs. Robert T. Allis

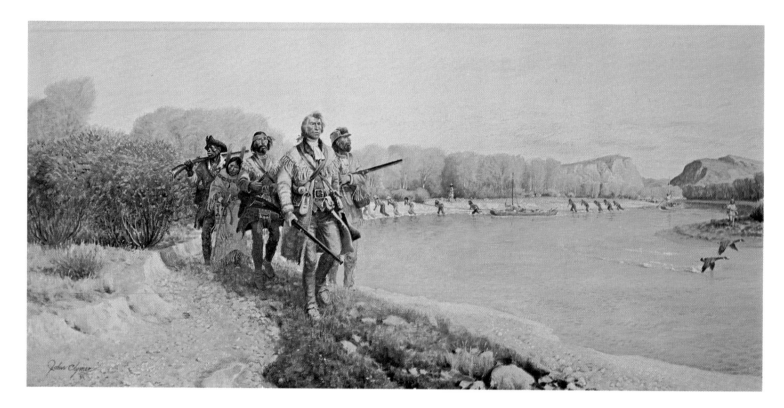

JOHN CLYMER

Up the Jefferson, 1973
Oil on canvas, 20″ x 40″
Private collection

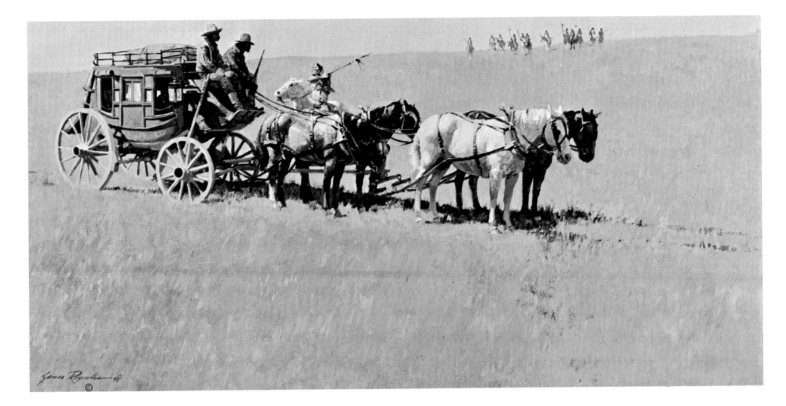

JAMES REYNOLDS
The Warning, 1973
Oil on Masonite, 30″ x 48″
Private collection

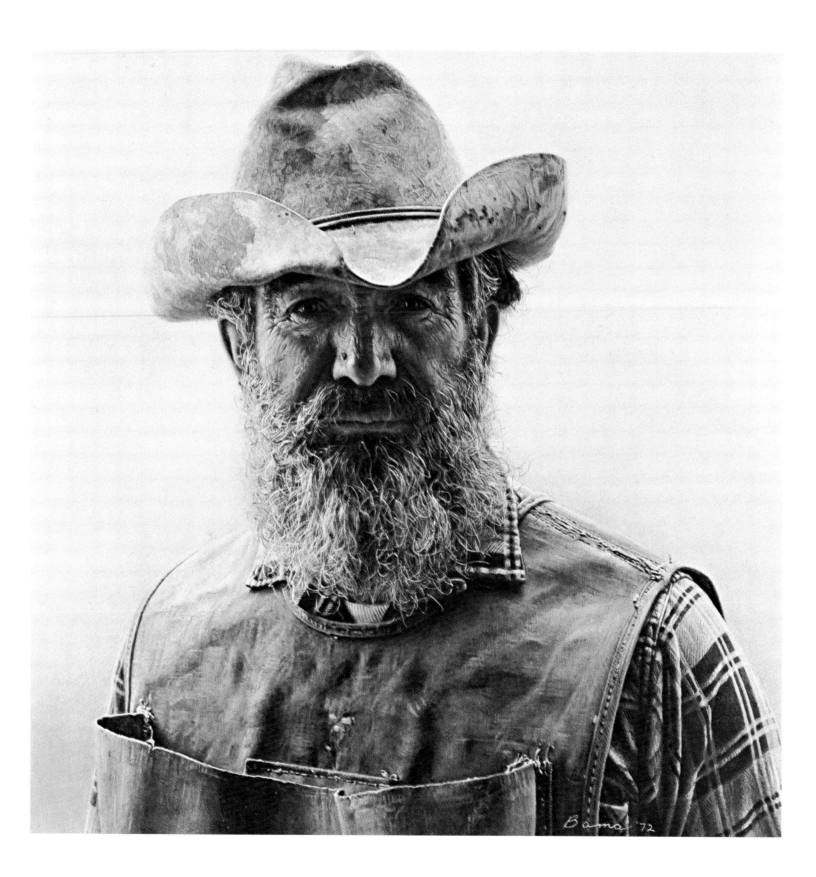

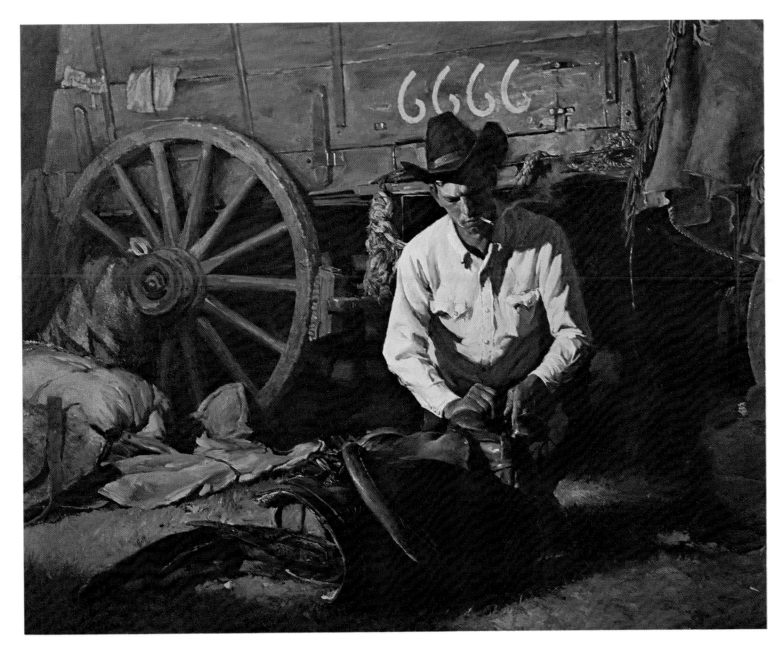

TOM RYAN

Patching his Saddle, 1968
Oil on Masonite, 24" x 30"
Ed Honnen

JAMES BAMA

Tom Laird, Prospector, 1972
Oil on panel, 16¼" x 16¼"
Tom Carson

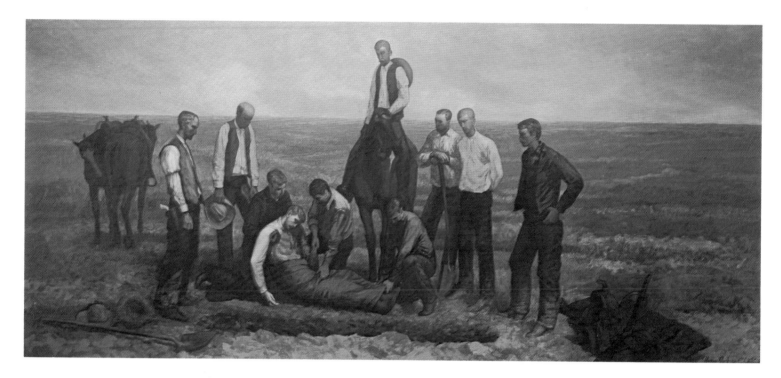

HARRY JACKSON

Range Burial, 1963
Oil on canvas, 10' x 21'
Whitney Gallery of Western Art
Cody, Wyoming

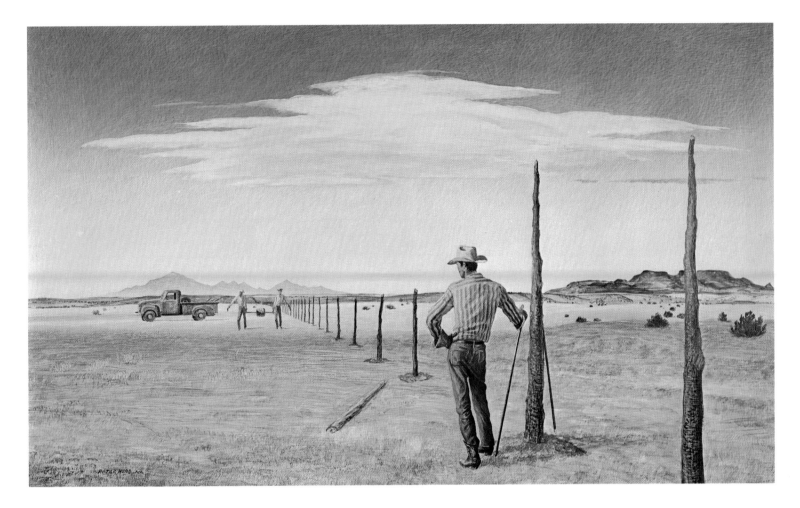

PETER HURD

The Fence Builders, 1963
Tempera on Masonite, 28¼″ x 47½″
Los Angeles Municipal Art Department

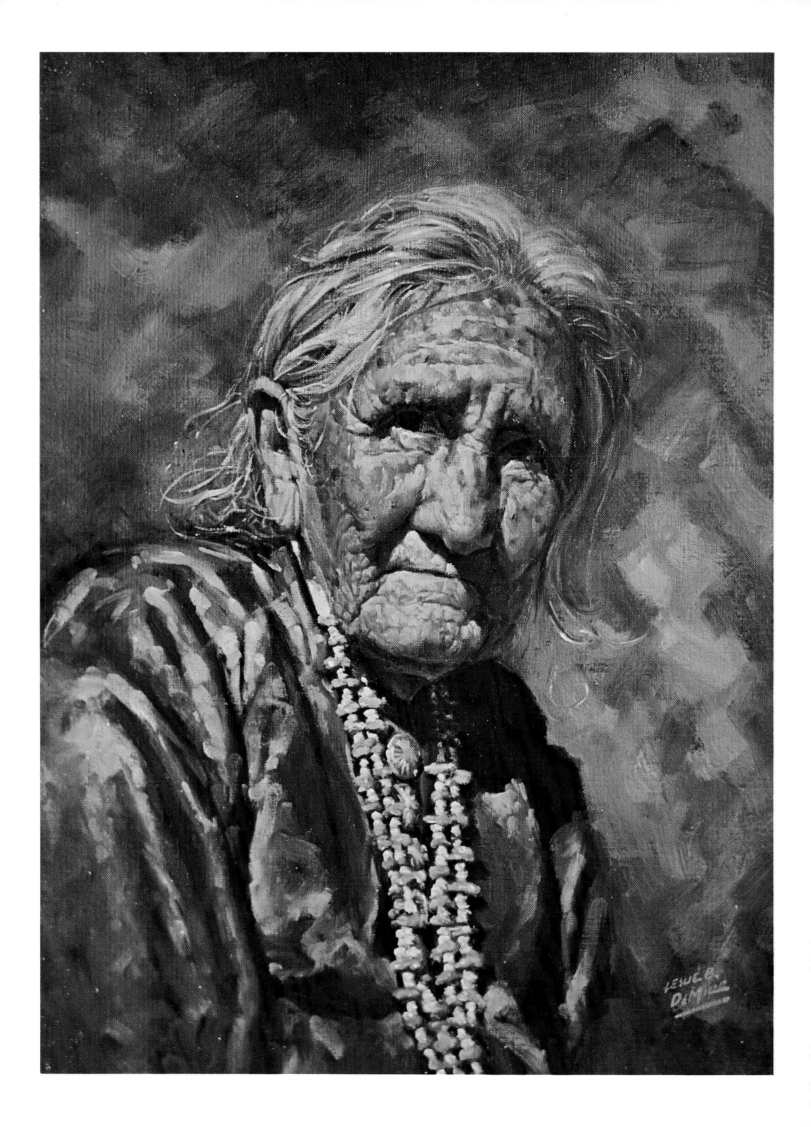

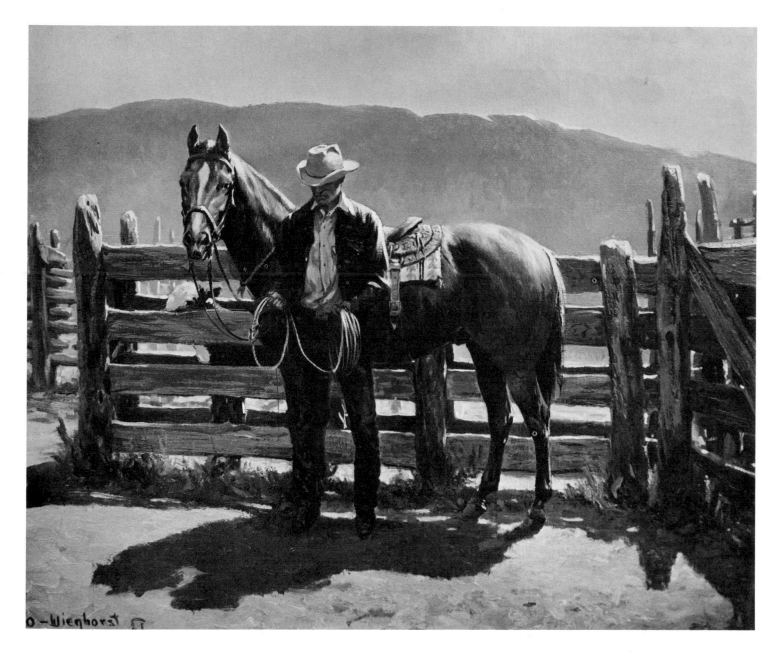

OLAF WIEGHORST

The Catch Rope, 1955
Oil, 24" x 30"
The Honorable Leonard K. Firestone

LESLIE B. DEMILLE

The Matriarch, 1972
Oil on canvas, 24" x 18"
Favell Museum of Western Art and Artifacts
Klamath Falls, Oregon

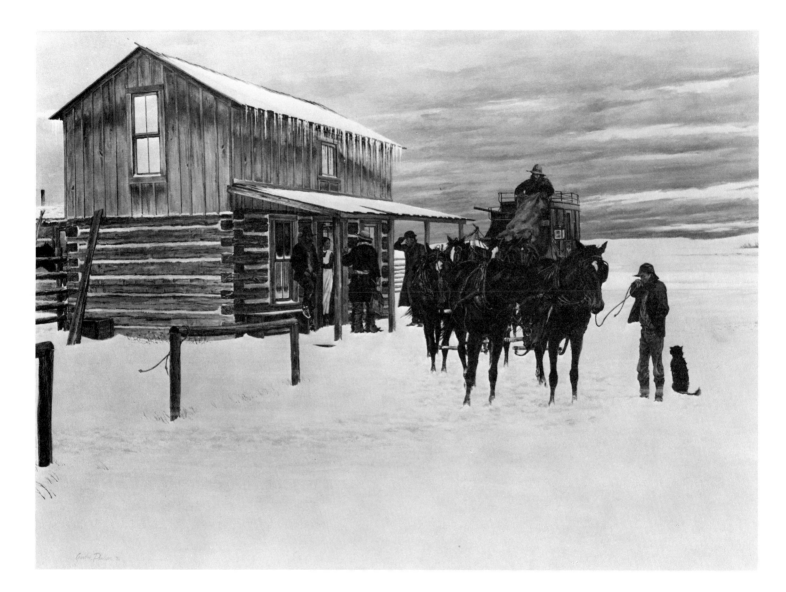

GORDON PHILLIPS

A Change of Horses, 1970
Acrylic on canvas, 30″ x 42″
Private collection

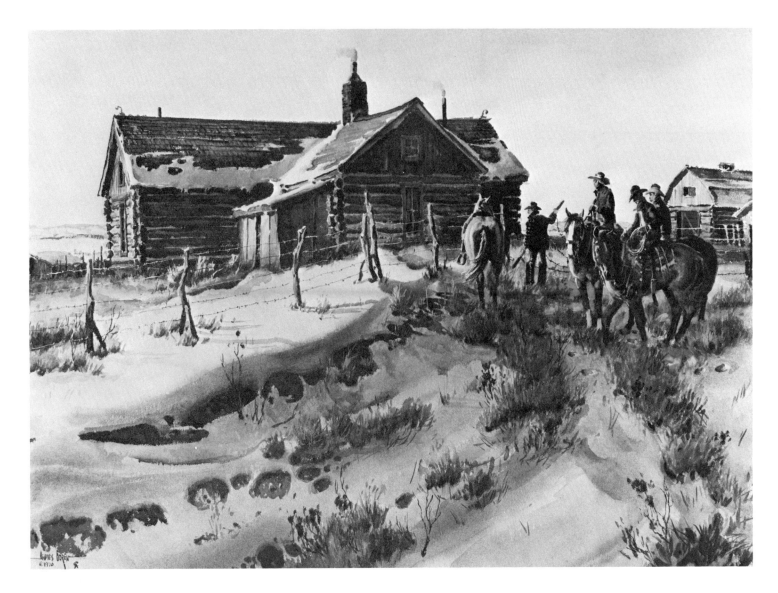

JAMES BOREN

When Saddles Creak, 1970
Watercolor, 24½″ x 38½″
National Cowboy Hall of Fame, Oklahoma City

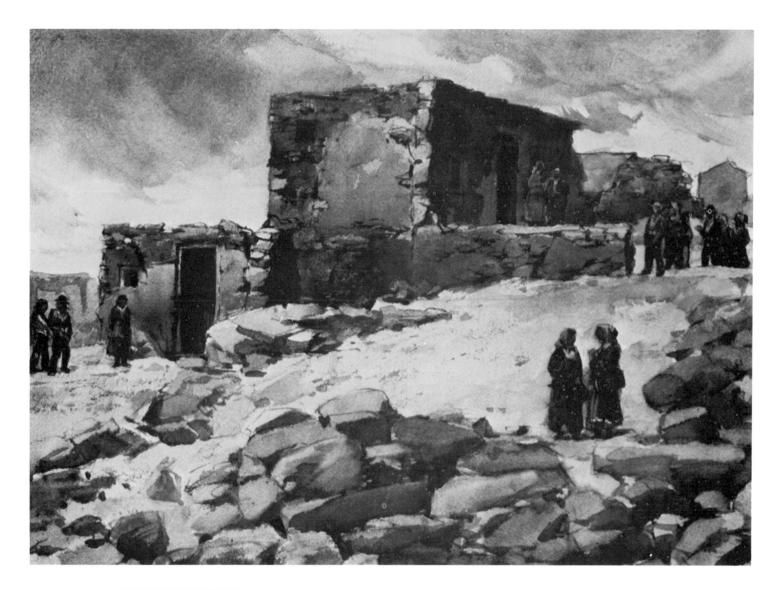

FREDERIC WHITAKER

Anticipating the Ceremony, 1970
Watercolor, 22″ x 30″
American Veterans Society of Artists, New York

JOSEPH BOHLER

High Country, 1974
Watercolor, 18″ x 24″
Settlers West Gallery, **Tucson**

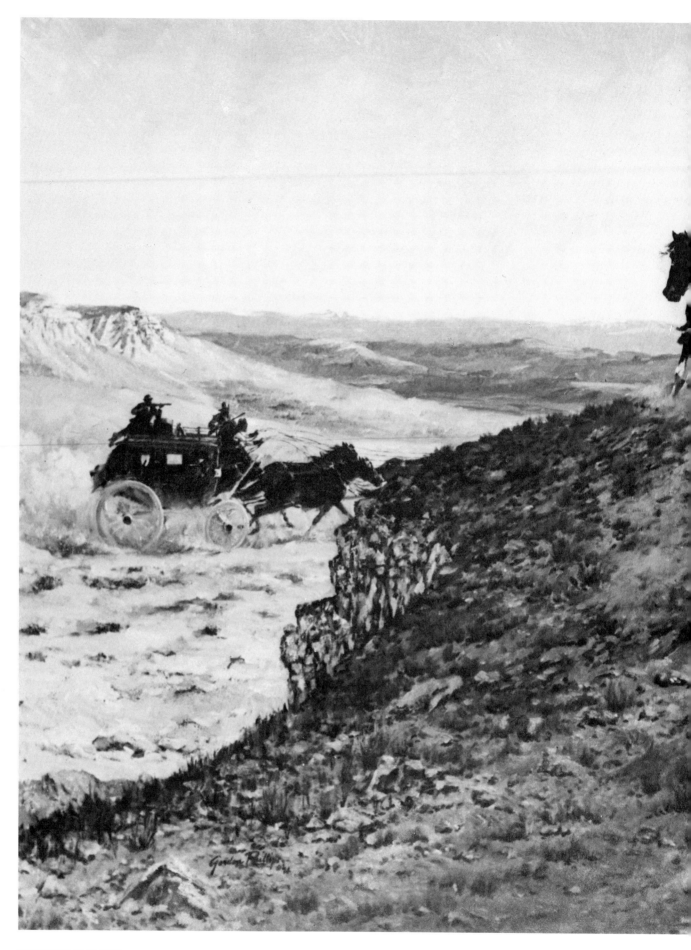

GORDON PHILLIPS

Home Stretch, 1974
Oil on canvas, 24″ x 36″
Private collection

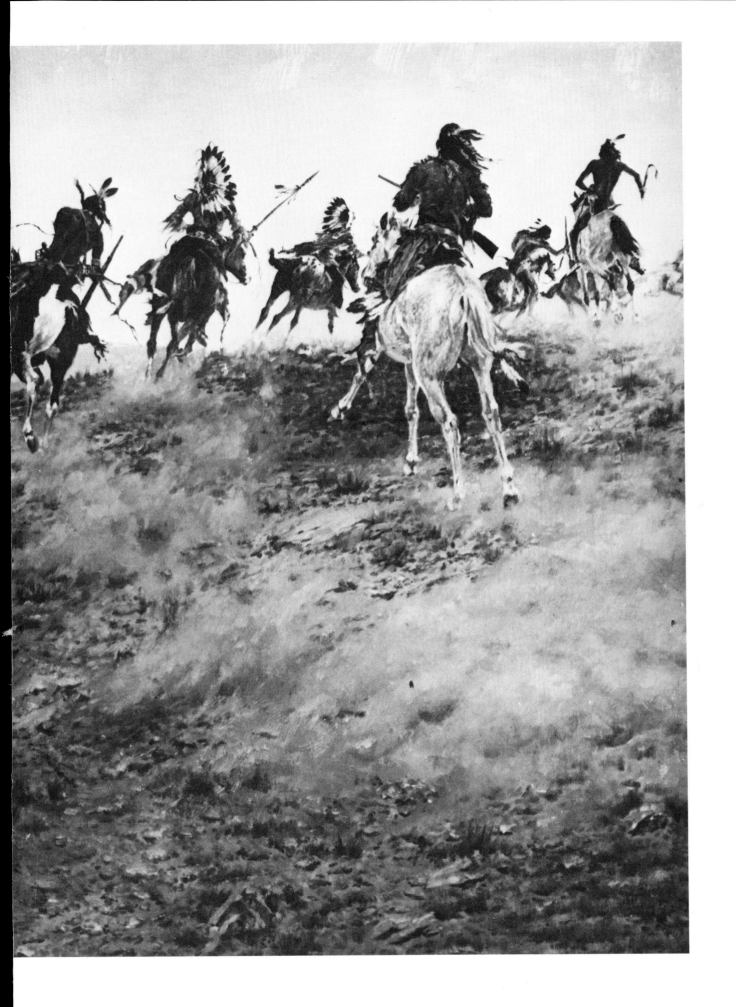

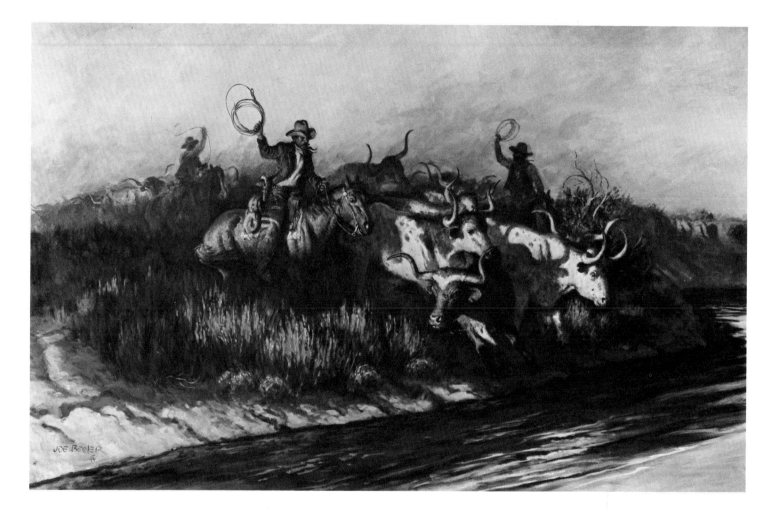

JOE BEELER

The Crossing, 1971
Oil on panel, 30″ x 48″
Charles Schreiner III

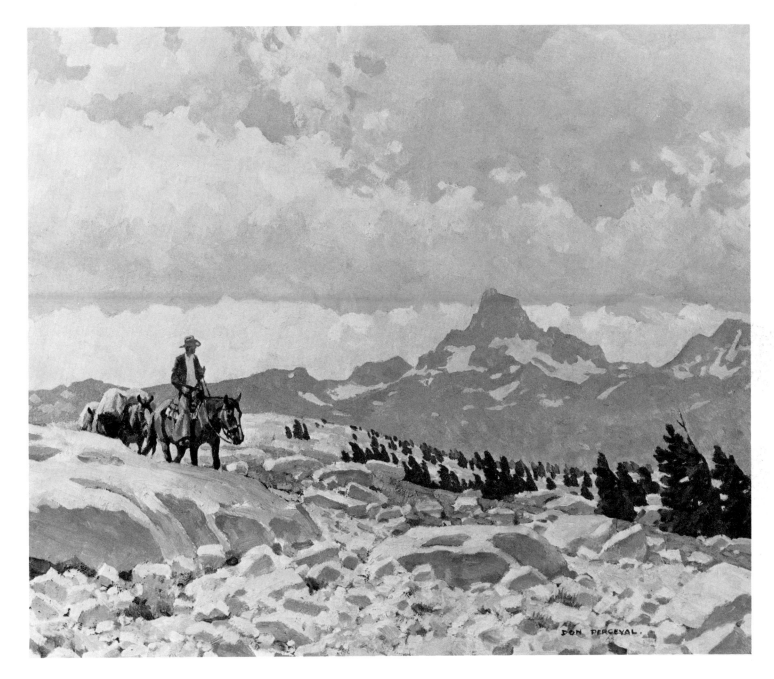

DON PERCEVAL

Trail at Timberline, 1971
Oil on Masonite, 20″ x 24″
Mr. and Mrs. Bruce M. Parrish
Santa Barbara

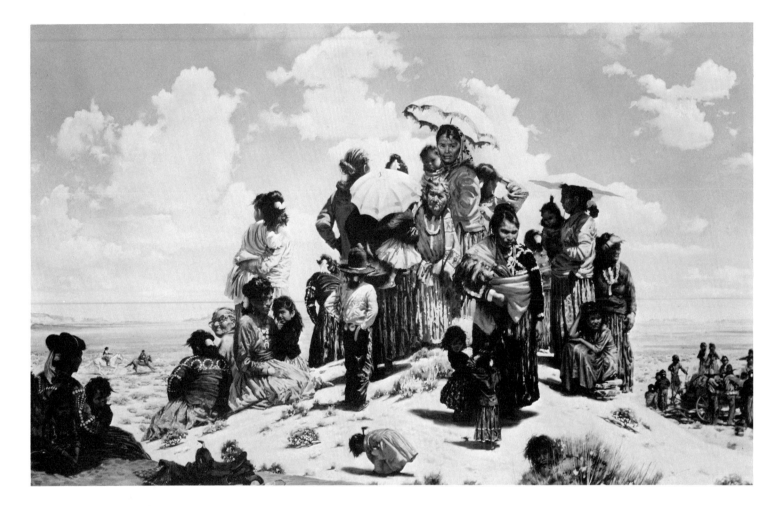

R. BROWNELL McGREW

The Race, 1965
Private collection, Oak Park, Illinois

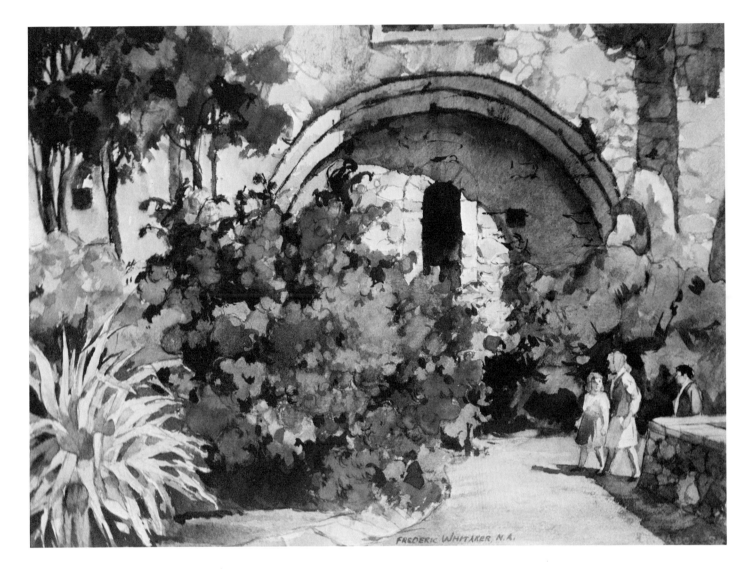

FREDERIC WHITAKER

Mission Visitors, 1972
Watercolor, 22″ x 30″
Mission San Juan Capistrano

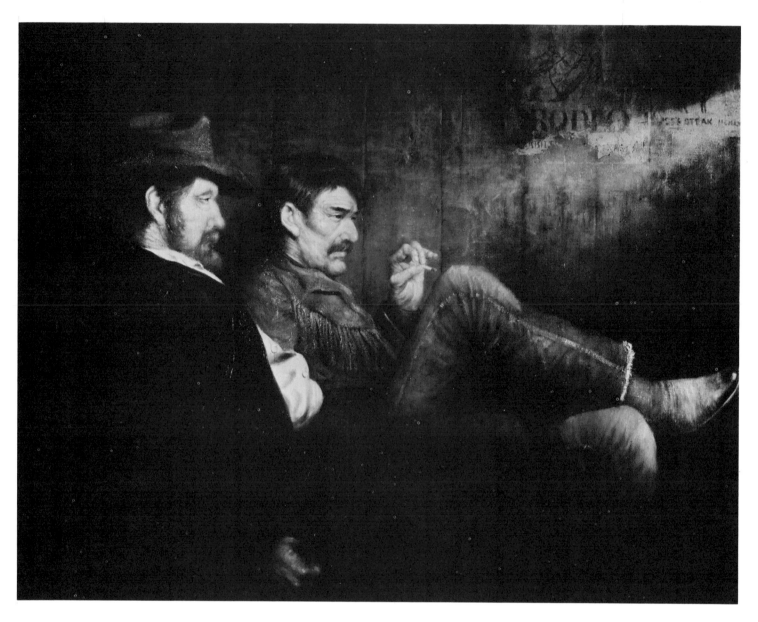

JOSEPH DAWLEY

Tough Hombres, 1974
Oil on canvas, 30" x 40"
Diamond M Museum, Snyder, Texas

Acknowledgments

This book would not have been possible without the ideas and assistance of many individuals. I am indeed grateful to Don Holden of Watson-Guptill Publications for his initiation of the subject; to Mitchell A. Wilder, Director of the Amon Carter Museum of Western Art, Fort Worth, Texas, for his recommendations; to my son Peter H. Hassrick, Curator of Collections at the Amon Carter Museum of Art and Dean Krakel, Managing Director of the National Cowboy Hall of Fame, Oklahoma City, Oklahoma, for their lists of artists; to Diane Casella Hines of Watson-Guptill for her assistance in organization; to Joan Fisher of Watson-Guptill for her editorial work; to my wife, Barbara Hassrick for her editorial advice and typing, and to Anne and Elizabeth Hassrick for their editorial comments. Particularly am I indebted to each of the artists who took the trouble to submit works and biographical information for inclusion in this publication. Without their contribution, this book would not be a reality.

Index

Page numbers in italic refer to illustrations

Edited by Joan E. Fisher
Designed by Bob Fillie
Set in 12 point Palatino by Publishers Graphics, Inc.